PHOTOGRAPHY
FOUNDATIONS
for art
&
design

PHOTOGRAPHY
FOUNDATIONS
for art
& design

the creative photography handbook

fourth edition

mark galer

ELSEVIER

AMSTERDAM • BOSTON • HEIDELBERG • LONDON • NEW YORK • OXFORD
PARIS • SAN DIEGO • SAN FRANCISCO • SINGAPORE • SYDNEY • TOKYO

Focal Press is an imprint of Elsevier

Focal Press is an imprint of Elsevier
Linacre House, Jordan Hill, Oxford OX2 8DP, UK
30 Corporate Drive, Suite 400, Burlington, MA 01803, USA

First published 1995
Reprinted 1997
Second edition 2000
Reprinted 2002
Third edition 2004
Reprinted 2005
Fourth edition 2007

British Library Cataloguing in Publication Data
A catalogue record for this book is available from the British Library

Library of Congress Cataloging-in-Publication Data
A catalog record for this book is available from the Library of Congress

ISBN–13: 978-0-240-52050-6
ISBN–10: 0-240-52050-5

For information on all Focal Press publications visit our website at
www.focalpress.com

Printed and bound in Italy

07 08 09 10 11 11 10 9 8 7 6 5 4 3 2 1

Working together to grow
libraries in developing countries

www.elsevier.com | www.bookaid.org | www.sabre.org

ELSEVIER BOOK AID International Sabre Foundation

Acknowledgements

Among the many people who helped make this book possible, I wish to express my gratitude to the following individuals:

Tom Davies for his enthusiasm for art and design education.

Jane Curry for her enthusiasm for photography in education.

Tim Daly for his advice and input to the first edition.

John Child and Adrian Davies for their input to the second edition.

John Child and Kerry Short for their input to the fourth edition.

Margaret Riley, Christina Donaldson, Stephanie Barrett, Julie Trinder and Emma Baxter for their vision and editorial input.

The students of Spelthorne College, Photography Studies College, RMIT University and Wanganui Park Secondary School for their overwhelming enthusiasm and friendship.

Dorothy, Matthew and Teagan for their love and understanding.

Picture Credits

Amanda DeSimone, Amber Williams, Andrew Butler, Andrew Goldie, Andy Goldsworthy, Angus McBean, Anica Meehan, Anitra Keough, Anna May, Ann Ouchterlony, Ansel Adams (CORBIS/Ansel Adams Publishing Rights Trust), Anthony Secatore, Ashlea Noye, Ashlee Clark, Bridie Watts, Burk Uzzle, Cas O'Keeffe, Catherine Burgess, Dave Silverstein, David Hockney, Debra Adams, Dorothea Lange, Dorothy Connop, Eikoh Hosoe, Faye Gilding, Ferenc Varga, Henri Cartier-Bresson (Magnum Photos), Henry Peach-Robinson (The Royal Photographic Society), Ian Berry (Magnum Photos), Itti Karuson, Jana Liebenstein, John Blakemore, John Hilliard, Jonathon Sumner, Julia McBride, Kaitlyn Ewart, Kim Noakes, Liam Shaw, Lorraine Watson, Louis Daguerre (Société Francais de Photographie), Luke Lewis, Maddi Crow, Maddy McGuffie, Maddy Smith, Madelene Reid, Madeline Green, Madi Wright, Marc Riboud (Magnum Photos), Matthew Orchard, Michael Mullan, Michael Wearne, Mike Wells, Natasha Zurcas, Oliviero Toscani (Benetton Group), Orien Harvey, Paul Allister, Peter Kennard, Pieta Lapworth, Rachel Ward, Rebecca Sloan, Rebecca Umlauf, Renata Mikulik, Ricky Bond, Rufina Breskin, Samantha Amor, Samantha Everton, Sarah Fridd, Sarah Gall, Sarah Jenkins, Sean Killen, Seok-Jin Lee, Shane Bell, Sharounas Vaitkus, Shaun Guest, Simon Bingham, Sophie Ritchie, Stephen Rooke, Stuart Wilson, Tamas Elliot, Tom Scicluna, Walker Evans, Wil Gleeson, Zarah Ellis.

All other photographs and illustrations by the author.

Contents

Introduction:

Introduction xiii
Introduction to students xiv

Foundation Module

1. The Frame 2

Aims 4
Composition 4
Subject placement 8
Balance 9
Line 10
Vantage point 12
Depth 13
Practical assignment 14

2. Light 16

Aims 18
Creating atmosphere 18
Quality of light 19
Direction of light 20
Subject contrast 21
Exposure compensation 22
Depth of field 23
Basic studio lighting 24
Practical assignment 25

3. Time 26

Aims 28
Photographic techniques 32
Flash photography 35
Practical assignment 37

Advanced Projects

4. Self Image 40
Aims 42
Practical assignment 46

5. Distortion 48
Aims 50
Distortion using the camera 51
Computer manipulation 54
Practical assignment 62

6. Photomontage 64
Aims 66
Political photomontage 68
Photomontage in the media 70
Photomontage in art 71
Practical assignment 1 73
Practical assignment 2 74

7. Landscape 76
Aims 78
Pictorial photography 79
Realism 80
Documentary 81
Personal expression 82
Expressive techniques 84
The constructed environment 87
Assignments 88

8. Portraiture 90
Aims 92
Environment 92
Design 93
Revealing character 96
Connecting with new people 97
Directing the subject 98
Character study 99
Assignments 100

9. Photo-story 102

Aims 104
Visual communication 106
Capturing a story 108
Creating a story 111
Editing a story 112
Ethics and law 113
Assignments 114

10. Still Life 116

Aims 118
The influence of painting 118
Pursuit of the aesthetic 119
Point of view 120
Background 121
Lighting 122
Composition 123
Balance 124
Dimension 125
Focus 126
Perspective 127
Practical assignment 128

11. Visual Literacy 130

Aims 132
Manipulation techniques 133
Glamor in advertising 135
Ambiguity in advertising 136

Technical Guides

12. Image Capture 142
Mastering the machinery 144
Digital cameras 145
Exposure 148

13. Image Editing 156
Aims 158
Image capture - Step 1 158
Cropping - Step 2 159
Tonal adjustments - Step 3 161
Color adjustments - Step 4 165
Cleaning - Step 5 167
Sharpening - Step 6 168
Saving - Step 7 169

14. Printing 172
1. Preflight checklist 174
2. Keeping a record 174
3. Preparing a test print 175
4. Print preview 176
5. Printer driver 177
6. Analysing the test print 178
7. Maximizing detail 179

15. Screen Presentations 180
Aims 182
Apple's iFamily 182
PDF presentations 184
Adobe Slide Show 186
Creating a slide background 188
PowerPoint 190

16. Resources 196

Digital setup 198
Commands and shortcuts 198
The monitor 199
File management 202
Settinngs and preferences in Photoshop 203
Photoshop or Photoshop Elements? 204
Mac or PC? 205
Student gallery 206
Controlled test 208
Progress report 209
Work sheet 210
Summer project 211

Glossary 212

Index 219

Introduction

Vision is the primary sense that allows us to understand the world. As we view photographs used by the mass media and visual arts we are exposed to some of the most complex ideas within our society. The ability to comprehend and communicate this visual information is a basic skill for students wishing to express themselves through the medium of photography. Knowledge and understanding of design and technique that relate to the creation of photographic images enables clarity of expression. These skills are presented as a structured educational framework to give students of photography a clear and discerning vocabulary for creative self-expression. The emphasis has been placed upon a creative rather than technical approach to the subject.

A structured learning approach

The photographic curriculum contained in this book offers a structured learning approach that will give students a framework for working on design projects and the photographic skills for personal communication. This book is intended to promote independent learning and help build design skills, including the ability to research, plan and execute work in a systematic manner. Students are encouraged to adopt a thematic approach, documenting all developmental work.

Implementation of the curriculum

The guides contain a degree of flexibility in giving students the choice of subject matter. This allows the student to pursue individual interests whilst still directing their work towards answering specific design criteria. This approach gives students maximum opportunity to develop self-motivation.

The first three study guides that form the 'Foundations Module' are intended to be tackled sequentially and introduce no more technical information than is necessary for students to complete the work. This allows students confidence to grow quickly and enables less able students to complete all the tasks that have been set. The activities and assignments of the first three study guides provide the framework for the more complex assignments contained in the advanced section.

The 'Resources' chapter looks at setting up a computer system that is suitable for editing photographs in order to present the images on the computer's monitor or print via a print service provider or desktop printer. The chapter also includes a work sheet and progress report which students can complete with the help of a teacher. This process will enable the student to organize their own efforts and gain valuable feedback about their strengths and weaknesses.

Photographic education

Stewart Mann in 1983 conducted extensive research to establish how photography was being used. He concluded that processing and printing from black and white negatives could consume most of the time available for students at school, giving them little time to consider 'why and what should be photographed'. Value, he found, was being given to form rather than content. 'Photography should be seen as a vehicle for visual communication not an exercise in times and temperatures. Teachers' aims to use photography primarily as a means of creative expression were compromised by the emphasis upon how to produce a given result technically with less consideration given to why and what should be photographed' (Stewart Mann, 1983). With the switch to a digital workflow there has never been a better time to embrace communication as the primary focus in photographic education.

Introduction to students

The projects that you will be given during this course are designed to help you learn both the technical and creative aspects of photography. You will be asked to complete tasks including research activities and practical assignments. The information and experience that you gain will provide you with a framework for your future photographic work.

What is design?

Something that has been designed is something that has been carefully planned. When you are set a photographic design assignment you are being asked to think carefully about what you want to take a photograph of, what techniques you will use to create this image and what you want to say about the subject you have chosen. Only when the photograph communicates the information that you intended is the design said to be successful. By completing all the activities and assignments in each of the projects you will learn how other images were designed and how to communicate visually with your own camera. You will be given the freedom to choose the subject of your photographs. The images that you produce will be a means of expressing your ideas and recording your observations. Design is a process which can be learnt as a series of steps. Once you apply these simple steps to new assignments you will learn how to be creative with your camera and produce effective designs.

Using the study guides

The projects have been designed to offer you support during your design work. Each project is presented as a series of skills or parcels of knowledge. The activities are to be undertaken after you have first read and understood the supporting section on the same page. If at any time you feel unclear about what is being asked of you, consult a teacher.

Equipment needed

The course that you are following has been designed to teach you photography with the minimum amount of equipment. You will need a camera with manual controls for aperture and shutter speed. Consult your teacher or a photographic specialist store if you are in doubt. Many dealers can supply second-hand equipment complete with a guarantee at reasonable prices. Large amounts of expensive equipment will not make you a better photographer. Many of the best professional photographers use less equipment than some amateurs. There are some areas of photography, however, which do require some very specialist equipment. These include some areas of sport and wildlife photography where you are unable to get very close to your subject. If these areas are of particular interest, you will need to think carefully about which of these sporting activities or animals are possible with the equipment you intend to use. Access to a computer and inkjet printer will be required if you are to have control over the production of the finished artwork.

Research and resources

The way to get the best out of each assignment is to use the activities contained in the projects as a starting point for your research. You will only realize your full creative potential by looking at a variety of images from different sources. Creative artists and designers find inspiration for their work in different ways, but most find that they are influenced by other work they have seen and admired.

'The best designers are those who have access to the most information.'
Stephen Bailey - former director of the Design Museum.

Getting started

Start by collecting images that are relevant to the activity you have been asked to complete. This collection of images will act as a valuable resource for your future work. By taking different elements from these different images, e.g. the lighting technique from one and the vantage point from another, you are not copying somebody else's work but using them as inspiration for your own creation. Talking through ideas with other students, friends, members of your family and with a teacher will help you to clarify your thinking, and develop your ideas further.

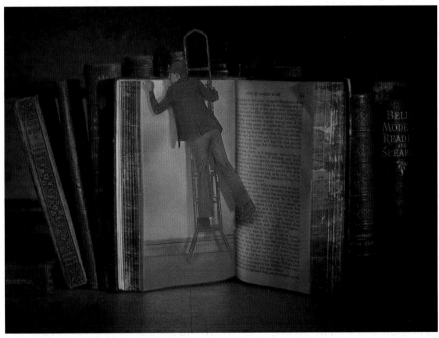

Samantha Everton

Choosing resources

When you are looking for images that will help you with your research activities try to be very selective, using high quality sources. Not all photographs that are printed are necessarily well designed or appropriate to use. Good sources of photography may include high-quality magazines and journals, photographic books and photography exhibitions. You may have to try many libraries to find appropriate material. Keep an eye on the local press to find out what exhibitions are coming to your local galleries.

Presentation of research

In each assignment you may be asked to provide evidence of how you have developed your ideas and perfected the techniques you have been using. This should be presented in an organized way so that anybody assessing your work can easily see the creative development of the finished piece of work. You should:

~ Make brief comments about images that you have been looking at and how they have influenced your own work. Copy or download these images if possible and include them with your research. Acknowledge the sources of your information (magazines, books, websites, etc.) and any primary sources such as gallery visits.

~ Comment on how your initial photographs in response to each assignment has influenced or changed the subsequent shoots. You should clearly state what you were trying to do with each picture and comment on its success. You should also state clearly how any theme which is present in your work has developed.

~ All images should be clearly referenced to relevant comments using either numbers or letters as a means of identification. This coding will ensure the person assessing the work can quickly relate the text with the image that you are referring to.

Presentation of finished work

The way you present your work can influence your final mark. Design does not finish with the print or image file. Consider also the most appropriate or effective way to present your images. Make sure the images are carefully cropped, straightened, and clear of dust and marks. Any writing that you include should be spell-checked and grammatically correct.

Storage of work

Prints should be kept clean and dry whilst all digital files should be archived on removable hard disks for safekeeping.

Talking about images

In talking about photographs it is important to understand the fundamental principles. Everybody is allowed an opinion. Listening to people's opinions helps us understand how different people view the world. Understanding how different people view the world helps us to create images that communicate clearly.

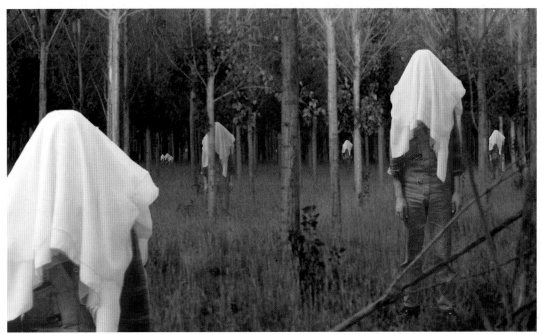

Zarah Ellis

Mirrors and windows

Subjective analysis

When we talk about a photograph we may make a comment that can be said to be either 'subjective' or 'objective'. A subjective comment is one that is someone's 'personal opinion' (something that they feel to be true). Someone else may disagree with this opinion because they do not feel or think in quite the same way. For example, one person may say, 'the sky in this image looks threatening', whilst another person may gain only a sense of tranquillity from looking at the same image. No matter how they view this image they do not gain the sense of foreboding the first person saw. Because we are individuals with unique histories and experiences, the act of viewing an image may trigger different emotional responses in different people. When we create a photograph it can sometimes be seen to be acting as a 'mirror', reflecting who we are, as shaped by our personal experiences and unique character.

When you are discussing an image talk about any emotional responses you may experience. Comment on what the content means to you or what you understand to be happening. Refer to any personal connections to the subject matter you may have so that others can understand why you may feel this way. You may make an 'aesthetic' judgement of the image. Aesthetic appreciation is a little like musical taste. There is no right or wrong as it is a very personal issue. Above all, be honest to yourself and respect the opinions of others.

Objective analysis

We can also make a comment about a photograph that cannot be disputed, because it is not colored by our feelings or opinions. This observation about a photograph can be said to be 'objective' as it is based on fact, e.g. 'the boy in the photograph is sitting on the grass'. When we create a photograph that documents the world around us it can be seen as a 'window' looking out to the external world to inform people about indisputable facts.

Discussions about a photographic image can start with a description of the explicit content of the image. You should state the context in which the image was presented if you are discussing an image that you have collected, e.g. gallery, magazine, etc. List the visible elements of design and technique that were used by the photographer/picture-editor to capture or organize the image.

Seeing is believing

Popular sayings such as 'seeing is believing' and 'the camera never lies' indicate a trust in the photographic image for presenting objective evidence. This perceived objectivity of photography by the public makes photography a powerful medium for communication by the media. Implied communication in photographs used by the media is used to reinforce ideas and concepts that they would often like us to view as evidence – evidence that buying the product will make us happy, or evidence that the event happened in the way that we were informed by the text. Very often we see only what we are guided to see by the supporting text.

> Cause of Death - John Hilliard
> 'This picture opposite demonstrates how framing affects the way a photograph is read and how captioning spells out its meaning - offering elegant forensic evidence that, although the camera cannot lie, photographs tell different truths.'
> Chris-Steele Perkins

Note > Although the difference between subjective and objective analysis may seem clearly defined, many people who look at a photograph have trouble separating what is explicit and what is implicit. We must ask the question 'What can I actually see, and what do I think I see?,' Concepts and ideas can be stated clearly in photographs using factual evidence (explicit communication) or merely implied or suggested (implicit communication).

seeing is

CRUSHED

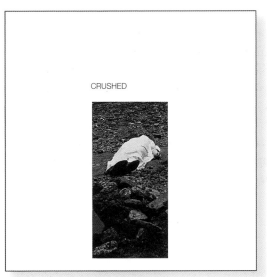

DROWNED

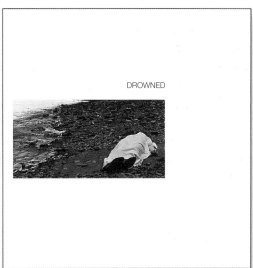

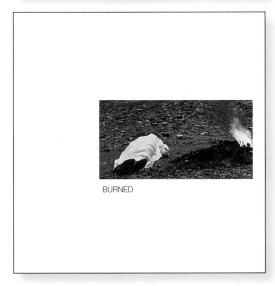

BURNED

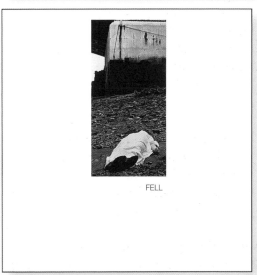

FELL

Cause of Death - John Hilliard, 1974 - Arts Council Collection, Hayward Gallery, London

believing

Viewing the image out of context

Leonardo's famous painting 'The Mona Lisa' in The 'Louvre' museum in Paris demands respect. We are expected to be in awe of the original master and appreciate the art, the value and the historical significance. Put a reproduction above your TV and the image at a glance may appear remarkably similar to that of the original (minus the gold frame), except that your wallpaper and your living room now surround it. The great work of art is stripped of its presentation and its relationship with the other great works of art it once shared its room with. The expectations for us to look carefully with admiration and appreciation are removed. The context in which we see an image makes a significant difference to how we respond to the image. When we present an image for discussion we must remember that we have removed it from its original context.

Note > The original context is therefore an important 'frame of reference' that should be recorded in your background work or research.

Presentation

Most people consume a large amount of 'ephemeral' (here today, gone tomorrow) images each day. The person who creates an image and expects the viewer to study the image for longer than three seconds must often provide a cue or context so that the viewer understands the purpose or intention behind the image's creation. Photographs are often passed around straight from a packet of 36 (traditional number) as part of a cultural communication pattern. Because we are used to having to view 36 we glance at them briefly because we know there are another 35 on the way. If you double the size of the image and present it either in a frame or in a folio you are telling people that the image has value - maybe only to you - but the image demands closer attention, comment and appreciation. When a single image cannot hope to communicate what it is you want to say a portfolio of images usually establishes connections and a dialog that is very difficult in a single image.

Note > Consider carefully how you will sequence and present your final images for viewing and/or assessment.

Reaction and interpretation

There can be no guarantee that anyone will view and read an image you have created the way you would like them to. Images are full of visual ambiguity and uncertainty. The appreciation is subjective. It is subjective because the image has been removed from its original context and the intellectual and emotional history of the viewer may vary enormously from that of the photographer. Again the production of a body of work that is united as a portfolio or study can help to clarify your aims and objectives. An image by the master photographer Henri Cartier-Bresson removed from its book and viewed alone is a lot less powerful than a book of images that define Henri as the master of 'the decisive moment'. A teacher or lecturer responding to your work can provide you with some technical feedback and some subjective opinions but the full power of the moment that you saw and responded to may well be lost - the teacher was not there.

Note > Everybody's personal opinion or appraisal of your work is valid even if you disagree.

The process of self-expression

Why do we take photographs? Do we take them for other people to admire our skill? Do we take them as a record, document or as a trophy? Do we create them to advertise to our friends that we are having a beautiful, successful, enviable life, or do we create them for ourselves, a process of expressing how we feel to be alive in our world.

I create images because the act of looking helps me to slow down and actually look at the life I am living. It gets me 'out of my head' and into my world - it helps me to connect and appreciate what is around me, and this act helps me to express myself. Art is about expressing yourself. It doesn't really matter if no one 'gets it' so long as it was a meaningful exercise to you. Buddhist monks make 'Mandala' paintings by pouring sand slowly and carefully to create intricate designs. They work on the art for days and then tip it into the sea when they are finished. The art is often about the process rather than the outcome. When someone appreciates your art it is indeed rewarding. Someone else understands us - someone else 'gets it' too.

Dreams Will Come True - Matthew Orchard

Symbols, metaphors and similes

Poets to pack an emotional charge in just a few lines use symbols, metaphors and similes. The poem may require the reader to work a little harder at unravelling the meaning - the enjoyment, however, for many is in the unravelling - a literary crossword puzzle if you like. It's a game not everybody enjoys, but the more you play the easier it gets. I am using a simile now to make my point. These literary tools can be used to extend the photographer's visual language by using images that represent more than their face value.

Our world is filled with symbols. The juxtaposition (careful placing of one thing next to another) of content can change meaning in an extraordinary way. We don't have to physically pick one thing up and place it next to the other. We can simply move ourselves until the different subjects are framed together.

Captions

Images are often used as evidence by the media to validate communication. The camera is seen by many as an objective tool for documenting our world. The subjective interpretation of photographic content, however, poses a problem for individuals wanting to create a specific message for a target audience. This subjective interpretation can be reduced or eliminated with the use of 'captions'. Captions are used by the media to reinforce or validate the intended communication and may resolve any questions that we otherwise might have had. Captions are used to spell out the meaning that the photograph then confirms as fact. Very often we see only what we expect, or are guided, to see. In advertising the captions may convince us of a need, or the relevance of a fantasy to our lives, that is then made real by the photograph.

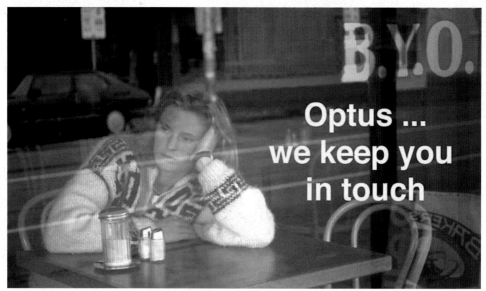

Bring Your Own - Mark Galer

Publicity

This century has seen an increasing reliance by the media to use visual images to communicate their messages. Our visual culture is now dominated by these media images. The ceaseless stream of images has defined the capitalist ideology of a consumer population. Before we can explore the subtleties of visual expression we must first learn to appreciate and understand the dominant communications of our time.

> 'Photographs are considered highly important sources of information but there is no requirement of literacy, from either those who view them or those that control their use. Advertisers, who put the pretty woman next to the car they are trying to sell, utilize an implied logic that, being nonverbal, is left unchallenged. Perhaps that is partially why photographic literacy is not encouraged - illiteracy works so well for advertising. If one knew how to read the images, the so called subliminal messages of advertising would be much more obvious: "Buy this car and the pretty woman will like you" is considerably less convincing when put bluntly.'

Fred Ritchin - *In Our Own Image*

Foundation Module

Seok-Jin Lee

Chapter 1

The Frame

From photographs each of us can learn more about the world. Images not only inform us about the products we never knew we needed, the events, people and places too distant or remote for us to see with our own eyes, but also tell us more about the things we thought we already knew. Most of us are too preoccupied to stand and look at something for any great amount of time. We glance at something briefly and think we have seen it.

Mark Galer

Our conditioning or desires often tell us what we have seen or would like to see. When we look at a photograph of something ordinary, however, it may show us the object as we had never seen it before. With a little creative imagination and a little photographic technique it is possible to release the extraordinary from the ordinary.

Aims

- Develop an awareness of how a photographic image is a two-dimensional composition of lines, shapes and patterns.
- Develop an understanding of how differing photographic techniques can affect both the emphasis and the meaning of the subject matter.

Henley on Todd Regatta - Mark Galer

Bill Brandt in 1948 said that 'it is the photographer's job to see more intensely than most people do. He must keep in him something of the child who looks at the world for the first time or of the traveller who enters a strange country.'

Choosing a subject

In order to photograph something that will be of interest to others you must first remove the blinkers and photograph something that is of interest to you. Your first creative decision is an important one. What will you choose to photograph? Your first technical decision is how to frame it.

Composition
Framing the subject

A common mistake made by many amateur photographers is that they stand too far away from their subject matter, in a desire to include everything. Their photographs become busy, unstructured and cluttered with unwanted detail which distracts from the primary subject matter. Subject matter can look unimportant and not worthy of closer attention and there is also a danger that the photographer will not have control over the composition.

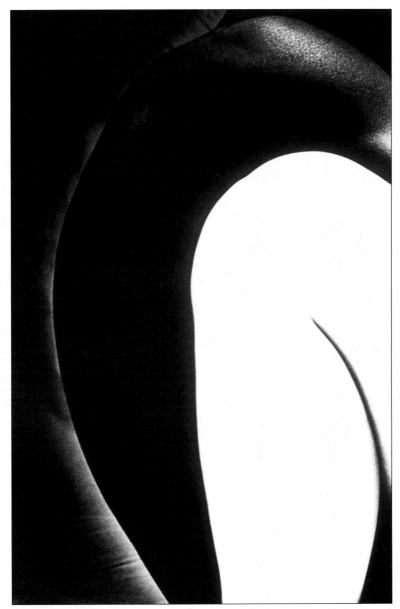

Embrace - Eikoh Hosoe 1970

The photograph above is a study of the human figure and also a composition of shape, tone and line. There are three dominant shapes. The woman's leg, the man's back and also the third shape which is created between the frame and the man's back. The act of framing a subject using the viewfinder of the camera imposes an edge that does not exist in reality. This frame also dissects familiar objects to create new shapes. The shapes that this frame creates must be studied carefully in order to create successful compositions.

The powerful arc of the man's back is positioned carefully in relationship to the edge of the frame and the leg of the woman is added to balance the composition.

Filling the frame

When the photographer moves closer, distracting background can be reduced or eliminated. There are less visual elements that have to be arranged and the photographer has much more control over the composition. Many amateurs are afraid of chopping off the top of someone's head or missing out some detail that they feel is important. Unless the photograph is to act as a factual record the need to include everything is unnecessary.

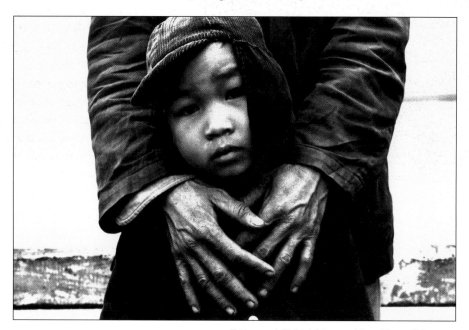

Father and Child, Vietnam - Marc Riboud/Magnum

When the viewer is shown a photograph they have no way of knowing for sure what lies beyond the frame. We often make decisions on what the photograph is about from the information we can see. We often have no way of knowing whether these assumptions are correct or incorrect.

The photograph above is of a father and child. The protective hands of a father figure provide the only information most people need to arrive at this conclusion. In order to clarify any doubt the photographer may have decided to move further back to include the whole figure. The disadvantage in doing this would have been that the background would also begin to play a large part in the composition and the power of this portrait of a child and his father would have been lost. Photographers do have the option, however, of taking more than one photograph to tell a story.

Activity 1

Look through assorted photographic books and observe how many photographers have moved in very close to their subjects. By employing this technique the photographer is said to 'fill the frame' and make their photographs more dramatic.

Find two examples of how photographers seek simple backgrounds to remove unwanted detail and to help keep the emphasis or 'focal point' on the subject.

The whole truth?

Photographs provide us with factual information but sometimes we do not have enough information to be sure what the photograph is about.

Hyde Park - Henri Cartier-Bresson/Magnum

What do we know about this old lady or her life other than what we can see in the photograph? Can we assume she is lonely as nobody else appears within the frame? Could the photographer have excluded her grandchildren playing close at hand to improve the composition or alter the meaning? Because we are unable to see the event or subject that the photograph originated from we are seeing it out of context.

Activity 2

Read the following passage taken from the book *The Photographer's Eye* by John Szarkowski and answer the questions below.

'To quote out of context is the essence of the photographer's craft. His central problem is a simple one: what shall he include, what shall he reject? The line of decision between in and out is the picture's edge. While the draughtsman starts with the middle of the sheet, the photographer starts with the frame.

The photograph's edge defines content. It isolates unexpected juxtapositions. By surrounding two facts, it creates a relationship. The edge of the photograph dissects familiar forms, and shows their unfamiliar fragment. It creates the shapes that surround objects.

The photographer edits the meanings and the patterns of the world through an imaginary frame. This frame is the beginning of his picture's geometry. It is to the photograph as the cushion is to the billiard table.'

Q. What does John Szarkowski mean when he says that photographers are quoting 'out of context' when they make photographic pictures?

Q. The frame often 'dissects familiar forms'. At the end of the last century photography was having a major impact on Art. Impressionist artists such as Degas were influenced by what they saw.
Find an example of his work which clearly shows this influence and explain why the public might have been shocked to see such paintings.

Subject placement

When the photographer has chosen a subject to photograph there is often the temptation, especially for the untrained eye, to place the subject in the middle of the picture without considering the overall arrangement of shapes within the frame. If the focal point is placed in the centre of the frame, the viewer's eye may not move around the whole image and this often leads to a static and uninteresting composition. The photographer should think carefully where the main subject is placed within the image, only choosing the central location after much consideration.

> 'A picture is well composed if its constituents - whether figures or apples or just shapes - form a harmony which pleases the eye when regarded as two-dimensional shapes on a flat ground.'
>
> *Peter and Linda Murray - A Dictionary of Art and Artists*

The rule of thirds

Rules of composition have been formulated to aid designers create harmonious images which are pleasing to the eye. The most common of these rules are the '**golden section**' and the '**rule of thirds**'.

The rule of thirds

The golden section is the name given to a traditional system of dividing the frame into unequal parts which dates back to the time of Ancient Greece. The rule of thirds is the simplified modern equivalent. Try to visualize the viewfinder as having a grid which divides the frame into three equal segments, both vertically and horizontally. Many photographers and artists use these lines and their intersection points as key positions to place significant elements within the picture.

Breaking the rules

Designers who are aware of these rules often break them by deliberately placing the elements of the image closer to the edges of the frame. This can often be effective in creating '**dynamic tension**' where a more formal design is not needed.

Activity 3

Find two examples of photographs that follow the rule of thirds and two examples that do not. Comment briefly on why and how you think the composition works.

Balance

In addition to content a variety of visual elements such as line, color and tone often influence a photographer's framing of an image. The eye naturally or intuitively seeks to create a '**symmetry**' or a harmonious relationship between these elements within the frame. When this is achieved the image is said to have a sense of '**balance**'. The most dominant element of balance is visual weight created by the distribution of light and dark tones within the frame. To frame a large dark tone on one side of the image and not seek to place tones of equal visual weight on the other side will create imbalance in the image. An image that is not balanced may appear heavy on one side. Visual tension is created within an image that is not balanced. Balance, although calming to the eye, is not always necessary to create an effective image. Communication of harmony or tension is the deciding factor of whether balance is desirable in the image.

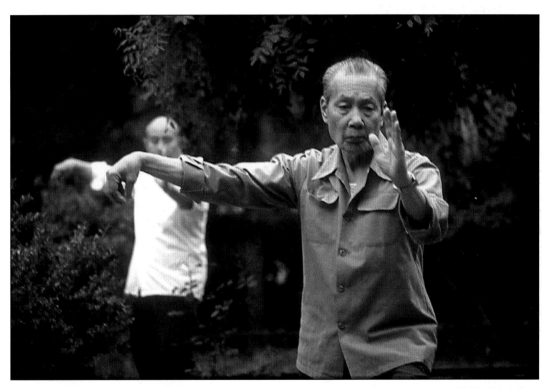

Tai Chi - Mark Galer

Activity 4

Collect one image where the photographer has placed the main subject off-centre and retained a sense of balance and one image where the photographer has placed the main subject off-centre and created a sense of imbalance.

Discuss the possible intentions of the photographer in creating each image.

Create four images, placing the focal point and/or visual weight in different areas of the frame. Discuss whether each image is balanced.

Line

The use of line is a major design tool that the photographer can use to structure the image. Line becomes apparent when the contrast between light and dark, color, texture or shape serves to define an edge. The eye will instinctively follow a line. Line in a photograph can be described by its length and angle in relation to the frame (itself constructed from lines).

Horizontal and vertical lines

Horizontal lines are easily read as we scan images from left to right comfortably. The horizon line is often the most dominant line within the photographic image. Horizontal lines within the image give the viewer a feeling of calm, stability and weight. The photographer must usually be careful to align a strong horizontal line with the edge of the frame. A sloping horizon line is usually immediately detectable by the viewer and the feeling of stability is lost.

Vertical lines can express strength and power. This attribute is again dependent on careful alignment with the edge of the frame. This strength is lost when the camera is tilted to accommodate information above or below eye level. The action of 'perspective' causes parallel vertical lines to lean inwards as they recede into the distance.

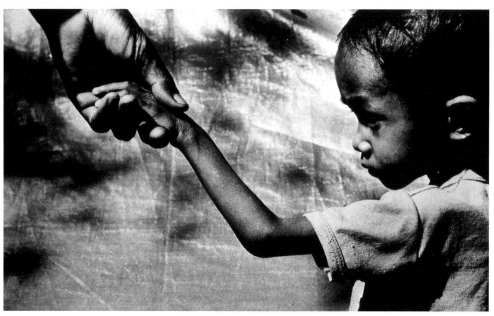

Cambodian Refugee Camp - Burk Uzzle

Suggested and broken line

Line can be designed to flow through an image. Once the eye is moving it will pick up a direction of travel and move between points of interest. The photograph above is a good example of how the eye can move through an image. Viewers tend to look briefly at the adult hand holding the child's, before quickly moving down the arm to the face. The direction of the child's gaze returns the viewer's attention to the hands. A simple background without distracting detail helps to keep our attention firmly fixed on this relationship.

Shane Bell

Diagonal lines

Whether real or suggested, these lines are more dynamic than horizontal or vertical lines. Whereas horizontal and vertical lines are stable, diagonal lines are seen as unstable (as if they are falling over) thus setting up a dynamic tension or sense of movement within the picture.

Curved lines

Curved line is very useful in drawing the viewer's eye through the image in an orderly way. The viewer often starts viewing the image at the top left-hand corner and many curves exploit this. Curves can be visually dynamic when the arc of the curve comes close to the edge of the frame or directs the eye out of the image.

Activity 5

1. Collect two examples of photographs where the photographer uses straight lines as an important feature in constructing the pictures' composition.
 In addition find one example where the dominant line is either an arc or S-curve.
 Comment briefly on the contribution of line to the composition of each example.

2. Create an image where the viewer is encouraged to navigate the image by the use of suggested line and broken line between different points of interest. Discuss the effectiveness of your design.

Vantage point

A carefully chosen viewpoint or '**vantage point**' can often reveal the subject as familiar and yet strange. In designing an effective photograph that will encourage the viewer to look more closely, and for longer, it is important to study your subject matter from all angles. The 'usual' or ordinary is often disregarded as having been 'seen before' so it is sometimes important to look for a fresh angle on a subject that will tell the viewer something new.

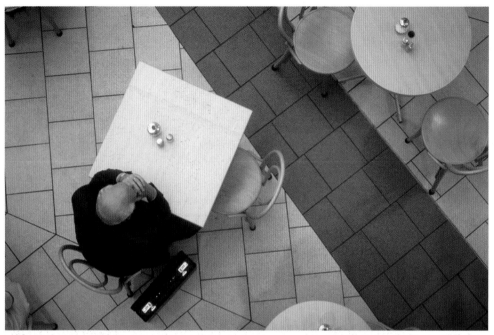

Melbounre Central - Mark Galer

When we move further away from our subject matter we can start to introduce unwanted details into the frame that begin to detract from the main subject. Eventually the frame is so cluttered that it can look unstructured. The careful use of vantage point can sometimes overcome this. A high or low vantage point will sometimes enable the photographer to remove unwanted subject matter using the ground or the sky as an empty backdrop.

Activity 6

Find two examples of photographs where the photographer has used a different vantage point to improve the composition (e.g. Alexander Rodchenko and André Kertész).
Comment on how this was achieved and how this has possibly improved the composition.

Depth

When we view a flat two-dimensional print which is a representation of a three-dimensional scene, we can often recreate this sense of depth in our mind's eye. Using any perspective present in the image and the scale of known objects we view the image as if it exists in layers at differing distances. Successful compositions often make use of this sense of depth by strategically placing points of interest in the foreground, the middle distance and the distance. Our eye can be led through such a composition as if we were walking through the photograph observing the points of interest on the way.

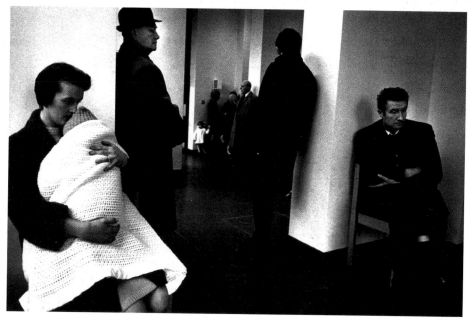

Doctor's Waiting Room, Battersea, London 1975 - Ian Berry

In the image above, our eyes are first drawn to the largest figures occupying the foreground on either side of the central doorway. In a desire to learn more from the image our eyes quickly progress towards the figures occupying the middle distance. Appearing as lazy sentinels the figures lean against the doorway and move our gaze towards the focal point of the photograph, the small girl holding her mother's hand in the centre of the image.

The technique of drawing us into the photograph is used in many photographs and can also be exploited using dark foreground tones that draw us towards lighter distant tones. Photographers can also control how much of the image is seen 'in focus', which again can contribute to a sense of depth (see 'Light > Depth of field').

Activity 7

Find two photographs where the photographer has placed subject matter in the foreground, the middle distance and the distance in an attempt either to fill the frame or to draw our gaze into the image.

Comment briefly on where you feel the focal points of these images are.

Practical assignment

Produce a set of six photographs investigating natural or man-made forms. Your work should demonstrate how the frame can be used to create compositions of shape, line and pattern. You should consider not only the shapes of your subject matter but also those formed between the subject and the frame.

Choosing a theme

Your photographs should develop a clearly defined theme. This could be several different ways of looking at one subject or different subjects that share something in common, e.g. a similar pattern or composition. If you are unfamiliar with your camera choose a subject that will keep still, allowing you time to design the composition.

A possible title for your set of prints could be:

1. Patterns in nature.
2. Rhythms of life.
3. Urban patterns.

Your work should:

a) make use of differences in subject distance including some work at, or near, the closest focusing distance of your camera lens;
b) show that you have considered the rule of thirds;
c) demonstrate the creative use of line in developing your compositions;
d) make use of different vantage points;
e) show that you have thought carefully about the background and the foreground in making your composition.

Note > Implement aspects of your research during your practical assignment.

Resources

Langford's Basic Photography - Michael Langford, Anna Fox and Richard Sawdon Smith. Focal Press. Oxford. 2007

Black and White Photography - Rand/Litschel. Delmar Learning. 2001.

Designing a Photograph - Bill Smith and Bryan Peterson. Watson-Gupthill Pubns. 2003.

Henri Cartier-Bresson: Masters of Photography Series. Aperture 2nd Edition. 1997.

Photography Composition - Tom Grill and Mark Scanlon. Amphoto. 1990.

Photography - London and Upton. Prentice Hall. 2004.

Principles of Composition in Photography - Andreas Feininger. Watson-Gupthill Pubns. 1973.

The Photographer's Eye - John Szarkowski. Museum of Modern Art, New York. 2007.

Racing Stripes - Sarah Gall

Chapter 2

Thomas Scicluna

Light

Light is the photographer's medium. The word photography is derived from the ancient Greek words *photos* and *graph* meaning 'light writing'. In photography, shadows, reflections, patterns of light, even the light source itself may become the main subject and solid objects may become incidental to the theme.

Bridie Watts

Aims

- To develop knowledge and understanding of how the quality and direction of light can change character and mood.
- To develop an awareness to the limitations of film and image sensors in recording subject contrast.

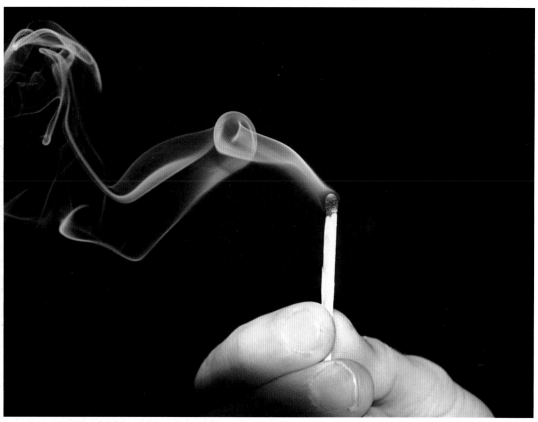

Blown Away - Sophie Ritchie

Creating atmosphere

Directional light from the side and/or from behind a subject can produce some of the most evocative and atmospheric photographs. Most snapshots by amateurs, however, are taken either outside when the sun is high or inside with a flash mounted on the camera. Both these situations give a very flat and even light which may be ideal for some color photography but for black and white photography it all too often produces gray, dull and uninteresting photographs.

Learning to control light and use it creatively is an essential skill for a good photographer. When studying a photograph that has been well lit you need to make three important observations concerning the use of light:

1. What type or quality of light is being used?
2. Where is it coming from?
3. What effect does this light have upon the subject and background?

Quality of light

Light coming from a compact source such as a light bulb or the sun can be described as having a very 'hard quality'. The shadows created by this type of light are dark and have well-defined edges.

Light coming from a large source such as sunlight that has been diffused by clouds or a light that has been reflected off a large bright surface is said to have a very 'soft quality'. The shadows are less dark (detail can be seen in them) and the edges are not clearly defined.

The smaller the light source, the harder the light appears.
The larger the light source, the softer the light appears.

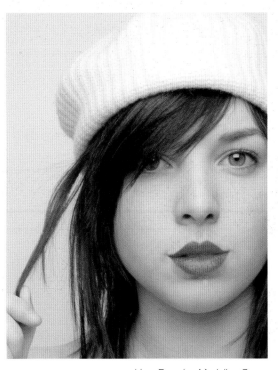

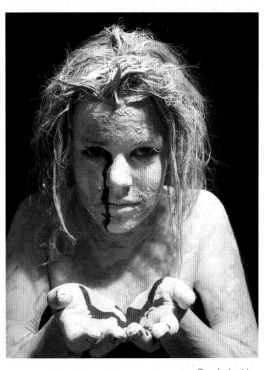

Very French - Madeline Green *Sarah Jenkins*

A soft light positioned high and to the right gives a flattering and glamorous effect. Note the soft shadows.

A single hard light positioned directly above casts deep shadows around the eyes giving a dramatic effect which complements the pose. Note how the hands add to the expression.

Activity 1

Look through assorted photographic books and find some examples of subjects lit by hard light and examples of subjects lit by soft light.

Describe the effect the light has on the subjects' texture, form and detail, and the overall mood of the picture.

Direction of light

The direction of light decides where the shadows will fall and its source can be described by its relative position to the subject. The light may be high, low, to one side, in front of or behind the subject.

The subject may be lit by a single light source or more than one. This additional light may be reflected back onto the subject from a nearby surface or may be shining directly onto the subject from a second light source, e.g. a flash mounted on or near the camera.

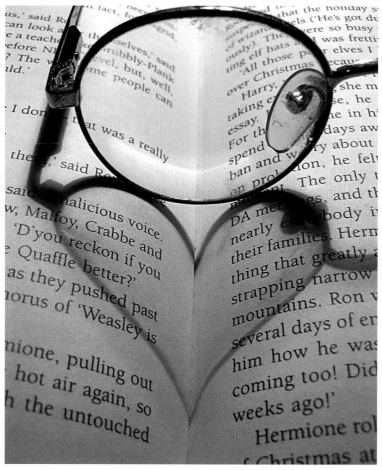

Love of Reading - Ashlee Clark

Activity 2

Find an example of a photograph where the subject has been lit by a single light source and an example where more than one light has been used.

Describe in each the quality and position of the brightest or main light and the effect this has on the subject. In the second example describe the quality and effect the additional light has.

Subject contrast

Contrast is the degree of difference between the lightest and darkest tones of the subject or photographic image. A high-contrast photograph is where the dark and light tones dominate over the midtones within the image. The highest contrast image possible is one that contains only two tones, black and white, and where no midtones remain. A low-contrast image is one where midtones dominate the image and there are few, if any, tones approaching black or white. Each subject framed by the photographer will include a range of tones from dark to light. The combined effects of quality of light and lighting direction give the subject its contrast. It is contrast that gives dimension, shape and form to the subject photographed.

Limitations of the capture medium

The human eye can register detail in a wide range of tones simultaneously. Film and digital image sensors are unable to do this. They can record only a small range of what human vision is capable of seeing.

High contrast - Debra Adams

Low contrast - Sarah Gall

Cloud cover diffuses and softens the light, leading to lower contrast. Shadows appear less harsh and with softer edges. The lighting may be described as being flat and the film or image sensor will be able to record all of the tones from black to white if the exposure is correct. When harsh directional light strikes the subject the overall contrast of the scene increases. The photographer may now be able to record only a small selection of the broad range tones.

Increasing exposure will reveal more detail in the shadows and dark tones.
Decreasing exposure will reveal more detail in the highlights and bright tones.

If the photographer wishes to photograph in harsh directional sunlight it is appropriate to increase the exposure from that indicated by the camera's TTL light meter to avoid underexposure. An additional one stop is usually sufficient to protect the shadow detail.

If a subject is lit by harsh directional light, increase the exposure by one stop from that indicated by the TTL light meter.

Exposure compensation

When you take a light meter reading of a subject you are taking an average reading between the light and the dark tones you have framed.

The meter reading is accurate when there is an even distribution of tones, or the dominant tone is neither dark nor light. It is very important that you '**compensate**' or adjust the exposure when the framed area is influenced by a tone that is dark, light or very bright.

If your subject is in front of a bright light, such as a window or the sky, the light meter will indicate an average reading between your subject and the very bright tone. The camera's meter will be influenced by this tone and indicate an exposure setting that will reduce the light reaching the film or image sensor. In these situations you have to override the meter and increase the exposure to avoid underexposing the subject. Most cameras take information for the light reading mainly from the centre of the viewfinder.

Layne on Horse - Sarah Jenkins

When you need to set the exposure for a subject that requires compensation you can:

1. Move in close so that your chosen subject fills the frame and set the exposure. Move back to your chosen camera position and take the shot at the same setting.
2. Point the centre of the viewfinder away from the bright light, set the exposure and reposition the camera. Some cameras have a memory lock to help you do this.

Activity 3

Find two images that have been shot into the light or included the light source.
Explain how the photographer may have gone about taking a light meter reading for these photographs.

Depth of field

You can increase or decrease the amount of light reaching the film or image sensor by moving one of two controls: by changing the shutter speed (the amount of time the shutter stays open) or by changing the f-stop (the size of the aperture through the lens).

If you change the aperture, the final appearance of the photograph can differ greatly. This will be the area of sharp focus in the scene, from the nearest point that is sharp to the farthest. The zone of acceptable sharp focus is described as the '**depth of field**'.

The widest apertures (f2, f4) give the least depth of field.
The smallest apertures (f16, f22) give the greatest depth of field.
The smaller the sensor the greater the depth of field at the same aperture.

Aperture wide open *Aperture stopped down all the way*

Shallow depth of field (above left) is created using the wider aperture settings of the lens. Subject matter behind and in front of the point of focus appears progressively out of focus. Due to the smaller sensors used in the prosumer digicams it is often difficult to achieve shallow depth of field unless you are working at the closest focusing distance of the lens, i.e. capturing an image using a prosumer camera using a small sensor will lead to greater depth of field than a DSLR using a lens set to the same aperture.

Maximum depth of field (above right) is created using the smaller aperture settings of the lens. Subject matter immediately in front of the lens and subject matter in the distance may appear acceptably sharp in the same image.

Activity 4

Find two examples of photographs which make use of maximum depth of field and two examples which have very shallow depth of field.

Describe how the photographer's selective use of aperture affects the subject in each of the photographs you have chosen.

Basic studio lighting

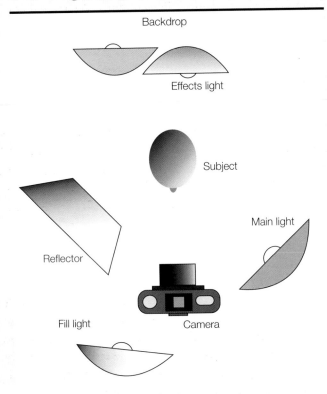

The subject - this may have to be placed some distance from the backdrop if the subject and backdrop are to be illuminated separately.

Main light source - the position is optional depending upon the desired effect required. If deep shadows are created by the main light they can be softened in one of three ways:

1. Reflector - this is used to bounce light from the main light back into the shadow areas.
2. Fill - this is usually a weaker light or one moved further away and is usually positioned by the camera.
3. Diffusion - the hard directional light can be softened at the source either by bouncing it off a white surface or by using tracing paper placed at variable distances between the light and the subject.

Effects light - this can be shone onto the background to create 'tonal interchange'. This is a technique where the photographer places dark areas of the subject against light areas of the background and vice versa.

Alternatively the effects light can be shone directly onto the back of the subject so as to 'rim light' otherwise dark areas. Care must be taken to avoid shining the light directly into the camera lens. This is usually achieved by placing the effects light low or obscuring the light directly behind the subject itself.

Practical assignment

Produce a set of six prints that express your feelings towards one of the following titles:

1. Shadows and silhouettes.
2. Broken light.
3. The twilight hours.
4. Face and figure.

Your final work should develop the insight gained from all areas of your research and should include investigations into both natural and artificial light. Try experimenting with window light, studio lights, projected images, light bulbs, candles, torches, etc.

If you are having difficulty thinking of a suitable subject, try working with another student using each other as 'models'. You may decide to use some other person for the final piece of finished work.

Presentation of work

Your visual research and all of your test images should be carefully collated. Explanatory notes and comments should also be included. You should rank the images of your final shoot and include alternate crops or edited versions. You should clearly state what you were trying to do with each picture and comment on its success. Images should be referenced to relevant comments using either numbers or letters as a means of identification. You should clearly state how your theme has developed and what you have learnt from your background work, and how this has contributed towards the final set of images.

Resources

Langford's Basic Photography - Michael Langford, Anna Fox and Richard Sawdon Smith. Focal Press. Oxford. 2007

Black and White Photography - Rand/Litschel. Delmar Learning. 2001.

Photography Composition - Tom Grill and Mark Scanlon. Amphoto. 1990.

Photography (8th Edition) - London and Upton. Prentice Hall. 2004.

Photographic Lighting - Child/Galer. Focal Press. Oxford. 2005.

Ricky Bond

Chapter 3

Time

All photographs are time exposures of shorter or longer duration, and each describes an individually distinct parcel of time. The photographer, by choosing the length of exposure, is capable of exploring moving subjects in a variety of ways. By choosing long exposures moving objects will record as blurs. This effect is used to convey the impression or feeling of motion.

Mark Galer

Although describing the feeling of the subject in motion much of the information about the subject is sacrificed to effect. By selecting fast shutter speeds photographers can freeze movement. We can see the nature of an object in motion, at a particular moment in time, that the human eye is unable to isolate.

Aims

- To develop an understanding of how a photograph can describe a subject over a period of time as selected by the photographer.
- To develop an appreciation of how the selected period of time or 'shutter speed' can affect the visual outcome of the print.

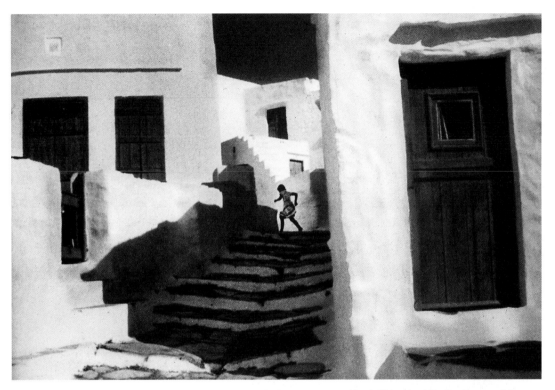

Greek Girl - Henri Cartier-Bresson/Magnum

The decisive moment

Henri Cartier-Bresson in 1954 described the visual climax to a scene which the photographer captures as being the '**decisive moment**'. In the flux of movement a photographer can sometimes intuitively feel when the changing forms and patterns achieve balance, clarity and order and when the scene becomes, for an instant, a well-designed picture.

Activity 1

Look at a Henri Cartier-Bresson photograph and discuss why you think that capturing the decisive moment has added to the picture's quality.

Fast shutter speeds

By freezing thin slices of time, it is possible to explore the beauty of form in motion. A fast shutter speed may freeze a moving subject yet leave others still blurred. The ability to freeze subject matter is dependent on its speed and the angle of movement in relation to the camera. For subject matter travelling across the camera's field of view, relatively fast shutter speeds are required, compared to the shutter speeds required to freeze the same subject travelling towards or away from the camera.

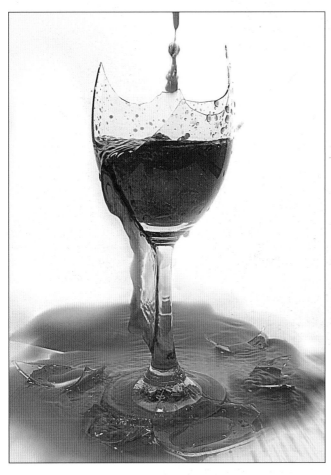

Red Red Wine - Dave Silverstein

Limitations

Wide apertures in combination with bright ambient light and/or a high ISO setting will allow the use of a fast shutter speed in order to freeze rapidly moving subject matter. Some telephoto and zoom lenses only open up to f4 or f5.6. If used with a slow ISO setting there is usually insufficient light to use the fastest shutter speeds available on the camera.

Activity 2

Find an example of a photograph where the photographer has used a very fast shutter speed and describe the subject matter including the background. Discuss any technical difficulties the photographer may have encountered and how he or she may have overcome them.

Discuss what has happened to the depth of field and why.

Discuss whether the image gives you the feeling of movement, stating the reasons for your conclusion.

Panning

Photographers can follow the moving subject with the camera in order to keep the subject within the frame. This technique, called '**panning**', allows the photographer to use a slower shutter speed than would otherwise have been required if the camera had been static. The ambient light is often insufficient to use the very fast shutter speeds, making panning essential in many instances.

For successful panning the photographer must aim to track the subject before the shutter is released and follow through or continue to pan once the exposure has been made. The action should be one fluid movement without pausing to release the shutter. A successful pan may not provide adequate sharpness if the focus is not precise. In order to have precise focusing with a moving subject the photographer may need to use a fast predictive autofocus system or pre-focus on a location which the moving subject will pass through.

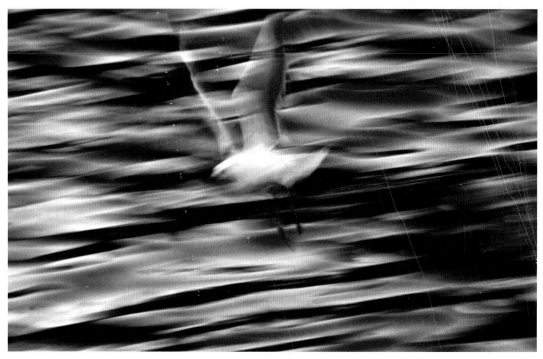

Bird in Flight - Jana Liebenstein

Activity 3

Take four images of a running or jumping figure using fast shutter speeds (faster than 1/250 second). Vary the direction of travel in relation to the camera and attempt to fill the frame with the figure. Examine the image for any movement blur and discuss the focusing technique used.

Take four images of the same moving subject using shutter speeds between 1/15 and 1/125 second. Pan the camera to follow the movement. The primary subject should again fill the frame. Discuss the visual effect of each image.

Slow shutter speeds

When the shutter speed is slowed down movement is no longer frozen but records as a streak. This is called '**movement blur**'. By using shutter speeds slower than those normally recommended for use with the lens, movement blur can be created with relatively slow moving subject matter. Speeds of 1/30, 1/15, 1/8 and 1/4 second can be used to create blur with a standard lens. If these slow shutter speeds are used and the camera is on a tripod the background will be sharp and the moving subject blurred. If the camera is panned successfully with the moving subject the background will provide most of the blur in the form of a streaking effect in the direction of the pan.

Camera shake

Movement blur may also be picked up from camera movement as a result of small vibrations transmitted to the camera from the photographer's hands. This is called 'camera shake'. To avoid camera shake a shutter speed roughly equal to the focal length of the lens is usually recommended, e.g. 1/30 second at 28 mm, 1/60 second at 50 mm and 1/125 at 135 mm. Many cameras give an audible signal when shutter speeds likely to give camera shake are being used.

With careful bracing, slower speeds than those recommended can be used with great success. When using slow shutter speeds the photographer can rest elbows on a nearby solid surface, breathe gently and release the shutter with a gentle squeeze rather than a stabbing action.

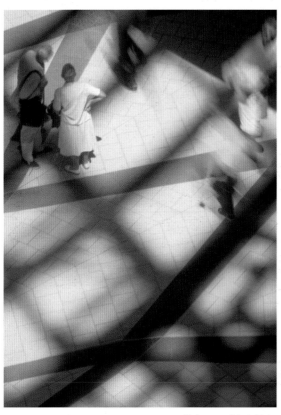

Daimaru - Mark Galer

Activity 4

Find a photograph where the photographer has used a slow shutter speed and describe the subject matter including the background. Discuss any technical difficulties the photographer may have encountered and how these may have been overcome.

Discuss what has happened to the depth of field and why.

Discuss whether the image gives you the feeling of movement, stating the reasons for your conclusions.

Photographic techniques

Very long exposures

For this technique you will need to mount the camera on a tripod and release the shutter using a cable release or a time delay exposure. You should select the smallest aperture possible on your camera lens, e.g. f11, f16 or f22, and use a low ISO setting. The shutter speed can be further extended by the addition of a light-reducing filter such as a neutral density filter or polarizing filter.

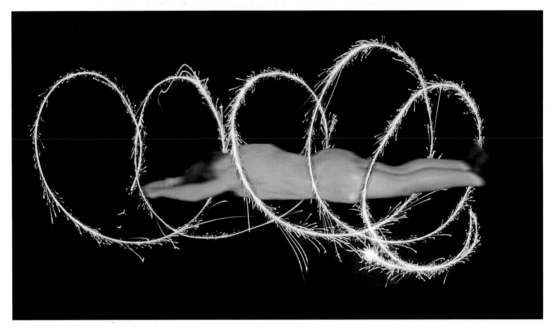

The Hoop Dance - Pieta Lapworth

Slow shutter speeds

For this technique you can either hold the camera or mount the camera on a tripod. By using shutter speeds slower than those recommended for use with the lens you are using you can create blur from moving objects. If you are using a standard lens try shooting a moving subject at speeds of 1/30, 1/15, 1/8 and 1/4 second. If the camera is in a fixed position on a tripod the background will be sharp but if the camera is panned with the subject the background will produce most of the blur. Try shaking the camera whilst exposing to increase the effect even more.

Fast shutter speeds

For this technique you need to select a wide aperture. Some telephoto and zoom lenses only open up to f4 so you will need to attach a lens that will allow you to open up to f2.8 or wider. Once you have selected the aperture take a light meter reading of your subject. If your indicated shutter speed is only up to 1/250 second then you must do one or both of the following. Either increase the amount of illumination reaching the subject and/or use a higher ISO setting.

Multiple exposures

Only a few digital cameras have a multiple exposure function so multiple exposures are usually created in the image editing software. Multiple exposures can, however, be achieved in camera by using flash equipment. This is best achieved in a dark studio using a black background or at night outside away from reflective surfaces.

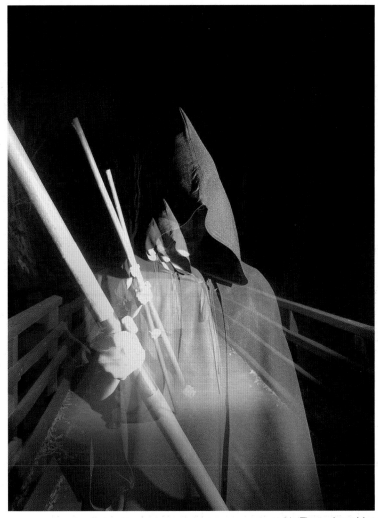

It's Time - Anna May

The camera can be mounted on a tripod and the shutter fired using a cable release. With the absence of ambient light a long exposure can be selected on the camera (maybe 30 seconds or more) without the danger of overexposing the image. A number of flashes can then be fired at a moving subject. If the subject remains in the same position within the framed image the subject will appear lighter as the exposure increases. Allow the unit to recharge after each flash. The flashgun will need to be fired manually and you should also ensure you have set the correct aperture on the lens as indicated by your flashgun or flash meter. See the section about working with flash in this chapter for more information.

Zooming

For this technique you need to use a lens that can alter its focal length, i.e. a zoom lens. A slow shutter speed should be selected, e.g. 1/15, 1/8 or 1/4 second. The camera can be mounted on a tripod. The effect of movement is achieved by making the exposure whilst altering the focal length or zooming the lens either in or out. The subject does not need to be moving. Bright highlights and/or bright colors increase the visual effect.

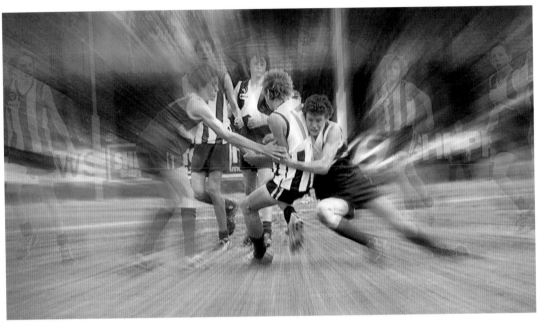

Clash - Simon Bingham

Manipulation in Photoshop

A stationary subject or one that has been frozen using a fast shutter speed can be blurred by applying a motion or radial blur filter. Movement or time passing can also be achieved by using David Hockney's 'Joiner' technique.

Limitations of semi-automatic

When selecting shutter priority or time value mode the photographer must take care not to underexpose images. Excessively fast shutter speeds for the available light may require an aperture greater than that available on the lens.

When selecting aperture priority or Aperture value mode the photographer must take care not to overexpose images. Excessively wide apertures to create shallow depth of field in bright light may require shutter speeds faster than that available on the camera.

Activity 5

Create four images that contain a mixture of solid (sharp) and fluid (blur) forms.

Flash photography

Flash is the term given for a pulse of very bright light of exceptionally short duration (usually shorter than 1/500 second). When additional light is required to supplement the daylight, flash is the most common source used by photographers. It used to be difficult to master flash photography with film cameras because the effects of the flash could not be seen until the film had been processed. Now it is much easier to experiment to find the correct settings for the task in hand.

Most flash units available are able to read the reflected light from their own flash during exposure. This feature allows the unit to extinguish or 'quench' the flash by a '**thyristor**' switch when the subject has been sufficiently exposed. When using a unit capable of quenching its flash, subject distance does not have to be accurate as the duration of the flash is altered to suit. This allows the subject distance to vary within a given range without the photographer having to change the aperture set on the camera lens or the flash output. These sophisticated units are described as either 'automatic' or 'dedicated'.

Automatic flash

An automatic flash unit uses a photocell mounted on the front of the unit to read the reflected light and operate an on-off switch of the fast-acting thyristor type. The metering system works independently of the camera's own metering system. If the flash unit is detached from the camera the photocell must remain pointing at the subject if the exposure is to be accurate.

Dedicated flash

Dedicated flashguns are designed to work with specific cameras. The camera and flash communicate exposure information through additional electrical contacts in the mounting bracket of the gun. The camera's metering system is used to make the exposure reading instead of the photo cell mounted on the flash unit. In this way the exposure is more precise and allows the photographer the flexibility of using filters without having to alter the settings of the flash.

Setting up a flash unit

- Check that the ISO has been set on the flash and camera.
- Check that the flash is set to the same focal length as the lens. This may involve adjusting the head of the flash to ensure the correct spread of light.
- Check that the shutter speed on the camera is set to the correct speed (usually slower than 1/125 second on most DSLR cameras).
- Check that the aperture on the camera lens matches that indicated on the flash unit.
- On dedicated units you may be required to set the lens aperture to an automatic position or the smallest aperture.
- Check that the subject is within range of the flash. On dedicated and automatic units the flash will only illuminate the subject correctly if the subject is within the two given distances indicated on the flash unit. If the flash is set incorrectly the subject may be overexposed if too close and underexposed if too far away.

Slow-sync flash

Slow-sync flash is a technique where the freezing effect of the flash is mixed with a long exposure to create an image which is both sharp and blurred at the same time.

Many modern cameras offer slow-sync flash as an option within the flash programme but the effect can be achieved on any camera. The camera can be in semi-automatic or manual exposure mode. A shutter and aperture combination is needed that will result in subject blur and correct exposure of the ambient light and flash.

- Choose a low ISO setting.
- Select a slow shutter speed that will allow camera movement blur (try experimenting with speeds around 1/8 second).
- Take an ambient light meter reading and select the correct aperture.
- Set the flash unit to give a full exposure at the selected aperture.
- Pan or jiggle the camera during the long exposure.

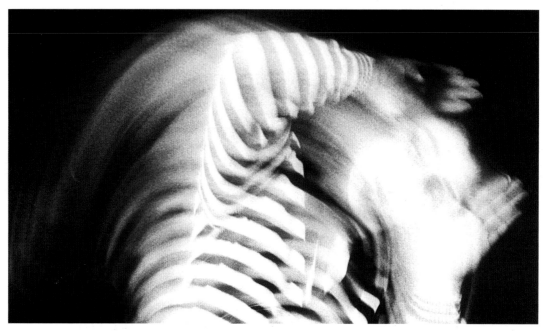

Movement - Renata Mikulik

Possible difficulties

Limited choice of apertures - Less expensive automatic flash units can dictate the use of a limited choice of apertures. This can lead to a difficulty in obtaining the suitable exposure. More sophisticated units allow a broader choice of apertures, making the task of matching both exposures much simpler.

Ambient light too bright - A low ISO setting or a lower level of lighting should be used if the photographer is unable to slow the shutter speed down sufficiently to create blur.

Practical assignment

Produce a series of six images that explore a moving subject by using a variety of techniques and shutter speeds. Your final presentation sheet should demonstrate that you have developed a theme from your initial investigations and that you have chosen appropriate techniques for your subject matter.

A possible title for your set of prints could be:

1. Sport.
2. Dance.
3. Vertigo.
4. The fourth dimension.

Your work should:

a) Make use of different shutter speeds, including some work at or near the slowest and fastest speeds possible with the equipment you are using.
b) Demonstrate an understanding of what is meant by the 'decisive moment'.
c) Show that you have considered both lighting and composition in your work.

Presentation of work

Your visual research and all of your test images should be carefully collated. Explanatory notes and comments should also be included. You should rank the images of your final shoot and include alternate crops or edited versions. You should clearly state what you were trying to do with each picture and comment on its success. Images should be referenced to relevant comments using either numbers or letters as a means of identification. You should clearly state how your theme has developed and what you have learnt from your background work, and how this has contributed towards the final set of images.

Resources

Great Action Photography - Bryn Campbell. Outlet. 1987.

Henri Cartier-Bresson: Masters of Photography Series (2nd Edition). Aperture. 1997.

Motion and Document Sequence and Time - Sheldon/Reynolds. Addison Gallery. 1993.

Photography - London and Upton. Prentice Hall. 2004.

Photographic Composition - Tom Grill and Mark Scanlon. Amphoto. 1990.

Books including work by Eadweard Muybridge, Gjon Mili, Harold Edgerton and Ernst Haas.

Advanced Projects

Seok-Jin Lee

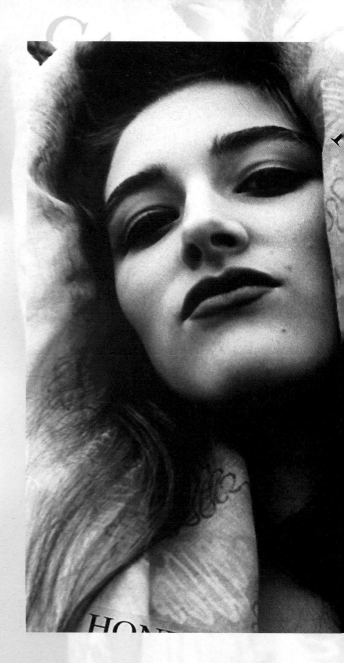

Chapter 4

Self Image

We are judged as individuals by our appearance, our actions and our status within society. These judgements contribute to our awareness of 'self' and our self image. The images we choose to represent ourselves help to establish our identity. In photographs we might find evidence of the way we conform, share similarities and fit in with society, e.g. uniforms, fashion, dress code, etc. In photographs we might find evidence of what makes us an individual, a unique person within society, e.g. expression, make-up, jewellery, important personal objects, locations and other people.

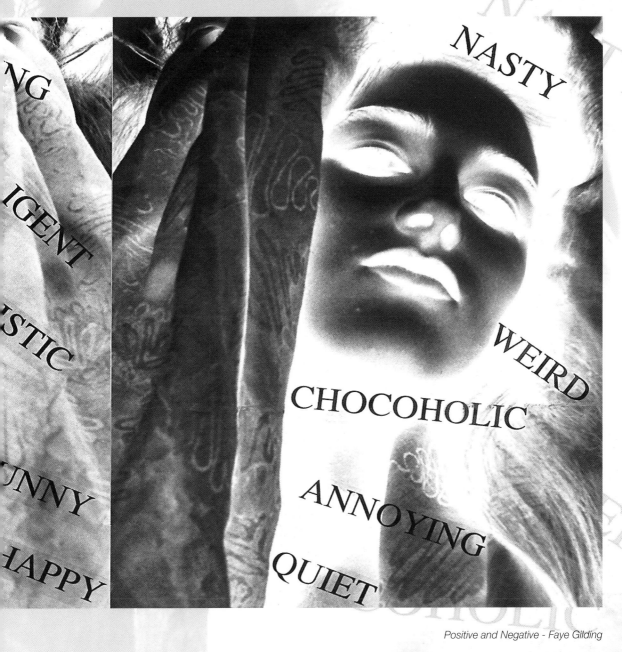

NG

IGENT

ISTIC

JNNY

HAPPY

NASTY

WEIRD

CHOCOHOLIC

ANNOYING

QUIET

Positive and Negative - Faye Gilding

The images we put forward of ourselves may vary depending on how we would like to be perceived by others. An individual may like to be seen as smart, serious and powerful in a business setting, but casual, friendly and relaxed in a family setting. The images we choose to frame or keep in our albums will tend to portray positive aspects of our self image, e.g. happiness, success and security. This, however, is only one aspect of our 'self image'.

Aims

- To develop an awareness of the links between self image and personal identity.
- To develop an awareness of symbolism and visual codes of practice.

Classifications

Individuals tend to seek out groups that they feel comfortable in. These groups contain individuals who are similar in some respects and together the group forms a collective identity. From this collective identity (team, family group, club or fraternity) we draw a part of our self image that is important to our own identity. Members of large collective groups adopt visual forms of recognition, e.g. items of clothing, body decoration or adornment (scarves, rings, tattoos, haircuts, etc.). Along with the visual forms of recognition, the individual is expected to adopt the customs, rituals or ceremonies that serve to unite the group in a common mutual activity, e.g. worship, singing or dancing, etc. The adolescent years and years of early adulthood can be turbulent and explosive for some as they strive either to 'fit in' or 'break out' of some of the categories they were brought up in, or labelled with. As individuals establish new identities conflict may lead to insecurity and anger. The struggle to recognize and define identity is one of life's most difficult tasks.

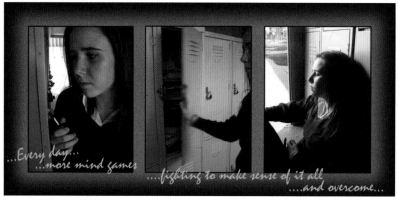

Teenage Mind Games - Ashlea Noye

Activity 1

What follows is a list of categories that serves to define and divide us. Make a personal list of the categories you belong to or have conflict with and visual symbols that are associated with each. Aspirations and expectations should also be listed.

1. Age/generation - This can dictate levels of independence afforded to the individual.
2. Gender - Our sex affects the way we are treated by some individuals.
3. Race - Prejudice and perceived racial superiority can affect hopes and aspirations.
4. Religion - Moral codes and ideologies that serve to guide, unite and divide.
5. Class or caste - A classification that an individual may never escape from.
6. Personality - Extrovert and introvert are classifications of personality.
7. Intelligence - We are often segregated by educational establishments using IQ.
8. Political persuasion - Left wing or right wing. Each carries its own ideology.

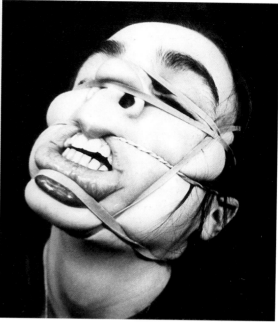

Images of beauty

Beauty and the Beast - Catherine Burgess

The photographs above are of the same student. Each image represents a different aspect of the same character. The image on the left represents how the student would most like to be seen, positive, calm and physically attractive. The image on the right represents how the student would least like to be seen, disfigured, in pain and physically repulsive.

Many people edit images of themselves before they are passed around or placed into a photographic album. People often destroy images that they feel do not portray themselves in a positive way. We are drawn to the image on the right because of its visual impact but we are shocked to learn that the image on the left is of the same student. We do not expect that a single individual has the capacity to be both beautiful and ugly, yet in reality we all feel these reactions to our own image at different times, depending on our state of mind, our physical well-being and the manner in which the camera has captured our likeness.

Activity 2

Find images in the media which have been used to represent attractive and unattractive aspects of the human face.

Examine and record carefully the photographic techniques used to accentuate both these qualities, drawing up a list that relates to the images you have found.

List the physical characteristics that we have come to admire in both the male and female face and write 100 words in response to the following questions:

1. Do you believe that media images or public opinion are responsible for the characteristics of beauty becoming universal stereotypes?
2. Do you believe any harm can be done by people admiring media images of glamorous models?

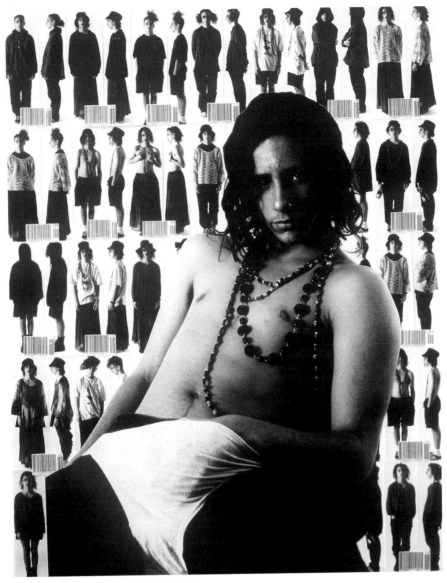

Fashion Statement - Tom Scicluna

Images of conformity

The photomontage above shows the same figure dressed in many strange ways. Each figure is accompanied by a bar code as seen attached to the products we buy in the supermarket. The orderly lines of figures contrast with the main figure in the foreground who is wearing his underpants outside his trousers and who stares straight at the viewer in an unnerving manner. The student is making the statement that fashion manipulates the young. Fashion rather than being an individual attempt at personal expression is a commercial way of pressurizing people to conform (no matter how silly the conformity looks). The main figure looks like he has just recognized this fact and is not amused.

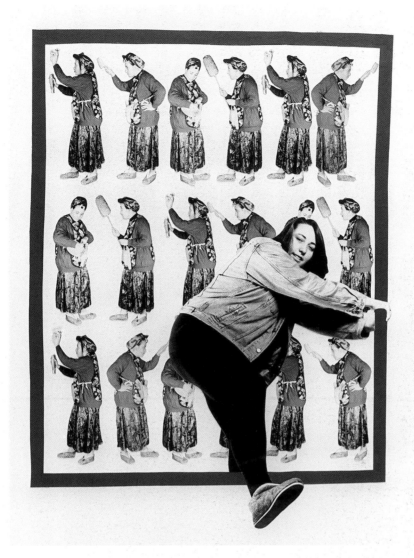

Boxes - Housewife - Julia McBride

The photomontage above expresses the student's awareness of social pressures to conform to the image and behavior of a typical housewife. The student is seen to be breaking out of the 'box' in which she feels she may be placed at some future date.

Activity 3

Consider some of the social pressures that you think may shape your behavior and personal image. List the images most commonly associated with the categories or 'boxes' you have already listed in Activity 1.

How have you responded to social pressures to conform by adopting an appearance that relates to the categories that you feel you have been placed in or have chosen?

Practical assignment

Using photography and other media put together a composite image or series of images that communicate how you see yourself in harmony or conflict within the social structure of which you are a part. The assignment may put forward one aspect or several concerning your self image and it is envisaged that you will explore not just the positive ones.

Your design sheets or sketch book should show evidence of the development of a variety of ideas or approaches to this assignment and together with the finished piece of work they will form an integral part of the assessment material.

Possible starting points for practical work concerning self image:

1. Reflections:
 - A window into the soul?

2. Different aspects or sides to our character could be illustrated through conflicting, contrasting or changing images:

 - Negative and positive, strong and weak, child and adult, etc.

 - Different aspects of our character viewed simultaneously or consecutively.

 - Triptychs, installations, constructions, e.g. cubes, cylinders, mobiles, etc.

 - Our dreams and aspirations versus the reality we inhabit.

 - A recognition of the sources of individual pressures within society to conform or adjust our behavior and appearance.

 - Stereotypes - racial, gender, etc.

Resources

Media images representing age, class, gender and race.

The family photograph album.

Personal collections of photographs.

The photographic work of Jo Spence, Cindy Sherman and Arno Minkkinen.

Cas O'Keeffe

Chapter 5

Distortion

All photographs distort reality to a lesser or greater degree. The very act of converting three-dimensional reality into a two-dimensional print is a distortion in itself. The simplest of photographic techniques used by the photographer and editor can manipulate and distort the information that the photograph puts forward to the viewer. The act of framing composes the visual elements within the frame and decides which of the visual elements in the original scene we can or cannot see in the final photograph.

Taxi - Jonathon Sumner

The viewer can be led through the print in a systematic way through the use of line, tone and color. The choice of lighting can affect the mood of the image, to reveal or disguise form and texture. Use of shallow depth of field can guide the viewer to individual elements within the frame. Visual elements can be removed or added after the photograph has been taken to change the meaning of the image and the use of text can be used to imply, clarify or contradict meaning.

Aims

- ⁓ To extend personal creativity through improved technique.
- ⁓ To explore the limitations of photographic materials and equipment through experimentation and exploration.

The limits of distortion

Photographic techniques control the way we read information from photographs in many ways, yet most people accept the accuracy of the photographic medium in recording the subject matter in front of the lens. This study guide is designed to give you the opportunity to discover the limits of distorting this information using both the equipment and the materials commonly used in the photographic process. Only when we fully understand how information can be changed and distorted can we learn how to interpret the photographic imagery that dominates the communications industry. This chapter stands as a building block for the Visual Literacy chapter that appears later in this book.

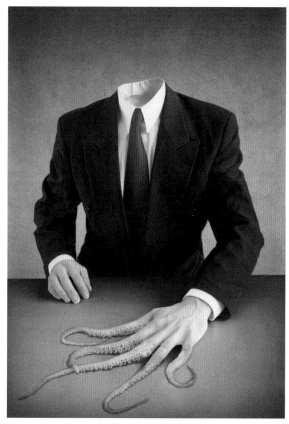

Paul Allister

Activities

a) Experiment with five of the techniques outlined in this chapter.
Use subject matter you feel is appropriate to the visual effect.
Record the procedures you have used accurately so that the process can be perfected at a second or third attempt.

b) Research both art and media sources for examples of photographic distortion and make notes as to how you think this effect may have been achieved.

Note > The final practical assignment requires that you work within a theme (as with previous assignments). It is advisable that you consider this theme whilst working through the activities section of this study guide. This will ensure that your research work is seen as appropriate.

Distortion using the camera

Lens distortion

Perspective compression - Shooting from far away compresses perspective (subject matter at different distances to the camera appear closer together) and using a long focal length allows you to see that compression more easily. If you cannot afford a very long focal length lens (say 400 mm or more) you can achieve the same effect by using a 200 mm lens with a teleconverter: a device that sits between the lens and camera and multiplies the focal length being used. Unfortunately it also multiplies the aperture, so a 200 mm f/4 lens with a 2x converter becomes a 400 mm f/8 lens. You will need a tripod or image stabilization to keep the picture steady.

Steep perspective - Close shooting distances exaggerate relative distance and scale. To get the most out of this technique, use a short focal length lens. Using a lens of wider than 28 mm is recommended. The shorter the focal length, the closer in you can get and still include all the subjects. Subjects close to the lens looks larger in proportion to their surroundings. Subject matter in the distance looks much further away. The overall effect is one of '**steep perspective**'.

Zooming - For this technique you need to use a lens that can alter its focal length, i.e. a zoom lens. The camera can be mounted on a tripod and a slow shutter speed selected, e.g. 1/15, 1/8 or 1/4 second. The effect is achieved by altering the focal length during the exposure. The subject does not need to move for the effect to work (see '**Time**').

Depth of field - Shallow depth of field is achieved by using one or more of the following techniques: a) long focal length lens, b) wide aperture, c) moving closer. Wide depth of field is achieved by using a combination of one or more of the following techniques: a) short focal length lens, b) small aperture, c) moving further from subject.

Refraction and reflection

Refraction - This is the action of light being bent or deflected as it passes through different media such as glass and water. Look at the swimmer photographed by André Kertész. Try photographing through patterned or textured glass, special filters, clear filters with Vaseline smeared on them, water, etc. in front of the lens.

Reflection - When light is reflected off smooth surfaces which are curved we get a view of the image distorted. Look at the nudes produced by André Kertész.
The mixing of reflections with the view through plain glass can also produce interesting effects, as can mirror images introduced into the picture. Possible sources for such images include chrome items, reflective foil, shiny black cars, etc.

Lighting

Try using unusual lighting conditions such as car headlights, desk lamps or portable video lights to illuminate your subject. Experiment mixing tungsten and flash or by placing opposite colored filters over the camera lens and a flashgun.

Streetlights - Luke Lewis

Light writing

Try exploring the original meaning of the word photography (light writing) by using extended shutter speeds and letting the movement of lights create light trails. You could experiment with hand-holding the camera or placing the camera on a tripod and photographing anything from car lights to star trails and fireworks or torches held by dancers.

Taking things one step further Luke in the image above has further distorted the image by using the Liquify filter in Photoshop.

Depth of field

The photograph below draws the viewer's attention to the key in the hand. The student has used a mixture of telephoto lens, close proximity to the subject and a wide aperture to create this photograph. This is a technique known as differential focusing and is an example of pushing the equipment to its limits (see '**Light**').

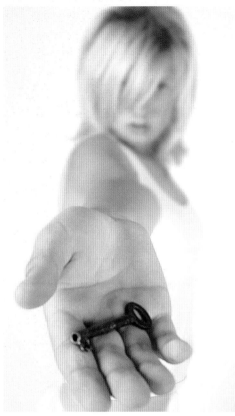

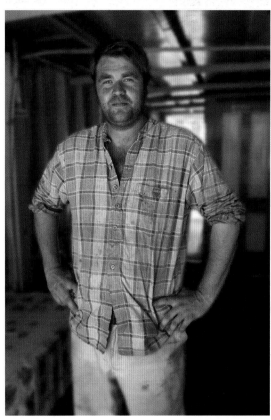

Unlocked - Maddy Smith

Stoker - Dorothy Connop

Shallow depth of field in post-production

When using digital compact cameras this very shallow depth of field is hard to achieve in the camera due to the small size of the sensor. Depth of field is greater at any given aperture when using these digital compacts or fixed lens cameras than if the photographer had used a DSLR camera. The shallow depth of field can, however, be achieved in post-production using image editing software such as Photoshop. The Background layer can be duplicated and then a Gaussian Blur or Lens Blur filter can be applied to the background layer. Selective areas of the sharp detail in the duplicate layer can then be masked or erased to reveal the blurred information underneath. The image on the right was shot with full depth of field and then the background was blurred in post-production by simply brushing directly into a layer mask. A careful selection can be used to increase the precise nature of the effect.

Computer manipulation

All photographic images destined for the commercial printed media now pass through an image-editing software program such as Photoshop or Photoshop Elements. Most images are just cropped, enhanced slightly (color correction and sharpening) and prepared for print but the temptation or goal of many photographers is to go beyond simple enhancement and either fabricate a completely different reality or perfect the existing one. It has never been easier to adjust the truth. Can we really say that 'seeing is believing' when we look at a photographic images these days?

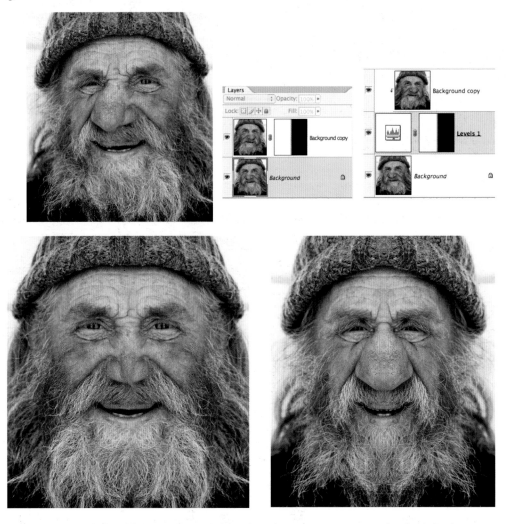

The image above of the old man is completely altered in just one minute by first duplicating the Background layer (drag the layer to the New Layer icon in the Layers palette), and then choosing the 'Flip Horizontal' from the Transform commands and then masking one half of the face. A Black, White gradient was used in the layer mask to create a gradual transition. In Photoshop Elements a layer mask on an adjustment layer can be used (see the section 'Digital montage' at the end of this chapter).

Posterization

The 'Posterize' command can be very effective for dividing a Grayscale image into large flat areas of tone for dramatic effect.

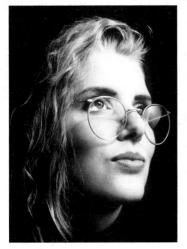 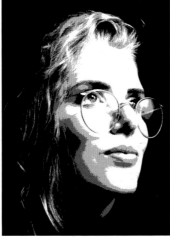

From the 'Layers' palette choose 'Posterize' in the 'Create Adjustment Layer' submenu. From the Posterize dialog box select the 4 levels (this will give you white, black and two tones of gray). Experiment with different numbers to see the variations of effect. If the 'Preview' box is checked you can see the effect on your image as you enter different values in the Levels field.

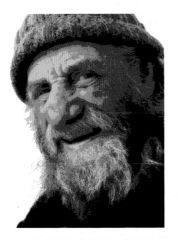 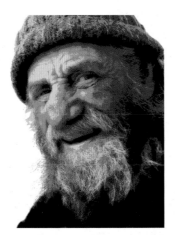

Color posterization

The effects of posterization, however, are often far less successful if the command is applied directly to an RGB color image. To posterize a color image effectively change the blend mode of the Posterize adjustment layer to Luminosity.

Note > You may also like to experiment with the layer opacity to modify the result. Select the Brightness/Contrast command from the 'Enhance' menu (Image > Adjustments for Photoshop users) and adjust the sliders to further refine the posterized effect.

Digital Sabattier effect

The Sabattier effect (sometimes referred to as solarization) that was made famous by the artist Man Ray can be achieved quickly and easily in Photoshop by using the blend modes.

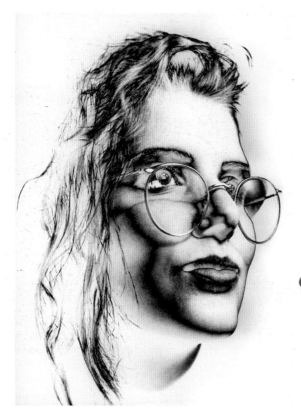

The Invert command can be accessed from the Adjustments submenu. This is to be found in the Image menu in Photoshop and the Filters menu in Photoshop Elements.

Start by duplicating the Background layer by dragging it to the New Layer icon in the Layers palette. Invert this 'Background copy' layer by going to 'Adjustments > Invert' and then apply a 'Difference' or 'Darken' blend mode to this layer. The 'Darken' option will render the negative version that is usually achieved in the darkroom before a reversal print is made.

Note > If the darken option is selected a 'Levels' adjustment can return the highlights to a bright white.

Blending

When an image, or part of an image, is placed on a separate layer above the background, creative decisions can be made as to how these layers interact with each other. Reducing the opacity of the top layer allows the underlying information to show through but there are many other ways of mixing, combining or 'blending' the pixel values on different layers to achieve different visual outcomes.

The different methods used by Photoshop and Elements to compare and adjust the hue, saturation and brightness of the pixels on the different layers are called '**blend modes**'. Blend modes can be assigned to the painting tools from the options bar but they are more commonly assigned to an entire layer when editing a multi-layered document. The layer blend modes are accessed from the 'blending mode' pull-down menu in the top left-hand corner of the Layers palette.

Applying the blend mode 'Overlay' to a texture or pattern layer will create an image where the form appears to be modelling the texture. Both the highlights and shadows of the underlying form are respected.

Tinting and toning

The Hue and Color blend modes can be used for toning or tinting images. The full version of Photoshop also offers photo filters as adjustment layers. The entire image can be tinted or colored or just selective areas can be adjusted by making use of layer masks or clipping groups (see 'Digital montage').

Hue

The 'Hue' blend mode modifies the image by using the hue value of the blend layer and the saturation value of the underlying layer. As a result the blend layer is invisible if you apply this blend mode to a fully desaturated image. Opacity levels of the blend layer can be explored to achieve the desired outcome.

Color

The 'Color' blend mode is useful for toning desaturated or tinting colored images. The brightness value of the base color is blended with the hue and saturation of the blend color.

A sample color swatch is placed on its own layer and then placed in the Hue and Color blend modes

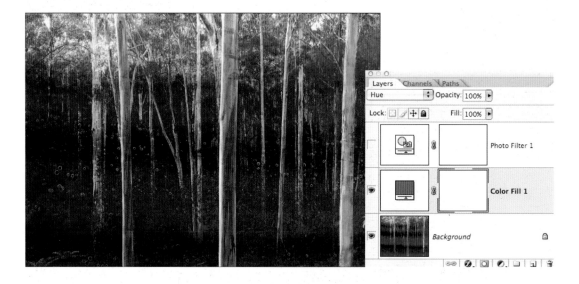

Note > Color fills can be used to tint or tone images by setting them to Hue or Color mode. Photoshop's new Photo Filter layers perform a similar task but without the need to set the layer to the Hue or Color mode.

Saturation

The brightness or 'luminance' of the underlying pixels is retained but the saturation is replaced with that of the blend layer. This blend mode has limited uses for traditional toning effects but can be used to locally desaturate colored images. To work with this blend mode try creating a new empty layer. Then either fill a selection with any desaturated tone or paint with black or white at a reduced opacity to gradually remove the color from the underlying image.

The color swatch at the top of the image is placed on a layer above the Background layer and then placed in the Saturation blend mode

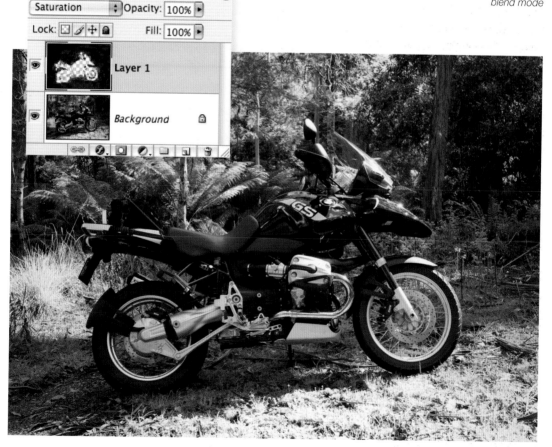

A saturation layer is used to desaturate the underlying image's background

Digital montage

Masks are used to control which pixels are concealed or revealed on any image layer except the background layer. If the mask layer that has been used to conceal pixels is then discarded the original pixels reappear. This approach to montage work is termed non-destructive. In the full version of Photoshop the mask is applied to the image layer whilst in Photoshop Elements a mask from an adjustment layer can be used.

In the full version of Photoshop the layer mask can sit on the same layer as the image you are masking. In Photoshop Elements there is no option to add a layer mask to an image layer so you need to create an adjustment layer below the layer you want to mask. Then click on the layer you want to mask and select 'Group with Previous' from the 'Layers' menu. The base layer of a group acts as a mask to the other layers. If you now paint in the adjustment layer mask or fill a selection with the adjustment layer mask active the pixels in the layer above are concealed rather than being deleted and can be made visible again.

Note > If you are interested in unleashing the hidden performance or Photoshop Elements then take a look at my book *Adobe Photoshop Elements 5.0 Maximum Performance*.

Filters

Photoshop's filters are a fantastic resource for distorting the photographic image. Some caution needs to be exercised when using the filters as the effects can quickly overwhelm the image. Try to explore effects and techniques that try to address a certain aesthetic goal or communication that you have in mind. It is also important to remember that you can use filters in localized areas of the image, fade or mask the effect of the filters. Moderation in all things.

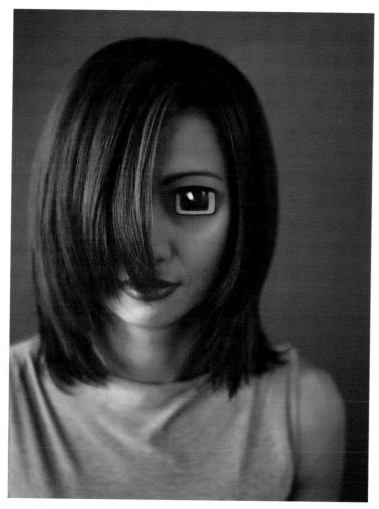

Paul Allister

The Liquify filter

In the image above the student has used the Liquify filter to create an advertising image for high-definition widescreen TVs. The student has used also made selective use of the Gaussian Blur filter to draw our attention towards the focal point of the image. It is recommended that you first duplicate the background layer before applying a filter. This will give you numerous options to adjust the effects of the filter and limit its effect by either dropping the layer opacity, applying a blend mode to the filtered layer or by masking certain areas of the layer using the techniques outlined on the previous page.

Practical assignment

Choose **ONE** assignment only. All work should be supported with research and background work. This should include evidence of how your ideas have developed for your chosen theme.

1. A publishing company has commissioned you to produce a set of photographs that will advertise their forthcoming book titled *Beyond Reason,* one of which will be used on the dust jacket of the book.
 The book is about psychic phenomena and it is envisaged that the photographs will use special effects to set the mood for the articles in the book.

2. You have been commissioned by a successful photographic studio to establish and promote a specialised area of photography. The area is to be known as '**The Dirty Tricks Department**'. This will be a mixture of specialized photographic effects together with original creative thinking.
 The promotion is to be a leaflet containing a number of images and you may wish to include the title as part of the presentation.

3. Choose one of the following themes from which to work. Think very carefully about the many ways you can approach your chosen theme. Do not choose the most obvious definition of the word unless you have considered alternatives.

 a) Sensation b) Force c) Transitions d) Rituals e) Faith f) Masks g) Dreams

4. Produce a set of promotional photographs that would be suitable for the pressure group Amnesty International. The images you produce should promote a particular aspect of their work that you feel strongly about.

5. Express in photographs one or more of the following emotions. You may consider using props and/or text to convey the emotion effectively.

 a) Anger b) Fear c) Love d) Hate e) Joy

Resources

André Kertész - Nudes - distorted reflections
Bill Brandt - Nudes 1945-1980 - wide-angle lens distortion
Ernst Haas - use of slow shutter speeds
Man Ray - solarization, negative prints, multiple exposures and photograms

Photoshop CS3: Essential Skills - Mark Galer and Philip Andrews. Focal Press. 2007.
Adobe Photoshop Elements 5.0 Maximum Performance - Mark Galer. Focal Press. 2006.

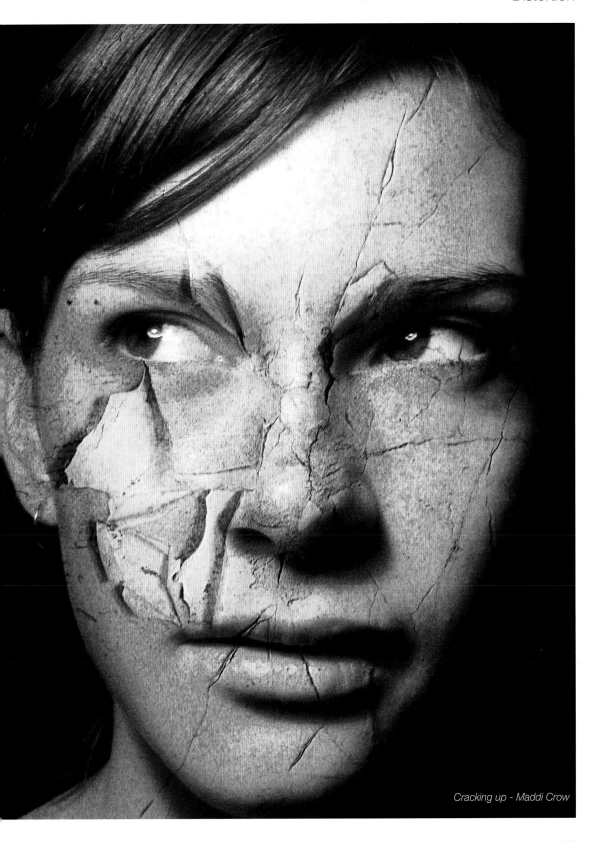

Cracking up - Maddi Crow

Chapter 6

Photomontage

When we look at a photograph we read the images as if they were words to see what information they contain. If the photographic image is accompanied by words they can influence our decision as to what the photograph is about or even alter the meaning entirely. The photographer can manipulate the message to some extent by using purely photographic techniques such as framing, cropping, differential focusing, etc. This controls which information we can or cannot see.

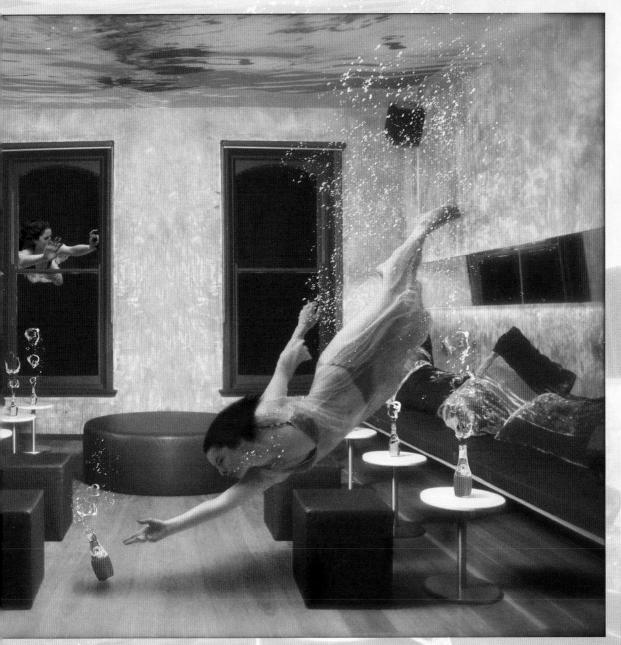

Some artists and photographers have chosen to increase the extent to which they can manipulate the information contained in a photograph by resorting to the use of paint, chemicals, knives, scissors and electronic means to alter what we see. The final result ceases to be a photograph and becomes a 'photomontage'.

Aims

- To develop an awareness of how visual elements interact with each other and with text to convey specific messages.
- To develop an awareness of the techniques employed by individuals in the media in order to manipulate photographic material.

Definition

A photomontage is an image that has been assembled from different photographs. By adding or removing information in the form of words or images the final meaning is altered. The resulting photomontage may be artistic, commercial, religious or political.

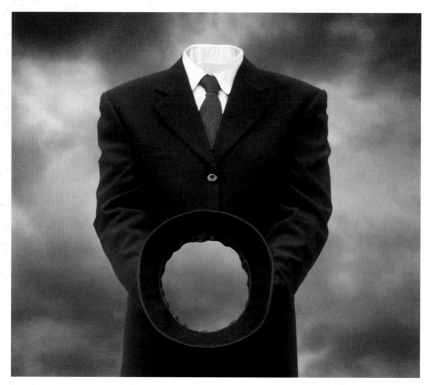

Anica Meehan

History

Photomontage is almost as old as photography itself. During the 1850s, several photographers and artists attempted to use photography to emulate the idealized scenes and classical composition that was popular in the Pre-Raphaelite painting of the period. Photographs during this time were restricted by the size of the glass plate used as the negative in the camera. Photographic enlargers were not common, so the images had to be contact printed onto the photographic paper. By using many negatives to create a picture the photographer could increase the size of the final image. This also released the photographer from the need to photograph complex sets using many models. The technique of 'combination printing' allowed the photographer to photograph each model individually and then print them on a single piece of paper, masking all the areas of the negative that were not needed.

Historical examples

A famous combination print of the Victorian era is called 'Two Ways of Life' by Oscar Gustave Rejlander, produced in 1857. As many as 30 negatives were used to construct this image. The picture shows the moral choice between good and evil, honest work and sin.

Another photographer who worked with this technique was the artist Henry Peach-Robinson. Robinson first sketched his ideas for the final composition on a piece of paper and then fitted in pieces of the photographic puzzle using different negatives. One of his most famous images is the piece titled 'Fading Away' which was constructed in 1859 from five negatives. The image depicts a young woman dying whilst surrounded by her family.

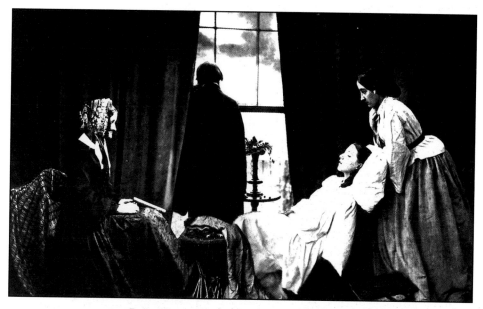

Fading Away - Henry Peach-Robinson/Royal Photographic Society at NMPFT

Historical developments

Both Peach-Robinson and Rejlander were heavily criticized by the fine art world for their work in this field but the technique was popular with the public and did survive. Commercial photographic studios in the 1860s started making their own composite photographs. They were made by cutting up many photographs, usually portraits of the famous or of beautiful women, and gluing them onto a board. This was then re-photographed and the resulting prints sold as souvenirs or given away as promotional material.

Activity 1

Briefly discuss why you think painters of the Victorian period might have criticized these early photomontages and why the pictures were popular with the general public.

This technique of piecing together separate images to create one picture is again very popular with both artists and the media.

What two reasons can you think of for this revival of an old technique?

Political photomontage

The technique of photomontage was not widely used again until the Cubists and the Dadaists in the 20th century experimented with introducing sections of photographs and other printed material into their paintings. A Dadaist by the name of John Heartfield further developed this use of photography and is now commonly attributed as the founder of political photomontage.

John Heartfield was influenced by Dadaism and the newly emerging socialism in the Soviet Union. Sergei Tretyakov, a Russian born writer, showed Heartfield how a collection of facts carefully edited could convey a significant message. John Heartfield was already deeply involved with politics and he now saw how the graphic use of assembled photographs, combined with the mass production printing techniques of the time, could reach a wide audience with his political messages.

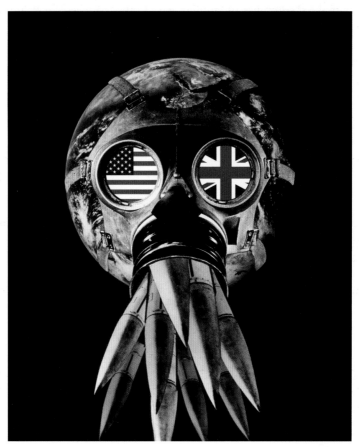

Defended to Death - Peter Kennard

The techniques that John Heartfield developed in the 1920s and 1930s are still used by contemporary artists such as Klaus Staeck and Peter Kennard. In the 1980s Peter Kennard used photomontage to draw attention to the escalating arms race, his most famous works being associated with the organization CND (the Campaign for Nuclear Disarmament). Both artists have found photomontage an ideal medium to communicate social and political injustice to the public in an immediate and effective way. Through photomontage the public are asked to question the media images they see every day, thus raising their visual literacy.

Techniques of political photomontage

1. Text: Text included with most photomontages sets out to reinforce the message of the photographer or artist. The words can remove any possible ambiguity that the viewer may find, draw the attention to the conflict in the images or contradict the images entirely, thus establishing a satirical approach to the work.

2. Recognizing the familiar: The viewer is meant to recognize familiar images, paintings, photographs, advertising campaigns, etc. that the photomontage is based upon. The viewer is drawn to the differences from the original and the new meanings supplied by the changed information. This technique is often used in contemporary photomontage works. The technique is to make the familiar unfamiliar, e.g. 'Cruise Missiles' Peter Kennard, 'Mona Lisa' Klaus Staeck.

3. Contradiction: In many photomontages we see images that contradict each other. Introduced parts of the photomontage may be inconsistent with what we would normally expect to see happening in the image, thus questioning the original point of view. The contradiction can also be between what we see is happening and the text. Our curiosity to establish a coherent meaning in both cases is raised.

4. Contrast: To gain our attention individual components of the photomontage may be in sharp contrast to each other, e.g. wealth and extreme poverty, tranquillity and violence, happiness and sadness, industrialization and the countryside, filth and cleanliness, etc.

5. Seeing through the lies: Many photomontages invite the viewer to look behind the surface or see through something to gain greater insight into the truth. Windows that open out to a different view, X-ray photographs that reveal a contradiction are all popular techniques.

6. Exaggeration of scale: By altering the scale of components of the photomontage the artist can exaggerate a point, e.g. a photomontage entitled 'Big Business' may include giant, cigar smoking, industrialists crushing smaller individuals under their feet.

7. Figures of speech: A very popular technique of the photomontage artist is to visualize figures of speech, e.g. puppet on a string, playing with fire, house of cards, etc. The artist may play upon the viewer's acceptance of these as truth or use them as a contradiction in terms, e.g. 'The camera never lies'.

Activity 2

Find two examples of political photomontages that are either from a historical or contemporary source. Discuss in what context they have been produced and how effective you think they communicate their intended message.

Discuss the techniques that have been used to assemble the examples you have chosen and offer alternative ways that the artist could have put over the same message.

Photomontage in the media

Advertisers and the press have embraced, with open arms, the new technology which makes image manipulation easy. It is fast, versatile and undetectable. Advertising images are nearly always manipulated in subtle ways to enhance colors, remove blemishes or make minor alterations. We are now frequently seeing blatant and extensive manipulation to create eye-catching special effects. We do not get unduly agitated or concerned over these images because advertising images have always occupied a world that is not entirely 'real'.

To manipulate or not to manipulate

We start to move into more questionable territory when images we take to be from real life, perhaps of real people, are altered without our knowledge. The top fashion models we see on the covers of magazines like *Vogue* and *Vanity Fair*, for instance, we believe to be real people, especially when they have been taken out of the advertising context. We expect models to have near perfect features and complexions, but it would come as a shock to many sections of the public to realize that these images are frequently altered as they are not quite perfect enough for the picture editors of the magazines. The editors do not distinguish between the images that appear on the cover of the magazine and the images that are sent to them in the form of advertisements. Minor blemishes to the model's near perfect skin are removed, the color of their lipstick or even their eyes can be changed to suit the lettering or the color of their clothes. Many women aspire to these models and their looks, and yet these people don't exist. It is important to remember that a publication is a product, whether it is a fashion magazine or a daily newspaper, and as such editors may be more interested in sales than in truth.

Most editors are at present using their own moral codes as to when, where and to what extent they will allow manipulation of the photographic image. Most editors see no harm in stretching pictures slightly so they can include text over the image or removing unsightly inclusions. What each editor will and will not allow can vary enormously. Occasionally the desire for an image to complete or complement a story is very strong and the editor is tempted to overstep their self-imposed limits. A fabricated image can change the meaning of a story entirely or greatly alter the information it contains. It is possible to construct a visual communication where none may otherwise have existed.

Activity 3

As editors exercise their ever increasing power over information control, what limits would you impose on them as to the extent to which they can manipulate the photographic image? Devise a series of guidelines that will control the release of images that have been constructed for media use so that the public are aware as to the extent of the manipulation.

Photomontage in art

Around the time that John Heartfield was developing the language of political photomontage, another artist, Laszlo Moholy-Nagy, was using photography in conjunction with drawn geometric shapes. The effect was to cause a visual conflict between the print viewed as a factual record of three-dimensional reality and the print as a two-dimensional surface pattern. This important work ensured that many contemporary artists would continue to use the camera as a creative tool. Some have found 'straight photography' limited as a medium for visualizing their own personal ideas or abstract concepts within a single image. Image manipulation and photomontage are two ways that photography can be used by the artist to communicate in more complex ways.

Surrealism

Surrealism followed Dadaism and photography was found to be an ideal tool and so became directly involved in this movement as it had been in Dadaism.

Surrealist images are constructed from the imagination rather than from reality. Many of the works by surrealist painters such as Salvador Dali and René Magritte appear as fantastic dream sequences where familiar objects are placed in unusual settings. Parts of the image may be distorted in scale or shape and the impossible is often visualized. Inspired by the work of these surrealists Angus McBean, in the 1930s, produced a whole series of photomontages of actors and actresses. The photographs are a strange mixture of fantasy and portraiture where the character is often surrounded by props from their current play.

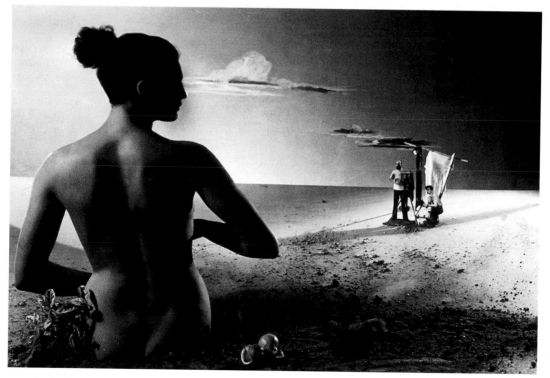

Audrey Hepburn - Angus McBean photograph. By permission of the Harvard Theatre Collection, copyright owner.

Joiners

David Hockney has used photomontage in many of his works. Individual photographs have been placed together to create a larger photographic collage which Hockney has termed a '**Joiner**'. The number of prints in each Joiner may vary depending on how much information Hockney feels he needs to explore in the subject matter. In some of his Joiners he has photographed more than one side of an object or person and then placed the individual images together to create a single picture. This technique was used by cubist painters such as Georges Braque and Picasso who show many facets of objects on a single canvas. Hockney has taken this one stage further and presented the subject at different moments in time. The photographic instant has been lengthened in some of Hockney's Joiners to become a study of a 'happening', different views from different times during the same event. A picture of a card game is no longer a record of that game at one particular moment but rather a study of the whole game.

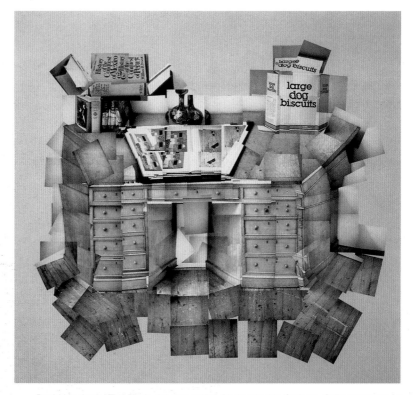

David Hockney 'The Desk, July 1st 1994' Photographic Collage. © David Hockney

Activity 4

Find two examples of photomontages that are either from a commercial source or from a fine art background. Discuss in what context they have been produced and what techniques they share with political photomontages.

What messages, if any, are communicated through these photomontages and how effective do you think they are? Consider different ways that each image could have been tackled by the artist and come up with an idea for 'another in the series'.

Practical assignment 1

Illustrate the cover of a photography book to be published by 'Focal Press'. Create a photographic montage using image editing software for the cover illustration. The montage should illustrate the following title:

'Seeing is believing'

'This book deals with the perceptions and misconceptions of photographic evidence. Problems are often encountered in the interpretation of the image. Technically speaking all photographs "lie", sometimes by accident and sometimes by deliberate misrepresentation. This book covers areas of difficulty in extracting facts from photographs and what photographs can and cannot reveal.'

<div align="right">Gale E. Spring</div>

Inspiration

The publisher has expressed a desire for the illustration to be inspired by the visual ambiguity found in the surrealistic work of Magritte.

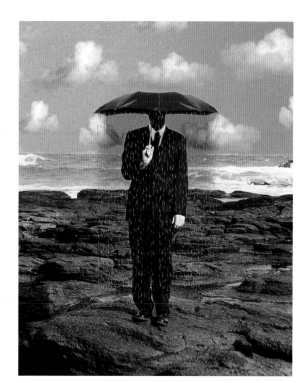

'The effect of strangeness derived from the juxtaposition in one and the same space of several elements, none of which causes any surprise, since they all belong to everyday reality. The visualization of the impossible which questions ordinary perception.'

Combine visual elements and/or concepts from two or more of Magritte's paintings. Include copies of these images with your final submission.

Anitra Keough

Specifications

Dimensions: 189 x 246mm.
Title: Seeing is Believing
Subtitle: Perceptions and Misconceptions of Photographic Evidence.
Image Mode and Resolution: Color (RGB) 240 ppi

Note > See the 'Digital montage' section in the 'Distortion' chapter for technical information on how to complete this Assignment using digital image-editing software.

Practical assignment 2

Produce a photomontage in response to one of the following titles:

a) Phobia - an abnormal or morbid fear of something
b) Metamorphosis - a change of form, character or conditions
c) Decay - decompose
d) Dream world
e) Strange but true
f) Fast food
g) Fashion.

Additional information

Your work should include:

1. A description of how you have photographed each individual element and the sources for 'found' images that you may have had to use (images from the printed media).
2. A description of how the final montage has been assembled.
3. A research sheet including your own proof sheets and ideas.

Resources

Books

Images for the End of the Century - Peter Kennard. Journeyman Press. 1990.
In Our Own Image - Second Edition - Fred Ritchin. Aperture Foundation. 1999.
John Heartfield: Aiz-VI 1930-38. Kent Gallery Inc. 1992.
Love for Sale: The words and pictures of Barbera Kruger. Harry N Abrams. 1996.
Photomontage - A Political Weapon - Evans and Gohl. Gordon Fraser. London. 1986.
Photomontage (World of Art) - Dawn Ades. Thames and Hudson. 1986

Work by the following artists and photographers:

Historical Photomontage - Oscar Gustave Rejlander & Henry Peach-Robinson.
Political Photomontage - John Heartfield, Klaus Staeck & Peter Kennard.
Surrealism - René Magritte, Salvador Dali, Laszlo Moholy-Nagy & Angus McBean.
Contemporary Artists - David Hockney and Babera Kruger.

Video

Photomontage Today - Peter Kennard (35 minute video). Arts Council of Great Britain.
Roland Collection of Films and Videos on Art.
http://www.roland-collection.com/rolandcollection/Section/36/667.htm

Websites

Peter Kennard - http://www.peterkennard.com/
Angus McBean - www.artphiles.com/photophiles/McBean/mcbean.html
Jerry Uelsmann - www.uelsmann.net
René Magritte - www.artcyclopedia.com/artists/magritte-rene.html

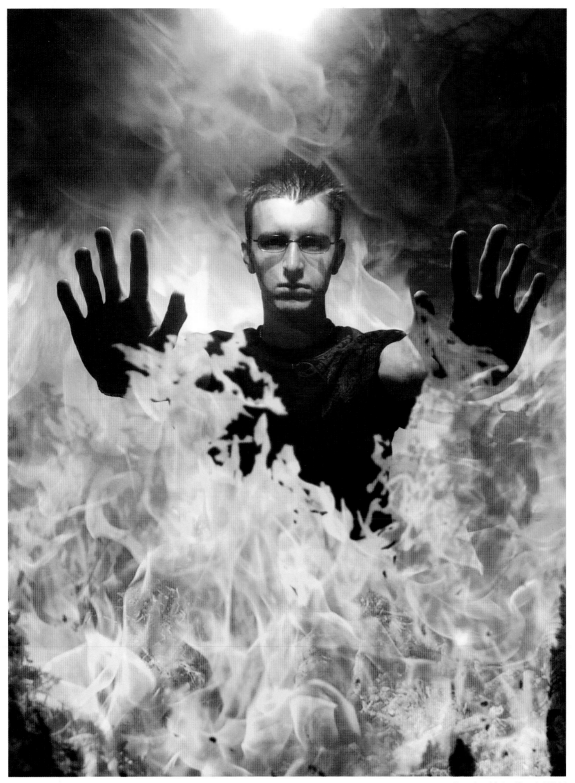

Burning Hot - Sarah Fridd

Chapter 7

Landscape

Picture postcards, calendars and travel brochures show us glimpses of romantic, majestic and idyllic locations to be admired and appreciated. The beautiful and wonderful are identified, observed, recorded and labelled repeatedly by professionals, tourists and travellers. Mankind is responding to the basic social needs and expectations to capture, document and appreciate. I came, I saw, I photographed. Photography allows the individual to pay homage to beauty and achievement as if in some religious ritual.

Morning Tide - Mark Galer

We mark the occasion of our endeavor and our emotional response by taking a photograph.

'Most tourists feel compelled to put the camera between themselves and whatever is remarkable that they encounter. Unsure of other responses they take a picture. This gives shape to experience: stop, take a photograph, and move on.'

Susan Sontag - *On Photography*

Aims

- ~ To increase knowledge of the historical development of the landscape image.
- ~ To express ideas, convictions or emotions through landscape images.
- ~ To develop an understanding of how different techniques can be employed to aid personal expression.

In order to avoid a stereotypical representation it is important to connect emotionally with the environment in order to express something personal. How do you as an individual feel about the location and what do you want to say about it?

Glimpse of the Future? - Rebecca Sloan

Early landscape images

Early landscape images were either created as factual records or looked to the world of painting for guidance in such things as composition and choice of content. Fox Talbot described his early photographs as being created by the 'pencil of nature'. On the one hand the medium was highly valued because of the great respect for nature at this time. On the other hand the medium was rejected as art because many perceived photography as a purely objective and mechanical medium. The question was asked, 'can photography be considered as an artistic medium?' Although it is the camera that creates the image, it is the photographer who decides what to take and how to represent the subject. This subjective approach enables individuals to express themselves in unique ways whether they use a brush or a camera.

Pictorial photography

The practice of recording the environment as the principal subject matter for an image is a fairly modern concept. Prior to the 'Romantic Era' in the late 18th century, the landscape was merely painted as a setting or backdrop for the principal subject. Eventually the environment and in particular the natural environment began to be idealized and romanticized. The picturesque aesthetic of beauty, unity and social harmony was established by painters such as John Constable and William Turner working just prior to the invention of photography. The first photographic movement was born and was known as 'pictorial photography'.

Pictorial photographers believed that the camera could do more than simply document or record objectively. The pictorial approach was not so much about information as about effect, mood and technique.

Pictorial photographers often felt, however, that the photographic lens recorded too much detail. This led to photographers employing techniques to soften the final look of the image. These techniques included taking the images slightly out of focus or using print manipulation to remove detail. The aim was to create an image which looked more like a drawing or painting and less like a photograph.

Pictorial style image - Itti Karuson

Naturalism

Dr Peter Henry Emerson promoted photographic 'Naturalism' in 1889 in his book *Naturalistic Photography for Students of Art*. Emerson believed that photographers shouldn't emulate the themes and techniques of the painters but treat photography as an independent art form. He encouraged photographers to look directly at nature for their guidance rather than painting. He believed that photography should be both true to nature and human vision. Emerson promoted the concept that each photographer could strive to communicate something personal through their work.

Realism

In 1902 a photographer named Alfred Stieglitz exhibited under the title 'Photo-Secessionists' with non-conformist pictorial photographs, choosing everyday subject matter taken with a hand-held camera. These images helped promote photography as an aesthetic medium.

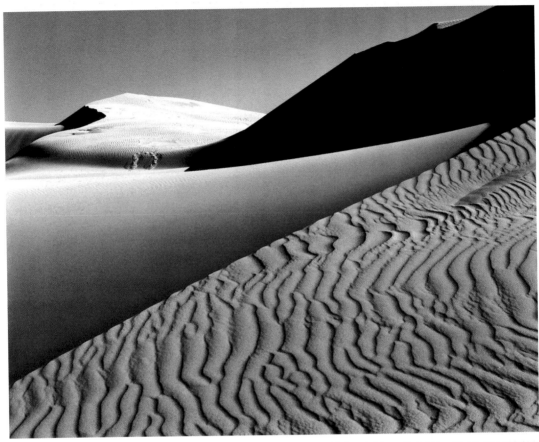

Dunes, Oceano, California 1963 - Ansel Adams © Ansel Adams Publishing Rights Trust/Corbis

F64

Another member of the group, Paul Strand, pioneered 'straight photography', fully exploring the medium's strengths and careful observation of subject matter. Strand believed that the emphasis should lie in the 'seeing' and not the later manipulation in order to communicate the artist's feelings. The work and ideas influenced photographers such as Edward Weston and Ansel Adams, who decided to take up this new '**Realism**'. They formed the group F64 and produced images using the smallest possible apertures on large format cameras for maximum sharpness and detail.

Straight photography heralded the final break from the pursuit of painterly qualities by photographers. Sharp imagery was now seen as a major strength rather than a weakness of the medium. Photographers were soon to realize this use of sharp focus did not inhibit the ability of the medium to express emotion and feeling.

Documentary

Photography was invented at a time when the exploration of new lands was being undertaken by western cultures. Photography was seen as an excellent medium by survey teams to categorize, order and document the grandeur of the natural environment. A sense of the vast scale was often established by the inclusion of small human figures looking in awe at the majestic view. These majestic views and their treatment by American photographers contrasted greatly with European landscape photographs. Landscape painters and photographers in Europe did not seek isolation. Indeed, seeking out a sense of isolation is problematic in an industrialized and densely populated land.

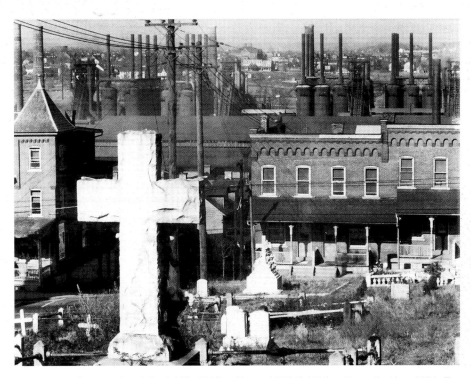

Bethlehem, Graveyard and Steel Mill - Walker Evans 1935 © Walker Evans Archive, 1994, The Metropolitan Museum of Art

In the 1930s Roy Stryker of the Farm Security Administration (FSA) commissioned many photographers to document life in America during the depression. Photographers such as Arthur Rothstein, Dorothea Lange and Walker Evans produced images which not only documented the life of the people and their environment but were also subjective in nature.

Activity 1

View the image by Walker Evans on this page and describe what you can actually see (objective analysis) and what you think the image is about (subjective analysis).

Discuss how effective Walker Evans has been in using a landscape image to communicate a point of view.

Can this photograph be considered as Art? Give two reasons to support your answer.

Personal expression

The image can act as more than a simple record of a particular landscape at a particular moment in time. The landscape can be used as a vehicle or as a metaphor for something personal the photographer wishes to communicate. The American photographer Alfred Stieglitz called a series of photographs he produced of cloud formations 'equivalents', each image representing an equivalent emotion, idea or concept. The British landscape photographer John Blakemore is quoted as saying:

> 'The camera produces an intense delineation of an external reality, but the camera also transforms what it "sees". I seek to make images which function both as fact and as metaphor, reflecting both the external world and my inner response to and connection with it.'

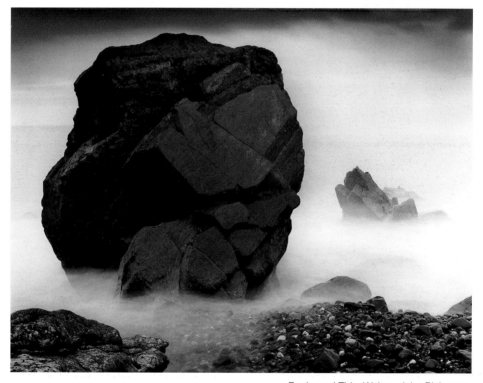

Rocks and Tide, Wales - John Blakemore

> 'Since 1974, with the stream and seascapes, I had been seeking ways of extending the photographic moment. Through multiple exposures the making of a photograph becomes itself a process, a mapping of time produced by the energy of light, an equivalent to the process of the landscape itself.'

John Blakemore 1991

Communication of personal ideas through considered use of design, technique, light and symbolic reference is now a major goal of many landscape photographers working without the constraints of a commercial brief. Much of the art world now recognizes the capacity of the photographic medium to hold an emotional charge and convey self-expression.

Alternative realities

There is now a broad spectrum of aesthetics, concepts and ideologies currently being expressed by photographers. The camera is far from a purely objective recording medium. It is capable of recording a photographer's personal vision and can be turned on the familiar and exotic, the real and surreal. This discriminating and questioning eye is frequently turned towards the urban and suburban landscapes the majority of us now live in. It is used to question the traditional portrayal of the rural landscape (romantic and idyllic) as a mythical cliché. It explores the depiction of the natural landscape for many urban dwellers as a mysterious location, viewed primarily through the windscreen of a car and from carefully selected vantage points. Landscape photography can be used to reflect the values of society. The landscape that has been traditionally portrayed as being unified and harmonious may instead be portrayed as confused and cluttered, to express the conflict between expectation and reality.

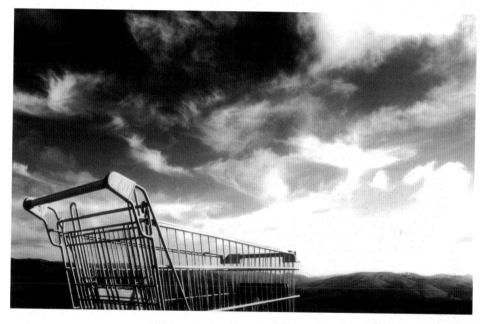

Dreams Will Come True - Matthew Orchard

Photographers also explore their personal relationship with their environment using the camera as a tool of discovery and revelation. To make a photograph is to interact and respond to the external stimuli that surround us. We may respond by creating images that conform to current values and expectations or we may create images that question these values. To question the type of response we make and the type of image we produce defines who we are and what we believe in.

Activity 2

Find two landscape photographs that question social values or act as a metaphor for personal issues that the photographer is trying to express. Discuss whether the communication is clear or ambiguous and how this communication is conveyed.

Expressive techniques

Sweeping panoramas are not caught by the frame of a standard lens. When a wide-angle lens is attached to include more of the panorama the resulting images may be filled with large areas of empty sky and foreground. This does little for the composition and can make the subject of interest seem far away and insignificant. The lens does not discriminate, recording everything within its field of vision. Painters recording a landscape have the option of eliminating information that would clutter the canvas or detract from the main subject matter. Unlike the painter, a photographer can only remove superfluous detail by using a carefully chosen vantage point or by moving in closer to reduce the information that is contained within the frame. If the photographer moves in too close, the feeling of the broader landscape is lost.

The Apostles - Mark Galer

Although it is difficult to communicate personal ideas or feelings and capture the mood of a location it is nevertheless possible and, when achieved, can be one of the most rewarding photographic experiences. Through increased awareness, careful observation and knowledge of the elements that create a successful landscape photograph, the photographer can learn to achieve expressive and effective results consistently.

Activity 3

Compare and contrast a landscape photograph with a landscape painting.
Discuss the expressive possibilities of each medium using your examples to illustrate your argument.
Choose your examples carefully as representative of the medium.

Composition

Composing subject matter is more than an aesthetic consideration. It controls the way we read an image and the effectiveness of the photographer's communication.

Format and horizon line

The most powerful design elements landscape photographers have to work with are choice of format and positioning of the horizon line. Most landscape images are horizontal or landscape format. The use of this format emulates the way we typically view the landscape. To further emulate the human vision we can crop to a wider image to reduce the viewer's sensation of viewing a truncated image. Many photographers make the mistake of overusing the vertical or portrait format when faced with tall subject matter. The placement of the horizon line within the frame is also critical to the final design. A central horizon line dividing the frame into two halves is usually best avoided. The photographer should consider whether the sky or foreground is the more interesting element and construct a composition according to visual weight and balance.

Mark Galer

Open or closed landscape

By removing the horizon line from the image (through vantage point or camera angle) the photographer creates a closed landscape. In a closed landscape a sense of depth or scale may be difficult for the viewer to establish.

Activity 4

Create two photographs in a location with tall buildings or trees using both formats.
Create a closed and open landscape at one location.
Discuss the different ways we read the resulting images.

Depth

Including foreground subject matter introduces the illusion of depth through perspective and the image starts to work on different planes. Where the photographer is able to exploit lines found in the foreground the viewer's eye can be led into the picture. Rivers, roads, walls and fences are often used for this purpose.

By lowering the vantage point or angling the camera down, the foreground seems to meet the camera. A sense of the photographer in, or experiencing, the landscape can be established. In the photograph below the beach and cliff walls are included along with the author's own footsteps to establish a sense of place.

Mark Galer

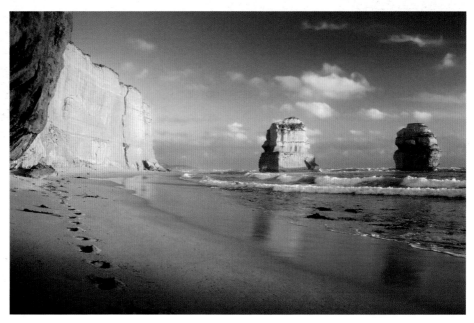

Mark Galer

Activity 5

Create a landscape utilizing foreground subject matter to create a sense of depth.
Discuss how the resulting image is likely to be read by the viewer.

The constructed environment

When Arthur Rothstein, FSA photographer, moved a skull a few metres for effect he, and the FSA, were accused of fabricating evidence and being dishonest. A photograph, however, is not reality. It is only one person's interpretation of reality. Rothstein perceived the skull and the broken earth at the same time and so he included them in the same physical space and photograph to express his emotional response to what he was seeing. Is this dishonest? The photograph can act as both a document and as a medium for self-expression. Truth lies in the intention of the photographer to communicate visual facts or emotional feelings. Sometimes it is difficult for a photograph to do both at the same time.

Andy Goldsworthy

The majority of photographers are content with responding to and recording the landscape as they find it. A few photographers, however, like to interact with the landscape in a more concrete and active way. Artists such as Andy Goldsworthy use photography to record these ephemeral interactions. Goldsworthy moves into a location without preconceived ideas and uses only the natural elements within the location to construct or rearrange them into a shape or structure that he finds meaningful. The day after the work has been completed the photographs are often all that remain of Goldsworthy's work. The photograph becomes both the record of art and a piece of art in its own right.

Activity 6

Make a construction or arrangement using found objects within a carefully selected public location. Create an image showing this structure or arrangement in context with its surroundings. Consider framing, camera technique and lighting in your approach. What do you think your construction communicates about your environment?

Assignments

Produce six images that express your emotions and feelings towards a given landscape. Each of the six images must be part of a single theme or concept and should be viewed as a whole rather than individually.

People may be included to represent humankind and their interaction with the landscape. The people may become the focal point of the image, but this is not a character study or environmental portrait where the location becomes merely the backdrop.

1. Wilderness.
2. Seascape.
3. Suburbia.
4. Sandscape.
5. Inclement weather.
6. City.
7. Mountain.
8. Industry.
9. Arable land.

Resources

A Collaboration with Nature - Andy Goldsworthy. Abrams. New York. 1990.

Ansel Adams: Classic Images. New York Graphic Society. 1986.

On Photography - Susan Sontag. Picador. 2001.

Inscape - John Blakemore. Art Books Intl. Ltd. 1991.

In This Proud Land - Stryker and Wood. New York Graphic Society. New York. 1973.

Land - Faye Godwin. Heinemann. London. 1985.

Naturalistic Photography for Students of the Art - P. H. Emerson. Arno Press. New York. 1973.

Small World - Martin Parr. Dewi Lewis Publications. 1995.

The History of Photography: an overview - Alma Davenport. Focal Press. 1991.

The Photograph - Graham Clarke. Oxford University Press. 1997.

The Story of Photography - Michael Langford. Focal Press. Oxford. 1998.

Walker Evans: Masters of Photography (2nd Edition). Aperture. 1997.

Websites

Ansel Adams: http://www.anseladams.com/

John Blakemore: http://collection.britishcouncil.org

Martin Parr: http://www.martinparr.com/

UK Landscape: http://www.uklandscape.net/

George Eastman House: http://www.geh.org/photographers.html

Dookie Morning - Sarah Gall

Kaitlyn Ewart

Chapter 8

Portraiture

The craft of representing a person in a single still image or 'portrait' is to be considered a skilled and complex task. The photographic portrait (just as the painted portrait that influenced the genre) is not a candid or captured moment of the active person but a crafted image to reveal character. The person being photographed for a portrait should be made aware of the camera's presence even if they are not necessarily looking at the camera when the photograph is made.

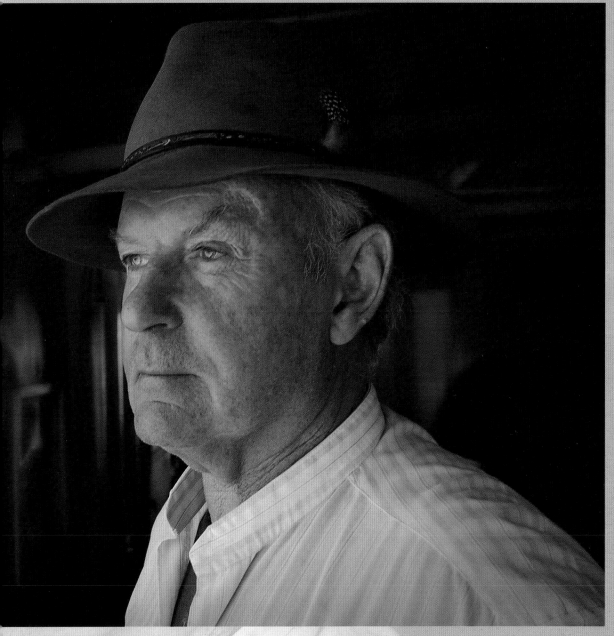

Mark Galer

This requires that the photographer connect and communicate with any individual if the resulting images are to be considered portraits. Portraits therefore should be seen as a collaborative effort on the part of the photographer and subject. A good photographic portrait is one where the subject no longer appears a stranger.

Aims

- To develop an understanding of the genre of photographic portraiture.
- To develop personal skills in directing people.
- To develop essential technical skills to work confidently and fluently with people.

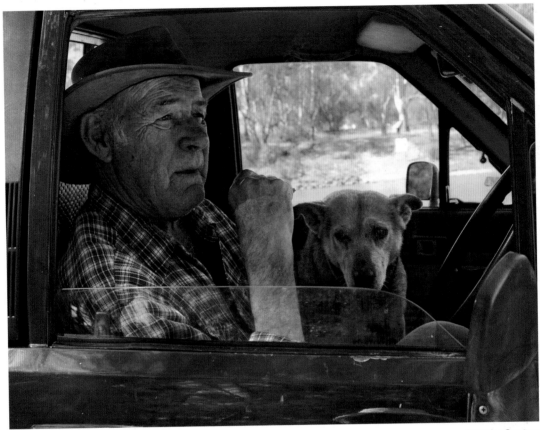

Dorothy Connop

Environment

The physical surroundings included in a portrait offer enormous potential to extend or enhance the communication. Just as facial expression, body posture and dress are important factors, the environment plays a major role in revealing the identity of the individual.

Activity 1

Look through assorted books, magazines and newspapers and collect four portrait photographs. The environment should be a key feature in two of the four images.
Describe the subject's character in each of the images.
What can you see within each image that leads you to these conclusions about the subjects' character.

Design

Choosing a suitable background or backdrop for the portrait can greatly influence the final design of the image. Using a plain backdrop with limited detail can retain focus on the individual being photographed whilst choosing an informative location can extend the communication and design possibilities. If the photographer is to reveal any connection between the subject and the background the two elements must be carefully framed together. Vantage point and the relationship and connection between foreground and background become major design considerations for the portrait photograph.

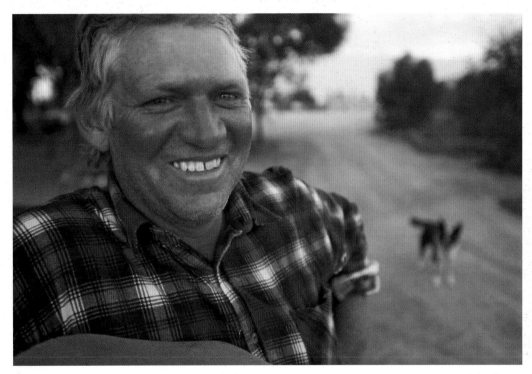

Orien Harvey

Format

The choice of vertical or horizontal framing and the placement of the subject within the frame will affect the quantity of the background that can be viewed in the image. A centrally placed subject close to the camera will limit the background information. This framing technique tends to be overused but should not be ruled out for creating successful portraits. The horizontal format is common when creating environmental portraits. Using the portrait format for environmental portraits usually requires the photographer to move further back from the subject so that background information is revealed.

Activity 2

Find four portraits that demonstrate the different ways a photographer has framed the image to alter the design and content.

Discuss the vantage point, depth of field and subject placement in all of the images.

Composing two or more people

Composing two or more people within the frame for a portrait can be difficult. The physical space between people can become very significant in the way we read the image. For a close-up portrait of two people the space between them can become an uncomfortable design element. Careful choice of vantage point or placement of the subjects is often required to achieve a tight composition, making optimum use of the space within the frame.

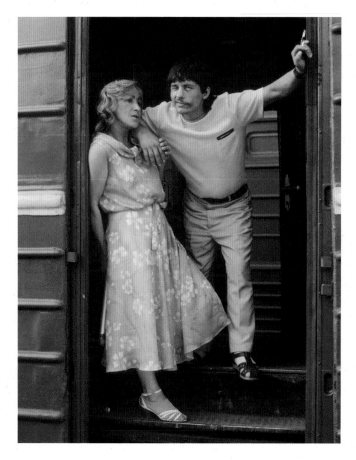

Mark Galer

The situation most often encountered is where two people sit or stand side by side, shoulder to shoulder. If approached face on (from the front) the space between the two people can seem great. This can be overcome by shooting off to one side or staggering the individuals from the camera. The considerations for design are changed with additional subjects.

Activity 3

Collect four portrait images with two to five subjects.

In at least one image the subject should have been placed in the foreground.

Comment on the arrangement of the subjects in relation to the camera and the effectiveness of the design.

Depth of field

Sophisticated 35 mm SLR cameras often provide a '**Portrait Mode**'. When this programme mode is selected a combination of shutter speed and aperture is selected to give the correct exposure and a visual effect deemed suitable for portrait photography by the camera manufacturers. The visual effect aimed for is one where the background is rendered out of focus, i.e. shallow depth of field. This effect allows the subject to stand out from the background, reducing background information to a blur. Although this effect is appropriate for many portrait images it is not suitable for most environmental portraits, where more information is required about the physical surroundings and environment. The student intending to create portraits is recommended to use their camera in either fully manual or aperture priority mode so that maximum control is maintained.

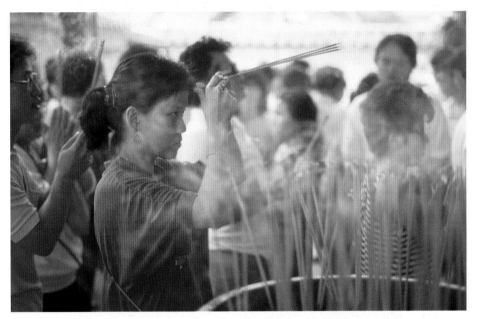

Mark Galer

Appropriate focal length

Photographic lenses can be purchased by manufacturers which are often referred to as 'portrait lenses'. The 'ideal' portrait lens is considered by the manufacturers to be a medium telephoto lens such as a 135 mm lens for a 35 mm camera. This lens provides a visual perspective that does not distort the human face when recording head and shoulder portraits. The problem of distortion, however, is not encountered with shorter focal length lenses if the photographer is not working quite so close to the subject. To record environmental portraits with a telephoto lens would require the photographer to move further away from the subject and possibly lose the connection with the subject that is required. Standard and wide-angle lenses are suitable for environmental portraiture.

Activity 4

Photograph the same subject varying both the depth of field and focal length of the lens. Discuss the visual effects of each image.

Revealing character

Significant and informative details can be photographed with the subject. These details may naturally occur or be introduced for the specific purpose of strengthening the communication. Connections may be made through the 'tools of the trade' associated with the individual's occupation. Informative artefacts such as works of art or literature may be chosen to reflect the individual's character. Environments and lighting may be chosen to reflect the mood or state of mind of the subject.

Ann Ouchterlony

The objects or subject matter chosen may have symbolic rather than direct connection to the subject. In the above image the bent walking stick of the old man and the path travelled could be purely coincidental or could have been chosen to represent the journey of his life.

Activity 5

Find one portrait image that has included significant or informative detail.

Describe the importance of the additional information and how it is likely to be read by the viewer.

Connecting with new people

The shift from receptive observer to active participant can sometimes be awkward and difficult for both the potential subject and the photographer. These feelings of awkwardness, embarrassment or even hostility may arise out of the subject's confusion or misinterpretation over the intent or motive behind the photographer's actions. The photographer's awkwardness or reticence to connect often comes from the fear of rejection.

Stephen Rooke

The initial connection with the subject is crucial for a successful environmental portrait. If the photographer is taking images at an event or activity the photographer must be very aware when someone within the frame makes eye contact with the camera. At this decisive moment the posture and facial expression usually remain unchanged from where the subject's attention was previously engaged. The photographer should be able to capture a single frame at this moment before lowering the camera. There is no time for re-focusing, re-framing and adjusting exposure. The camera should be lowered and a friendly and open response offered by the photographer. If the photographer continues to observe the subject after having been noticed the subject's sense of privacy can be invaded and the photographer's chance for an amicable contact can be lost. Most people will gladly cooperate if a friendly connection has first been established.

Directing the subject

The photographer should display an air of confidence and friendliness whilst directing subjects. Subjects will feel more comfortable if the photographer clearly indicates what is expected of them. There can be a tendency for inexperienced photographers to rush an environmental portrait. The photographer may feel embarrassed, or feel that the subject is being inconvenienced by being asked to pose. The photographer should clarify that the subject does have time for the photograph to be made and indicate that it may involve more than one image being created. A subject may hear the camera shutter and presume that one image is all that is required.

Passive subject

Subjects should be directed to pause from the activity that they were engaged in. The photographer can remain receptive to the potential photographic opportunities by keeping the conversation focused on the subject and not oneself.

Expression and posture

Often a subject will need reminding that a smile may not be necessary. Subjects may need guidance on how to sit or stand, what they should do with their hands and where to look. It may be a simple case of just reminding them how they were standing or sitting when you first observed them.

Shooting decisively

As a photographer takes longer to take the picture the subject will often feel more and more uncomfortable about their expression and posture. To freeze human expression is essentially an unnatural act. Exposure, framing and focus should all be considered before raising the camera to the eye.

Stephen Rooke

Activity 6

Connect with someone new and create three environmental portraits.
At least one image should demonstrate how you have directed them towards a relaxed expression and body posture.
Discuss the process of direction.

Character study

Environmental portraits often stand alone in editorial work but can also form part of a larger body of work. A series of environmental portraits may be taken around a single character, or characters, connected by profession, common interest or theme.

With additional images the photographer is able to vary the content and the style in which the subject is photographed to define their character within the study. The photographer may choose to include detail shots such as hands or clothing to increase the quality of information to the viewer. The study may also include images which focus more on the individual (such as a straight head and shoulders portrait) or the environment to establish a sense of place.

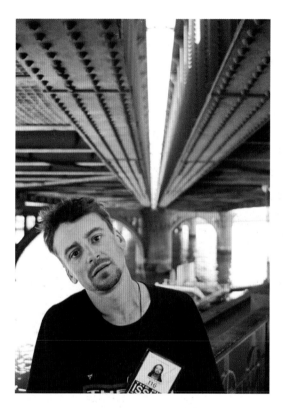

Sean Killen

The images above show the diversity of approach to present the character of a single individual. The images are of Martin, a homeless individual who lived under a bridge in Melbourne and who sold copies of *The Big Issue* to support himself.

Activity 7

Collect one photographic essay where the photographer has varied the content of the images to define the character or characters of the individual or individuals.

Describe the effectiveness of the additional images that are not environmental portraits.

Assignments

Produce six environmental portraits giving careful consideration to design, technique and communication of character. At least one of the images should include more than one person. Choose one category from the list below.

1. Manual laborers dockers, builders, mechanics, bakers, etc.
2. Professional people... doctors, nurses, lawyers, etc.
3. Craftsmanship............................ potters, woodworkers, violin makers, etc.
4. Club or team members footballers, golfers, scouts, etc.
5. Corporate image.................................. business consultants, bankers, etc.
 This study should include three environmental portraits,
 two images of close-up detail and one portrait.
6. Character study ... celebrity, politician, busker, etc.
 This study should include three environmental portraits,
 two images of close-up detail and one close-up portrait.

Resources

Editorial:

National Geographic
Newspapers and magazines

Books:

Arnold Newman - TASCHEN America Llc. 2000.
August Sander: 1876-1964. TASCHEN America Llc. 1999.
Brandt: The Photography of Bill Brandt. Harry N Abrams. 1999.
East 100th Street - Bruce Davidson. St Ann's Press. 2003.
Immediate Family - Sally Mann. Aperture. 1992.
Karsh: A Biography in Images. MFA Publications. 2004.
Portraits - Steve McCurry. Phaidon Press Inc. 1999.
Pictures of People - Nicholas Nixon. Museum of Modern Art. New York. 1988.
Richard Avedon Portraits Harry N. Abrams. 2002.
The Brown Sisters - Nicholas Nixon. Museum of Modern Art. New York. 2002.
The Photographs of Dorothea Lange. Hallmark Cards. 1996.
Women - Annie Liebowitz and Susan Sontag. Random House. 1999.
The Story of Photography - Michael Langford. Focal Press. Oxford. 1998.

Web:

Many of the links to the above photographers can be found at http://photography.about.com

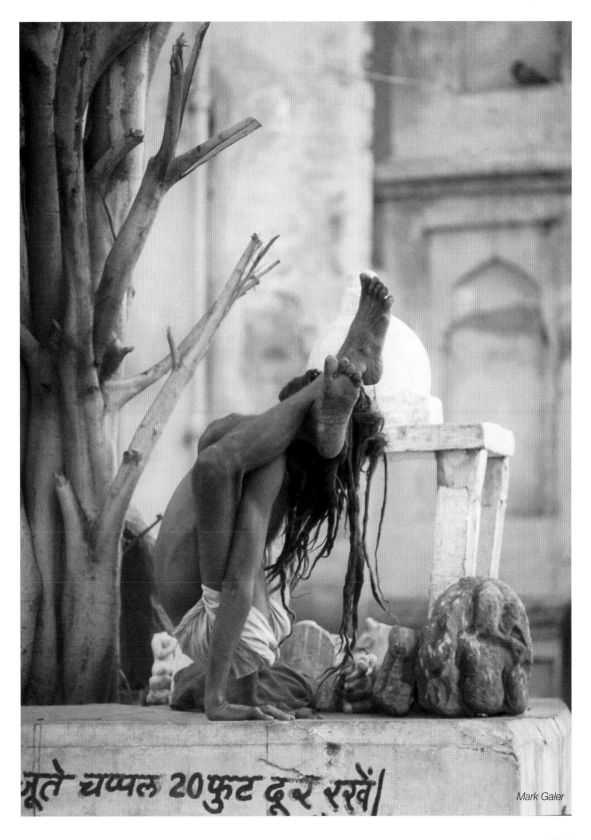

ूते चप्पल 20 फुट दूर रखें।

Mark Galer

Chapter 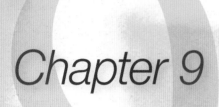 9

Photo-story

The purpose of constructing a photographic essay is to communicate a story through a sequence of images to a viewer. Just as in writing a book, a short story or a poem, the photographer must first have an idea of what they want to say. In a photographic essay it is the images instead of words that must be organized to tell the story. Individual images are like descriptive and informative sentences.

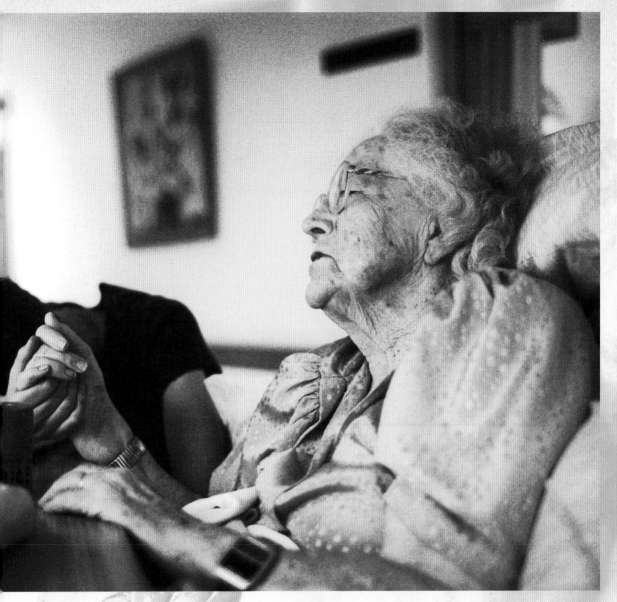

Andrew Goldie

When the images are carefully assembled they create a greater understanding of the individual, event or activity being recorded than a single image could hope to achieve. Words should be seen as secondary to the image and are often only used to clarify the content.

Aims

- To understand visual communication through narrative techniques.
- To develop an awareness of receptive and projective styles of photography.
- To understand the process of editing to clarify or manipulate communication.
- To increase awareness of commercial, ethical and legal considerations.

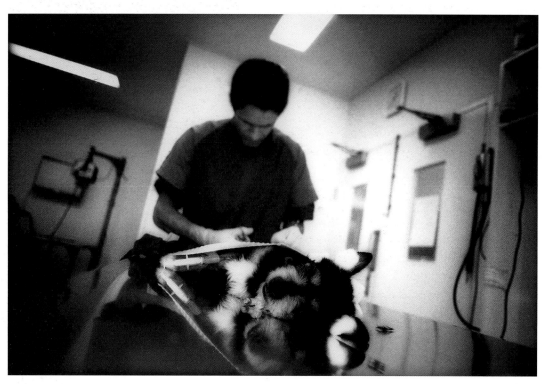

The Vet - Michael Mullan

The first stories

In 1890 the photographer Jacob Riis working in New York produced one of the earliest photographic essays titled *How the Other Half Lives*. *National Geographic* magazine began using photographs in 1903 and by 1905 they had published an eleven-page photographically illustrated piece on the city of Lhasa in Tibet. In 1908 the freelance photographer Lewis W. Hine produced a body of work for a publication called *Charities and the Commons*. The photographs documented immigrants in the New York slums. Due to the concerned efforts of many photographers working at this time to document the 'human condition' and the public's growing appetite for the medium, photography gradually became accepted. The first **'tabloid newspaper'** (the *Illustrated Daily News*) appeared in the USA in 1919. By this time press cameras were commonly hand-held and flash powder made it possible to take images in all lighting conditions.

'I saw and approached the hungry and desperate mother, as if drawn by a magnet. I do not remember how I explained my presence or my camera to her, but I do remember she asked me no questions. I made five exposures, working closer and closer from the same direction. I did not ask her name or her history. She told me her age, that she was thirty-two. She said that they had been living on frozen vegetables from the surrounding fields, and birds that the children killed. She had just sold the tires from her car to buy food. There she sat in that lean-to tent with her children huddled around her, and seemed to know that my pictures might help her, and so she helped me. There was a sort of equality about it.' Dorothea Lange from: *Popular Photography*, Feb. 1960.

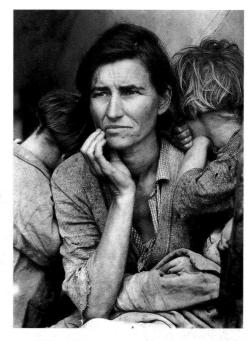

Migrant Mother - Dorothea Lange

FSA

The 1930s saw a rapid growth in the development of the photographic story. During this decade the Farm Security Administration (FSA) commissioned photographers to document America in the grip of a major depression. Photographers including Russell Lee, Dorothea Lange, Walker Evans and Arthur Rothstein took thousands of images over many years. This project provides an invaluable historical record of culture and society whilst developing the craft of documentary photography.

The photo agencies

In the same decade '*Life* magazine' was born along with a host of like-minded magazines. These publications dedicated themselves to showing 'life as it is'. Photographic agencies were formed in the 1930s and 1940s to help feed the public's voracious appetite for news and entertainment. The greatest of these agencies, Magnum, was formed in 1947 by Henri Cartier-Bresson, Robert Capa, Chim (David Seymour) and George Rodger. Magnum grew rapidly with talented young photographers being recruited to their ranks. The standards for honesty, sympathetic understanding and in-depth coverage were set by such photographers as W. Eugene Smith. Smith was a *Life* photographer who produced extended essays, staying with the story until he felt it was an honest portrayal of the people he photographed. He went on to produce the book *Minamata* about a small community in Japan who were being poisoned by toxic waste being dumped into the waterways where the people fished. This was and remains today an inspirational photo-essay.

Activity 1

Research a photographic story that was captured by either an FSA photographer or a photographer working for the Magnum photo agency.
What do the images communicate about the human condition?

Visual communication

Photographic stories are the visual communication of personal experience; as such, each story is potentially unique and is the ideal vehicle for personal expression. To communicate coherently and honestly the photographer must connect with what is happening. To connect the photographer should research, observe carefully, ask questions and clarify the photographer's personal understanding of what is happening. Unless the photographer intends to make the communication ambiguous it is important to establish a point of view or have an 'angle' for the story. This can be achieved by acknowledging feelings or emotions experienced whilst observing and recording the subject matter. All images communicate and most photographers aim to retain control of this communication. Photography can be used as a powerful tool for persuasion and propaganda, and the communication of content should always be the primary consideration of the photographer.

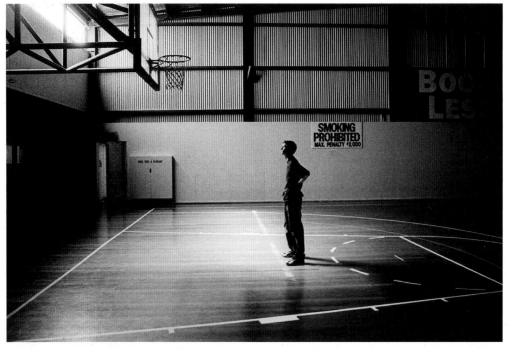

Kim Noakes

Choosing a subject

The most popular subject for the photographic story has always been the 'human condition'. This is communicated through experience-based discovery. The aim is to select one individual or group of individuals and relate their story or life experience to the viewer. The story may relate the experience of a brief or extended period of time.

Finding a story, gaining permission to take images and connecting with the individuals once permission has been granted are some of the essential skills required to produce a successful story. Tracking down a story often requires curiosity, perseverance, motivation and patience. These skills are required by the majority of professional photojournalists who are freelance. Freelance photographers find, document and sell their own stories.

The comfort zone

The 'comfort zone' is a term used to describe the familiar surroundings, experiences and people that each of us feel comfortable in and with. They are both familiar and undemanding of us as individuals. Photography is an ideal tool of exploration which allows us to explore environments, experiences and cultures other than our own. For professional photojournalists this could be attending the scene of a famine or a Tupperware party.

Shane Bell

A photographer may feel they have to travel great distances in order to find an exotic or unusual story. Stories are, however, much closer at hand than most people realize. Interesting stories surround us. Dig beneath the surface of any seemingly bland suburban population and the stories will surface. People's triumphs, tragedies and traumas are evolving every day, in every walk of life. The interrelationships between people and their environment and their journey between birth and death are the never ending, constantly evolving resource for the documentary photographer. The photographer's challenge is to find and connect in a non-threatening and sympathetic way to record this. The photojournalist should strive to leave their personal 'comfort zone' in order to explore, understand and document the other. The photographer should aim to become proactive rather than waiting to become inspired and find out what is happening around them.

Activity 2

Find two meaningful photographic stories containing at least four images.
What is being communicated in each story?
Have the captions influenced your opinion about what is happening?
Could a different selection of images alter the possible communication?
Make a list of five photo-essays you could make in your own home town.
Describe briefly what you would hope to find out and communicate with your images.

Capturing a story

How many movie films have you seen where the opening scene begins with a long and high shot of a town or city and moves steadily closer to isolate a single street or building and then a single individual. This gives the viewer a sense of the place or location that the character inhabits. A story constructed from still images often exploits the same technique. To extend and increase the communication of a series of images the photographer should seek to vary the way in which each image communicates. There is a limit to the communication a photographer can achieve by remaining static, recording people from only one vantage point. It is essential that the photographer moves amongst the people exploring a variety of distances from the subject. Only in this way will the photographer and the viewer of the story fully appreciate and understand what is happening.

The photographer should aim to be a witness or participant at an activity or event rather than a spectator.

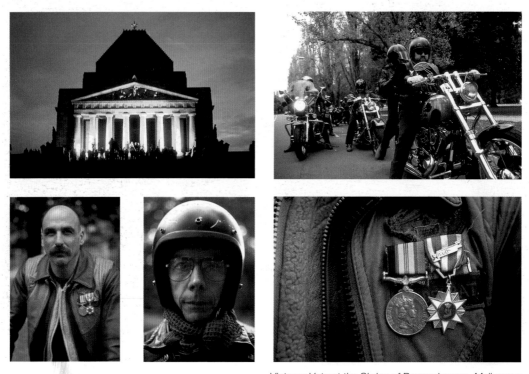

Vietnam Vets at the Shrine of Remembrance, Melbourne

The images that create a well-crafted photographic story can usually be divided or grouped into four main categories. Not all stories contain images from all four categories but many editors expect to see them. The categories are:

1. Establishing image.
2. Action image.
3. Portrait.
4. Detail image.

Establishing image

In order to place an event, activity or people in context with their environment it is important to step back and get an overview. If the photographer's essay is about a small coal-mining community in a valley, the viewer needs to see the valley to get a feeling for the location. This image is often referred to as the establishing image but this does not necessarily mean that it is taken or appears first in the story. Often the establishing image is recorded from a high vantage point and this technique sets the stage for the subsequent shots. In many stories it can be very challenging to create an interesting establishing image. An establishing image for a story about an animal refuge needs to be more than just a sign in front of the building declaring this fact. The photographer may instead seek out an urban wasteland with stray dogs and the dog catcher to set the scene or create a particular mood.

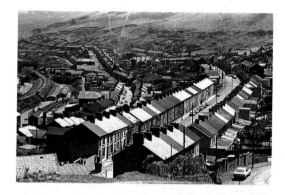

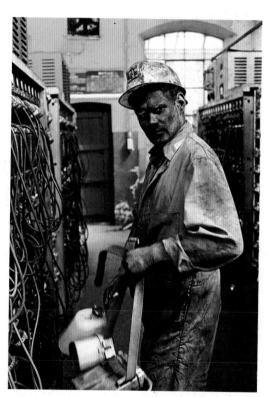

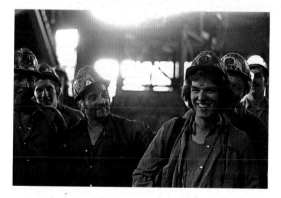

Coal mine in the Rhondda valley

Action image

This category refers to a medium-distance image capturing the action and interaction of the people or animals involved in the story. Many of the images the photographer captures may fall into this category, especially if there is a lot happening. It is, however, very easy to get carried away and shoot much more than is actually required for a story to be effective. Unless the activity is unfolding quickly and a sequence is required the photographer should look to change the vantage point frequently. Too many images of the same activity from the same vantage point are visually repetitive and will usually be removed by an editor.

Portraits

Portraits are essential to any story because people are interested in people and the viewer will want to identify with the key characters of the story. Unless the activity the characters are engaging in is visually unusual, bizarre, dramatic or exciting the viewer is going to be drawn primarily to the portraits. The portraits and environmental portraits will often be the deciding factor as to the degree of success the story achieves. The viewer will expect the photographer to have connected with the characters in the story and the photographs must illustrate this connection. Portraits may be made utilizing a variety of different camera distances. This will ensure visual interest is maintained. Environmental portraits differ from straight head and shoulder portraits in that the character is seen in the location of the story. The interaction between the character and their environment may extend the communication beyond making images of the character and location separately.

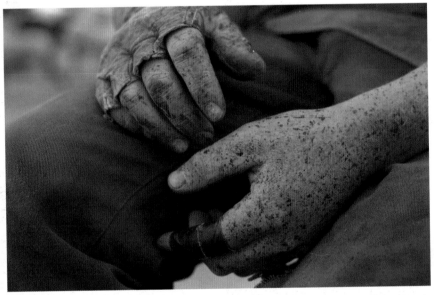

Orien Harvey

Close-up or detail image

The final category requires the photographer to identify significant detail within the overall scene. The detail is enlarged either to draw the viewer's attention to it or to increase the amount or quality of this information. The detail image may be required to enable the viewer to read an inscription or clarify small detail. The detail image in a story about a craftsperson who works with their hands may be the hands at work, the fine detail of the artifact they have made or an image of a vital tool required for the process. When the detail image is included with images from the other three categories visual repetition is avoided and the content is clearly communicated.

Activity 3

Find one photographic story that contains images from all four categories listed.
How does each image contribute to the story?
Describe alternative images for each of the categories in the story you have chosen?

Creating a story

To create a story it is possible to plan and arrange the timing, the subject matter and location so that the resulting images fit your requirements for the communication of a chosen narrative.

To create a story you first need to start with the concept or idea that you would like to illustrate. The story can be inspired by the words of a poem or novel that you have read or the lyrics of a song. Start with words that create images for the mind and then illustrate what is in your mind's eye. Keep the story short or simple and remember to be realistic about your technical ability and the resources (human and physical) to create the story for the camera.

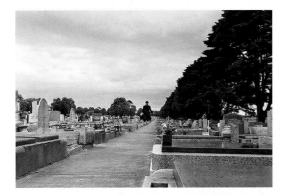 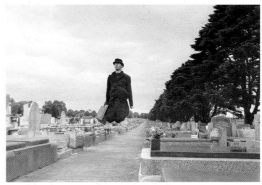

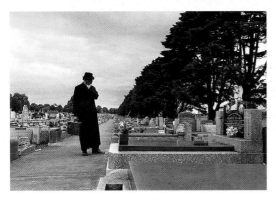

Sharounas Vaitkus

A 'storyboard' should first be made that shows the sequence of events that can later be photographed. The categories used in 'capturing a story' can be used effectively to create a story as well. This will ensure that all of the images required to communicate the story are made with efficient use of your resources.

Activity 4

Look at the work of a photographer who uses sequences of images to narrate a story.
Can the story be read without words?
Discuss the effectiveness of the communication.

Editing a story

The aim of editing is to select a series of images from the total production to narrate an effective story. Editing can be the most demanding aspect of the process requiring focus and energy. The process is a compromise between what the photographer originally wanted to communicate and what can actually be said with the images available.

Editorial objective

The task of editing is often not the sole responsibility of the photographer. The task is usually conducted by an editor or in collaboration with an editor. The editor considers the requirements of the viewer or potential audience whilst selecting images for publication.

The editor often has the advantage over the photographer in that they are less emotionally connected to the content of the images captured. The editor's detachment allows them to focus on the ability of the images to narrate the story, the effectiveness of the communication and the suitability of the content to the intended audience.

The process

Images are viewed initially as a collective. A typical process is listed as follows:

- All images are viewed as thumbnails in the image editing software.
- All of the visually interesting images and informative linking images are selected or ranked and the rest are hidden from view.
- Similar images are grouped together and the categories (establishing, action, portrait and detail) are formed.
- Images and groups of images are placed in sequence in a variety of ways to explore possible narratives.
- The strength of each sequence is discussed and the communication is established.
- Images are selected from each category that reinforce the chosen communication.
- Images that contradict the chosen communication are removed.
- Cropping and linking images are discussed and the final sequence established.

Activity 5

Create at least 20 images of a chosen activity or event, taking care to include images from all of the four categories discussed in this chapter.

Edit the work with someone who can take on the role of an editor.

Edit and sequence the images to the preference of the photographer and then again to the preference of the editor.

Discuss the editing process and the differences in outcome of both the photographer's and editor's final edit.

Ethics and law

Will the photograph of a car crash victim promote greater awareness of road safety, satisfy morbid curiosity or just exploit the family of the victim? If you do not feel comfortable photographing something, question why you are doing it. A simple ethical code of practice used by many photographers is: 'The greatest good for the greatest number of people.'

Paparazzi photographers hassle celebrities to satisfy public curiosity and for personal financial gain. Is the photographer or the public to blame for the invasion of privacy?

The first legal case for invasion of privacy was filed against a photographer in 1858. The law usually states that a photographer has the right to take a picture of any person whilst in a public place so long as the photograph:

- ~ is not used to advertise a product or service;
- ~ does not portray the person in a damaging light (called defamation of character).

If the photographer and subject are on private property the photographer must seek the permission of the owner. If the photograph is to be used for advertising purposes a model release should be signed.

Other legal implications usually involve the sensitivity of the information recorded (military, political, sexually explicit, etc.) and the legal ownership of copyright. The legal ownership of photographic material may lie with the person who commissioned the photographs, published the photographs or the photographer who created them. Legal ownership may be influenced by country or state law and legally binding contracts signed by the various parties when the photographs were created, sold or published.

Digital manipulation

Images are often distributed digitally which allows the photographer or agency to alter the images subtly in order to increase their commercial potential. Original image files may never be seen by an editor. A photographer, agency or often the publication itself may enhance the sharpness, increase the contrast, remove distracting backgrounds, remove information or combine several images to create a new image. What is legally and ethically acceptable is still being established in the courts of law. The limits for manipulation often rests with the personal ethics of the people involved.

Activity 6

Discuss the ethical considerations of the following:

- ~ Photographing a house fire where there is the potential for loss of life.
- ~ Photographing a celebrity, who is on private property, from public property.
- ~ Manipulating a news image to increase its commercial viability.

Assignments

Produce a six-image photo-story giving careful consideration to communication and narrative technique. For each of the five assignments it is strongly recommended that students:

- ⁓ Choose activities, events or social groups that are repeatedly accessible.
- ⁓ Avoid choosing events that happen only once or run for a short period of time.
- ⁓ Approach owners of private property in advance to gain relevant permission.
- ⁓ Have a back-up plan should permission be denied.
- ⁓ Introduce yourself to organizers, key members or central characters of the story.
- ⁓ Prepare a storyboard if you are creating a story.

Capture a story. Document one of the following categories:

1. Manual labor or a profession.
2. Minority, ethnic or fringe group in society.
3. An aspect of modern culture.
4. An aspect of care in the community.

Create a story to illustrate one of the following:

5. The dream.
6. The journey.
7. The encounter.
8. A poem, short story or the lyrics to a song.

Resources

Books

American Photographers of the Depression - Charles Hagen. Thames and Hudson. 1991.
Don McCullin. Jonathon Cape. 2003.
Photofile - Duane Michals. Thames and Hudson. London. 1990.
Farewell to Bosnia - Gilles Peress. Scalo. New York. 1994.
In This Proud Land - Stryker and Wood. New York Graphic Society. New York. 1973.
Minamata - W. Eugene and Aileen Smith. Chatto and Windus. London. 1975.
Sleeping with Ghosts - Don McCullin. Vintage. London. 1995.
Terra: Struggle of the Landless. Phaidon Press Inc. 1998.
The Concerned Photographer 2 - Cornell Capa. Viking Press. 1973.
The Photographs of Dorothea Lange. Hallmark Cards. 1996.
Workers - Sebastião Salgado. Phaidon Press. London. 1993.

Magazine

National Geographic magazine.

Websites

Black Star photo agency - http://www.blackstar.com
FSA - http://lcweb2.loc.gov/ammem/fsowhome.html
Magnum photo agency - http://www.magnumphotos.com

Anthony Secatore

Chapter 10

Still Life

Once the sole domain of the painter, who richly detailed the objects of his surroundings, from the classic fruit bowl to the trappings of the hunting shoot, still life emerged late in the 1800s into the world of the photographer. It is understandable that early photographic still life photographs mimicked the subjects, and artistic expressions, of the painted still life.

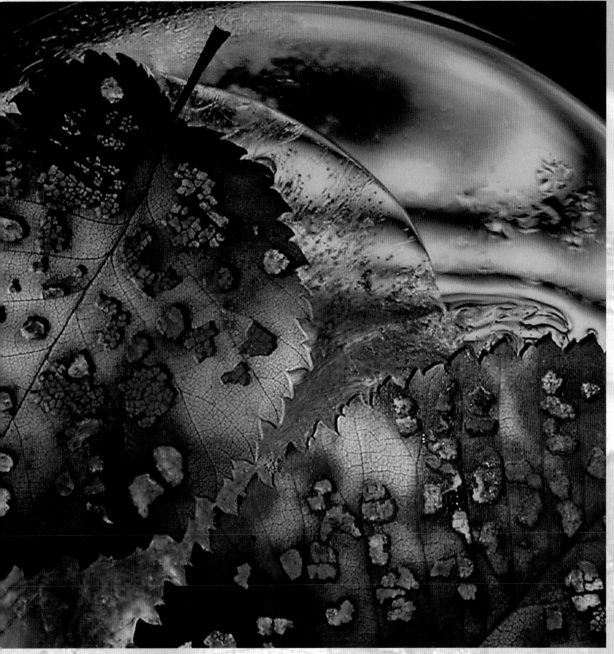

Rufina Breskin

Now the still life genre covers a diverse range of photographic images that have been created with differing intentions in order to communicate a broad range of messages. Whether the aims are artistic expression or commercial gain, all photographers who work within the genre are exploring the interaction of light with an arrangement of objects in an environment where the photographer has control of most, if not all, of the elements that contribute to the making of the still life image.

Aims

- Learn how to craft images using carefully selected or found objects in an environment where you can control the lighting.
- Develop an understanding of how differing photographic techniques can affect both the emphasis and the meaning of the subject matter.

Still Life 1837 - Louis Daguerre © Société Francaise de Photographie

The influence of painting

Even after the unique characteristics of the photographic image were recognized, traditional still life paintings continued to influence photographers. Leisure and comfort, wealth and position were all communicated in the still life of the painter. A closer look at early still life paintings may reveal some type of timepiece, a clock or fob-watch, a sundial or the setting sun. The appearance of a dead pheasant or other fowl was also commonplace, and is thought to be a reminder to the affluent purchaser of the painting that life is brief, and that their worldly goods could not be taken with them at death. Although emulating the work of painters the objects recorded by the camera in early still life photographs were often viewed at the time, not as art, but as objets trouvés (found objects) as if in a museum cabinet where no secondary meaning was intended (the photograph acting merely as a mirror with a memory). Although the long exposure times required to create a still life photograph have been consigned to history the still life genre lives on in both art and commercial practice. The photographic still life now represents many and varied subjects, and even moods. It has become a major tool in our economy of commercialism as we view, at every turn, images depicting products for sale, rent or hire.

Pursuit of the aesthetic

Whether it is for artistic or commercial reasons many photographers who work within the still life genre are fascinated with how light and shadow, volume and depth will affect the aesthetic of their still life subject, and work purely towards the goal of exploring these elements.

Shaun Guest

The tradition of examining inanimate objects is still with us, but has been expanded, in contemporary works, to include the inane, as well as the beautiful. We consider the broken window shutter, the rusted tin and the old shed door, as suitable subjects for still life, right alongside the fruit bowl, the rose-filled vase and the velvet high-backed chair. Regardless of the motivation for choosing the objects for a still life photograph the one thing that all good still life photographers share is their meticulous attention to detail. The sections that follow are designed to introduce the component skills that are a feature of this meticulous craft.

Activity 1

Look through assorted photographic books and observe how photographers have arranged and illuminated their subjects. Find one example of how a photographer has sought to emulate the early still life paintings and another where the photographer is working with a more modern aesthetic.

Point of view

Working in the genre of still life a photographer has ample time in which to explore the subject in great detail. The photographer is not limited to capturing a precise moment in history that will never occur again. This creates the opportunity to view the subject from all possible angles without the risk of 'losing the shot'.

Amanda DeSimone

Start with, but immediately be tempted to discard, the 'normal' viewpoint. Look for something different and unusual but still capable of communicating with the viewer. Try different focal lengths, climbing a ladder or lying on the floor. Forget how you would see the subject from a normal vertical position and try to visualize how the camera, which is not subject to any normal viewpoint, might be used to interpret the subject.

Background

Viewing the subject in relation to its background is essential to forming an understanding of compositional framing. By definition a background is something secondary to the main subject. It should be at the back of the image and of relatively less or little importance. This does not mean it should be ignored, but should be controlled.

Ferenc Varga

It is a common fault to position the camera too far away from the subject. This is compounded by the problem of filling in the empty space (background) created by this point of view. Too much information can lead to confusing photographs. Keep it simple is often the best rule. Move closer, reduce the background to a minimum. Move even closer until the subject fills the whole frame and becomes the dominant part of the composition. A truck full of props is no substitute for an interesting subject and a good concept.

Activity 2

Find two examples of still life photographs where the photographer has either kept the background simple or moved in closer to reduce the amount of background visible in the image.

Lighting

Without light there is no photography. The sun, the dominant light source in our world, is the starting point to understanding lighting. There are many approaches to lighting but an understanding of how to use a single light source to achieve many varied results is a discipline worth mastering. Every time you move a light or alter its quality you will learn something. The main difference between studio still life photography and other forms is the studio itself has no ambient or inherent light. This means, unlike photography undertaken in daylight, light cannot be observed and interpreted because it does not exist until the photographer introduces it.

Rebecca Umlauf

The photographer starts with no light at all and has to previsualize how to light the subject matter and what effect the light will have upon the subject. In order to best use a light source, we must first be aware of how light acts and reacts in nature. Observation of direct sunlight, diffuse sunlight through cloud and its many variations will develop this understanding. A spotlight or direct flash imitates the type of light we see from direct sunlight, a hard light with strong shadows and extreme contrast. A floodlight/soft box imitates the type of light we see on an overcast day, a soft diffuse light with minor variations in contrast and few shadows.

Composition

Composition is not a question of getting all the relevant information in the frame. Although information is necessary it is more important to attract and keep the viewer's attention. This calls for composition where the subject matter receives prominence without distraction from other elements within the frame.

Ricky Bond

Photographs used commercially are rarely random images and are therefore useful for understanding composition. They are images conceived in order to relate the intended communication. The commercial still life image should encourage the viewer to explore without complicating the communication and decreasing the importance of the subject matter. In other words it is essential the viewer understands what they are looking at. Avoid placing the main subject in the centre of the image unless there is a good reason to do so. Use the whole frame in which to compose your image.

Balance

In nature there is a natural balance or harmony of texture, shape, form and color that photographers often subconsciously try to recreate in their images. It is this control of balance by the photographer that determines the level of harmony or disharmony that the viewer perceives. We naturally gravitate towards a balanced image (symmetrical in visual weight if not in pattern). When there is symmetry or an equal distribution of visual weight within the frame the image is said to have a sense of balance.

Ricky Bond

A balanced image, although pleasing to the eye, can sometimes appear static (even boring). A photographer can change this balance to achieve a different result. An unbalanced image (asymmetrical) will often create visual tension, interest and a sense of things not being as they should be.

Dimension

A still life photograph is usually a two-dimensional representation of a three-dimensional subject. To imply a sense of depth within an image a photographer can artificially create dimension by placing objects in front of (foreground) and behind (background) the main subject. The foreground objects will appear larger than the subject and the background objects will appear smaller. This illusion of depth can be increased by careful use of focus, contrast, color, and composition. When these elements work successfully the viewer will create the third dimension in their mind.

Ricky Bond

Activity 3

Find two examples of still life photographs where the photographer has used objects placed at different distances to the lens in order to create a sense of depth.

Focus

'Focus' is the point at which an image is sharp or is the 'centre of interest'. When composing an image the lens is focused on the point of interest to the photographer. The viewer of an image is instinctively drawn to this point of focus. In this way the photographer 'guides' the viewer to the point of focus and thereby the point of interest. Everything at the same distance as the point of focus will be equally sharp. Subjects nearer or further away are progressively less sharp due to the choice of aperture made by the photographer (depth of field). When aperture is increased or decreased the depth of field changes. This changes the area of sharp focus to a greater or lesser extent. It is the conscious decision made by a photographer to use a combination of focus and aperture to create a selective field of focus that draws the observers' viewpoint to one area or selected areas of the image.

Shaun Guest

Depth of field

Photographing still life usually implies working with subjects that by their nature dominate the composition. Selective choice of aperture and its associated depth of field enables the photographer to control the point of focus even within the subject itself. If, for example, the subject is an apple but the only point of focus is the stalk then choice of aperture is very important. When using fixed lens or compact digicams it is often difficult to achieve very shallow depth of field in camera and often it has to be created in post-production image editing instead.

Perspective

Visual perspective is the relationship between objects within the frame and their place within the composition. It is this relationship that gives a sense of depth in a two-dimensional photograph. 'Diminishing perspective' is when objects reduce in size as the distance from the camera to that object increases. 'Converging perspective' is when lines that in real life are parallel appear to converge as they recede towards the horizon. A wide-angle lens appears to distort distance and scale, creating 'steep perspective'.

Little Shots - Madelene Reid

A subject close to the lens will look disproportionately large compared to its surroundings. Objects behind and to the side of the main subject will appear much further away from the camera. A long lens condenses distance and scale, creating 'compressed perspective'. A subject close to the lens will look similar in size to other subject matter. Objects behind and to the side of the main subject will appear closer together than reality.

Activity 4

Find two examples of still life photographs where the photographer has created a sense of perspective by using converging lines or similar objects of known size placed at different distances to the lens.

Practical assignment

Produce a set of four still life photographs investigating the play of light on natural or man-made forms. Your work should demonstrate how the arrangement of objects, the controlled use of light and a carefully chosen point of view can create interesting compositions of shape, line, pattern and texture. You should consider not only the shapes, textures and lines of your subject matter but also those formed between the subjects and the edge of the frame.

Choosing a theme

Your photographs should develop a clearly defined theme. This could be several different ways of looking at one subject or different subjects that share something in common, e.g. a similar mood, style or communication. Capture your still life images in an environment where you have absolute control over all aspects of the image-making process.

Possible titles for your set of prints could be:

1. Light and form.
2. Symbols and metaphors.
3. Trash or treasure.

Your work should:

a) make use of an interesting point of view;
b) show that you have considered the amount of visible background in your image;
c) explore the use of directional lighting;
d) consider the technique of placing the focal point off-centre;
e) consider the use of creating depth and depth of field.

Note > Implement aspects of your research during your practical assignment.

Resources

Studio Photography - John Child. Focal Press. Oxford. 2005.
Designing a Photograph - Bill Smith and Bryan Peterson. Watson-Gupthill Pubns. 2003.
Studio Lighting Solutions - Jack Neubart. Amphoto Books. 2005.
The Daybooks of Edward Weston - Edward Weston. Aperture. 1996.
Master Composition Guide for Digital Photographers - Ernst Wildi. Amherst Media. 2006.
Photography (8th Edition) - London and Upton. Prentice Hall. 2004.
Principles of Composition in Photography - Andreas Feininger. Watson-Gupthill Pubns. 1973.
The Photographer's Eye - John Szarkowski. Museum of Modern Art. 2007.

Chapter 11

Visual Literacy

A photograph, whether it appears in an advertisement, a newspaper or in a family album, is often regarded as an accurate and truthful record of real life. Sayings such as 'seeing is believing' and 'the camera never lies' reinforce these beliefs. In this study guide you will learn that the information we see in photographs is often carefully selected by the photographer or by the editor so that what we believe we're seeing is usually what somebody else would like us to see.

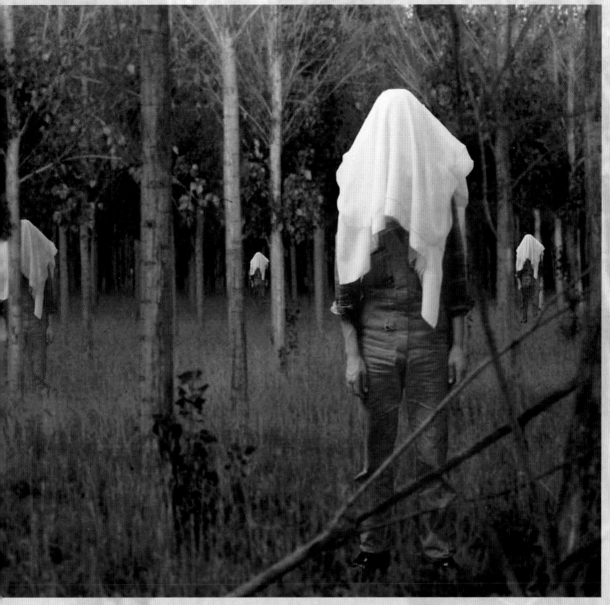

Zarah Ellis

By changing or selecting the information we can change the message. The concepts of time, motion and form that exist in the real world are accurately translated by the photographic medium into timeless and motionless two-dimensional prints.

Aims

- To develop an understanding of why and how photographic images are constructed.
- To develop an awareness of how the photographic image can be manipulated to communicate specific messages.

Photographers, editors and the general public frequently use photography to manipulate or interpret reality in the following ways:

1. Advertisers set up completely imaginary situations to fabricate a dream world to which they would like us to aspire.
2. News editors choose some aspects of an event, excluding others, to put across a point of view.
3. Family members often choose to record only certain events for display in the family album, excluding others, so that we portray the image of the family as a happy and united one.

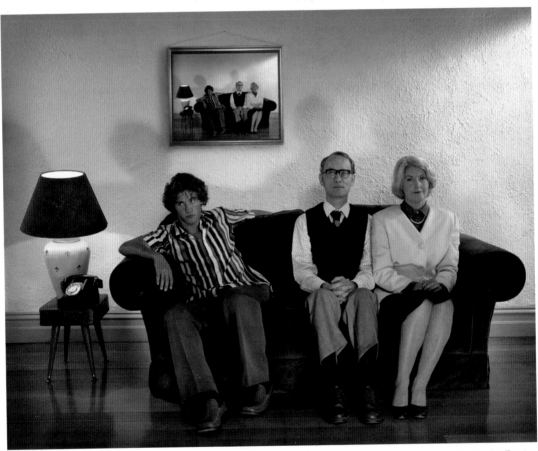

Samantha Everton

Photography is a powerful media tool capable of persuasion and propaganda. It appears to offer truth when in reality it can portray any manipulative or suggestive statement.

The camera may record accurately but it is people who choose what and how it records. A photograph need only be sufficiently plausible so that it appears to offer the truth.

Manipulation techniques

Framing and cropping - This technique is used to include or exclude details that may change the meaning of the photograph. The photographer, by moving the frame, or the editor, by cropping it, defines the content of what we see. By framing two facts it can create a relationship where none may otherwise exist. By excluding a fact it may break one, e.g. an old woman sitting on a park bench feeding the birds might appear lonely if we have moved the frame slightly to exclude her granddaughter playing nearby.

Editing - A photographer chooses a subject matter that he believes to be important and selects the decisive moment to take the picture. In order to present a personal point of view the editor may then decide to select only one aspect of the photographer's work.

Captions - A caption may give the picture a moral, social, political, emotional or historical meaning that emphasizes the intended message.

Focusing - The amount we see 'in-focus' can vary and draw our attention to a specific part of the photograph.

Vantage point or angle - The photograph may be taken from above, below or at eye level. Photographs taken from a low vantage point tend to increase the power and authority of the subject whilst those taken from above tend to reduce it.

Lighting - This can change the atmosphere or mood of the scene, e.g. soft and subtle, dramatic or eerie.

Image mode - Black and white or color. The contrast and colors may vary.

Subject distance - The closer we appear to be to the subject the more involved we become and the less we discover about the subject's environment or location.

Lens distortion - By using a telephoto lens detail and depth can be compressed, condensed and flattened. Subject matter appears to be closer together. By using a wide-angle lens distances are exaggerated and scale is distorted. Things that are close to the lens look larger in proportion to their surroundings than they really are. Things in the distance look much further away. An estate agent may use a wide-angle lens to make a room look bigger.

Composition - Lines, shapes and areas of tone or color are placed within the picture frame to attract or guide our attention, e.g. diagonal lines, whether real or implied, make the picture more dramatic and give us a sense of movement. Due to the strong color contrast, a person wearing a red jacket in a green field will instantly draw our attention.

Photomontage - An image may be assembled from different photographs. By adding or removing information the final meaning is altered (see '**Photomontage**').

Photographic categories

Art	- A display of skill and/or creative expression.
Documentary	- A factual record often with a social or political theme.
Commercial	- Social photography (weddings, portraits, etc.) and the promotion of products or services.

Activity 1 - Coverage

Collect one glossy magazine, one 'tabloid' newspaper and one 'broadsheet' newspaper.
What percentage of each publication is covered by photographs?
What percentage of these are advertising images?

Activity 2 - Analysis

1. Remove a selection of photographs complete with any text and captions from the media sources you have used in Activity 1. After studying each photograph prepare a table, as in the example below, using the same headings. In describing the subject matter you will need to consider:

- Who is the main figure in the photograph.
- How they look.
- Who else appears and how they react to the main figure.
- What else appears in the photograph, e.g. objects, location, setting.

Category	Subject matter	Photographic techniques	Implied message
Advert for beauty product.	Woman well-dressed in the grounds of a large country house. Handsome, well-dressed young man looking on.	Warm colors, softly lit low vantage point, focus on woman. Woman placed centrally in foreground.	Affluence, glamor, sexual admiration, happiness, contentment.

2. Twenty years ago John Berger wrote in *Ways of Seeing* that advertising showed us images of ourselves, made glamorous by the products it was trying to sell. He claims the images make us envious of ourselves as we might become, as a result of purchasing the product. Berger also believes that advertising makes us dissatisfied with our present position in society.
Look at the images you have collected. Which of the following are we likely to envy or admire in each image:

- Power
- Prestige and status
- Happiness
- Glamor
- Sexuality.

Do any of your advertisements appeal to different emotions other than admiration and envy? With advertising becoming increasingly sophisticated and less blatant, do John Berger's claims still ring true?

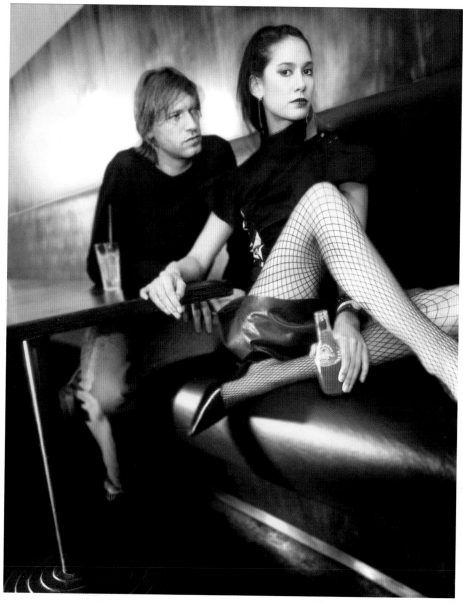

'San Pellegrino' - Andrew Butler

Glamor in advertising

A connection between the product and a glamorous individual or lifestyle is often established in advertising. In the example above an attractive woman is sitting at a table in a café with a male onlooker. Her style of clothing, expression and body language are indications of her sophistication and confidence.

Implied communication: The woman is sophisticated, sexy and self-assured. Sophisticated, sexy and self-assured women purchase this brand of water. Purchasing this water will make you this glamorous.

Ambiguity in advertising

Almost in response to John Berger's attempts to unravel the communication of advertising, the communication of some adverts became less obvious. The communication of a 'feel good factor' instead of the promotion of glamor became a popular style of advertising in the 1990s, the content of the advert often having little to do with the product.

The 'feel good' factor

The aim of this style of communication is for the consumer to connect a positive emotion with the product. The game is 'find the product' or 'solve the riddle'. The reward is achievement. For many years cigarette-advertising campaigns, such as those run by 'Benson & Hedges' and 'Silk Cut', disguised the product or failed to show the product at all. The campaigns invite the viewer to solve a visual puzzle. By solving the puzzle the viewer feels good. The viewer starts to associate the feeling with the product. It is important to understand that if ambiguity is present in media images, it is there usually by intention or design.

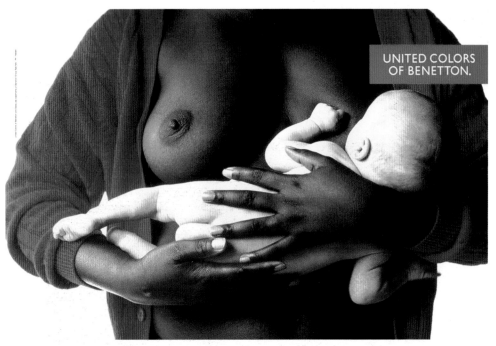

© 1989 Benetton Group S.p. A. Ph.: Oliviero Toscani

Media images are designed by their authors or editors to communicate specific messages to their targeted audience. Lifestyle magazines often remove visual reminders of the real world from their pages. Peter Kennard says 'The problems and contradictions of our society are contained by keeping the elements rigidly separate'. Public confusion and anger was created when viewers could not find the glamor or 'feel good factor' in Benetton's advertisements of the 1990s. Why were they not advertising the product? Benetton claim that they are using the vehicle of advertising for social comment. If we identify with the social concerns of the company, however, is the feel good factor still present?

Activity 3 - Captions

In this activity you will look at how captions reinforce the message implied in a photograph. Captions that accompany photographs can be:

- ~ Explicit - stating something very clearly as fact.
- ~ Implicit - suggesting that something is true.

For this activity you need to choose photographs and their captions from both the advertising and documentary categories. Rewrite the captions that accompany each to give a different point of view or bias. You may like to think of captions that change the moral, political, emotional or historical meaning of the photograph. The caption you choose may even change the category in which the photograph first appeared.

Present your work and discuss how you have changed the meaning of the photographs and how effective the new messages have become.

Activity 4 - Juxtaposition

Photomontage is a technique where separate photographs are combined to create new meanings. The interaction between the new elements creates a new meaning. Below we see the unintentional and incongruous juxtaposition of two posters in the street.

> 'An entirely new meaning is made in the distance that exists between the glamor and eroticism of western fashion and the economics of survival in the third world.'
>
> Peter Kennard - *Photomontage Today.*

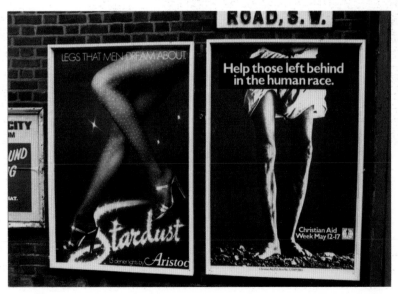

Mike Wells 1980

Using some of the photographs you have collected, cut out various elements from each and rearrange them to make new images with new messages. The sort of new images that work best are where strong contrasts are placed together, e.g. unemployment queues standing next to advertisements for luxury merchandise.

Activity 5 - Group practical

For this practical activity you should split up into groups of three or four. Your group will have a broader perspective if the members are not all male or female.
The things you will need for this activity are as follows:

- ~ Camera
- ~ Location
- ~ Assortment of props.

Using appropriate photographic techniques as discussed earlier, take photographs for each of the following categories:

- ~ Advertising
- ~ Documentary.

Repeat the exercise using one or more inappropriate techniques to create a satirical photograph for each of the categories. Allow six frames for each individual in the group.

Important

Discuss in detail each shot before you commit yourself to taking the picture. You might like to consider a possible caption for each shot before planning your photographs.
Prepare for any technical difficulties that you think you may encounter, e.g. working with a tripod if you are shooting indoors without a flash.
You have probably already noticed how many photographers fill the frame with their subject matter in order to make a bold statement. Avoid standing too far back in your own shots unless you have a specific reason to do so.

Activity 6 - Editing

This activity requires that you work in pairs to act as a newspaper editor and photojournalist.
Your objective is to produce a short news story that is either biased or unbiased.
Use titles, photographs and captions. Text is optional but you may consider pasting down some text to create a realistic mock-up of the finished article.
The editor may choose not to tell the photographer which stance he or she is going to take on the subject. The photographer may choose to manipulate the range of images supplied to the editor.
Your teacher will give you advice on the range of topics you may choose from, or you can make your own suggestions.

Activity 7 - The family album

1. In this activity you will be looking at the way the family is portrayed both in the media and in our own family albums.

Collect some media photographs that portray the family and analyse them using the criteria you used in Activity 2:

- ～ Category
- ～ Subject matter
- ～ Photographic techniques
- ～ Implied message.

Apply the same criteria to the photographs that appear in a typical family photograph album. Pay particular attention to the way the photographs have been edited. What aspects of family life were edited out or simply not recorded in the first place? Do you think the family album is a true representation of family life? How useful or damaging would it be to alter the type of events that are considered worthy of being placed in the family album?

2. Write a short essay evaluating your findings. Discuss how you think media images have affected you, your family and the general public. Try to be as honest as you can.

Resources

The following resources are suggestions only. You or your teacher may add to this list.

Images from the press

Magazines and newspapers (both 'tabloid' and 'broadsheet').

Recommended reading

On Photography - Susan Sontag. Picador. 2001.
Ways of Seeing - John Berger. Viking Press. 1995.

Images with accompanying text

About 70 Photographs - Chris Steele-Perkins. Arts Council of Great Britain. 1980.
Langford's Basic Photography - M. Langford, A. Fox and R. S. Smith. Focal Press. Oxford. 2007.
Images for the End of the Century - P. Kennard. Journeyman Press. London. 1990.
In Our Own Image - Fred Ritchin. Aperture. 1999.
Looking at Photographs - John Szarkowski. Bulfinch Press. 1999.
The Media - Brian Dutton. Pearson Schools. 1997.
The Photograph - Graham Clarke. Oxford University Press. 1997.

Video

Photomontage Today - Peter Kennard (35 minute video). Arts Council of Great Britain.
http://www.roland-collection.com/rolandcollection/Section/36/667.htm

Personal photographs

Family photograph albums.

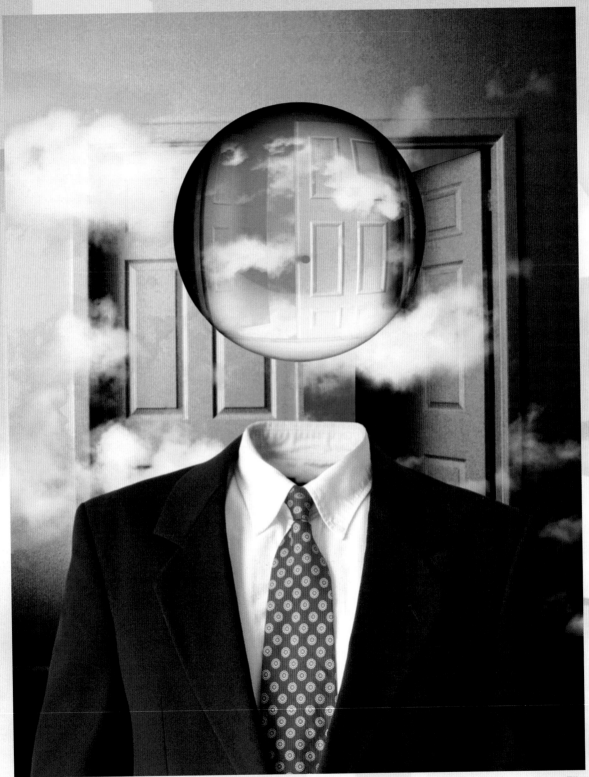

Tamas Elliot

Technical Guides

Chapter 12

Image Capture

Although the primary importance of a photographic image is in its ability to communicate the photographer's concept, it is essential that the photographer has some degree of control over the initial capture stage and is using a camera that can deliver a reasonable amount of quality. Image quality has more to do with a basic understanding of light and exposure than it has to do with the size of the zoom lens and the number of megapixels the camera is sporting.

Mark Galer

This chapter is designed to give you a basic level of understanding about the types of digital cameras available, their strengths and weaknesses, and some of the features that are desirable or necessary to complete the job in hand. It also outlines the basics for acquiring images that are well exposed in order to create high-quality images for monitor viewing, printing or further manipulation or editing in a software program such as Photoshop.

Mastering the machinery

At first glance some digital cameras can appear to be complex and confusing pieces of equipment. Just as with any other piece of sophisticated machinery the user can, over a period of time, become very familiar with its operations and functions until they are almost second nature. Operating the digital camera, just like driving a car, is a skill which is attainable by most people. How long it will take to acquire this skill will very much depend on the individual and how much time they are prepared to spend operating the camera. Different makes and models of digital cameras may appear very different but they all share the same basic features. The features may be placed in different locations on the camera body or operated automatically. If you have any difficulty in finding a particular feature on your own camera ask the salesperson at your local camera store, a photographic teacher or consult your camera manual.

Digital SLR cameras are now relatively inexpensive compared to just a few years ago but may still have a higher price point than a fixed lens or digital compact camera. If you choose to purchase a digital compact camera instead of a digital SLR you must ensure that the model you choose has adequate control over both the shutter speed and lens aperture in order for the camera to be a creative tool. The SLR is the most popular camera used by keen amateurs and professionals. The term SLR (single lens reflex) describes the way we view the image with this type of camera. The SLR camera allows for the lens to be changed and uses a larger sensor that increases image quality over the small size of sensors used in digital compact cameras (even though the number of megapixels may be the same, the size of the DSLR sensor will be larger than the equivalent fixed lens camera). The lens of the SLR camera is used both to view the subject and take the picture. This is achieved by the use of a mirror behind the lens which reflects the image up into the viewfinder via the 'pentaprism'. If we change the lens, use a colored filter or change the focus we can see all of these changes through the viewfinder. Most fixed lens digital cameras also use a single lens for viewing and taking the image but the image used to compose the picture is usually viewed via an LCD screen or an electronic rather than an optical viewfinder.

Automatic or manual

If you are used to operating your camera using the Auto setting spend some time finding out how the camera can be switched to manual operation or how you can override the automatic function. Automatic cameras are programmed to make decisions which are not necessarily correct in every situation. A good photographer must be able to use the manual controls of the camera.

Care of the camera

1. Avoid dropping your camera - use a strap to secure it around your neck or wrist.
2. Avoid getting your camera wet - cover the camera when it starts to rain.
3. Only clean your camera lens with a soft brush or a lens cleaning cloth.
4. Never touch the mirror, shutter or digital chip inside an SLR camera body.
 These items are extremely delicate.

Note > Damage to your camera can usually only be repaired by a camera specialist and will usually incur a minimum fee which can be greater than the value of your camera.

Digital cameras

Digital cameras use a light-sensitive image sensor instead of film. The advantage of the image sensor is that it is reusable. It is able to 'download' (transfer) its information to a disk or 'card' after every captured image. The image is able to be viewed as soon as it is captured (without the need for chemical processing). Although the initial purchase of the digital camera may be a little more expensive than a film camera the money saved on film and processing makes the digital camera a more cost-effective choice for photographers. In making a decision to purchase a digital camera the following points should be considered:

- ~ Creative control
- ~ Quality
- ~ Cost and convenience.

Creative control
Establish whether the digital camera offers the individual control over the lens aperture and the shutter speed (the creative controls for depth of field and movement blur).

Quality of image
With digital cameras offering over 4 megapixels the limiting factor to final quality is usually the lens, the image processor or the quality of the ouput device or printer, and not the resolution of the image sensor. Four megapixels is usually sufficient to create a high quality full-page inkjet print.

Cost and convenience
A digital SLR costs more than a compact digital or fixed lens digital camera but usually has superior quality due to the larger sensors used in these cameras (physical size rather than megapixels). The digital SLR user may have to purchase an additional lens to cover the larger optical zoom range capable by some fixed lens super-zoom fixed lens digital cameras. The user of the fixed lens digital camera does not have to worry about dust and dirt entering the camera when the lens is removed.

Comparing features

Fixed lens digital cameras are sometimes referred to as 'Digicams', 'Prosumer cameras', 'Bridge cameras' or 'EVFs' (an acronym for 'Electronic ViewFinders'). There is no traditional name because this is an entirely new breed of camera where typical examples in the genre are neither compact nor feature the mirror and pentaprism mechanisms to enable them to be called an SLR. The quality and list of professional features that these cameras boast has been growing over the last few years and the spec sheets have raised more than a few eyebrows amongst professional photographers. Although the size of these cameras has been growing (largely in response to the huge optical zooms that are integral to most of the models on offer) their price point has pretty much remained the same.

Let's play spot the DSLR - The Fuji s9500 and Olympus E-500

Many sophisticated fixed lens cameras have sensors that are capable of capturing more than 8 megapixels and have a 10x (or greater) optical zoom range. With the arrival of these impressive lenses the need to change a lens (which is obviously not possible if the lens is fixed) has been rendered a non-issue. In fact the inability to change the lens can be viewed as a positive point when you consider the 'dust on the sensor' issue* that is problematic for some DSLR users. The one thing you cannot describe these prosumer-level digicams as is 'compact'. Many of these super-zoom digicams are either about the same physical size and weight as some of the lighter DSLRs (Sony Alpha 100, Olympus E-500, Pentax ist and Canon EOS 400D - to name but a few).

*** Some DSLR cameras have addressed the problem of dust by using sensors that utilize an anti-static coating and/or a sensor that vibrates to shake the dust off when the camera is switched on or off.**

Image stabilization

Many fixed lens cameras now offer some form of 'image stabilization' or 'anti-shake' technology. This allows hand-held shots in low light or at the limit of telephoto extension. Image stabilization is not unique to fixed lens digicams - professional DSLRs also feature this technology and while Sony build an anti-shake system called 'Steady Shot' into the DSLR camera body, Canon's IS system (image stabilization) and Nikon's VR system (vibration reduction) are designed into their pro-grade lenses. If you intend to use a camera for classic telephoto purposes such as wildlife or sports, this may be important to you. It is also useful for hand-held portrait shots in available light. However, it is worth remembering that image stabilization may only remove the shake in your own hands and if the subject is not absolutely motionless then motion blur may still occur. It's also worth bearing in mind that the image stabilization system itself may introduce unwanted artifacts to an image.

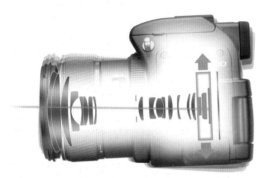

Viewfinders and LCDs

Single lens reflex (SLR) cameras use a mirror and pentaprism design to display an optical view of your subject in the viewfinder prior to capture. The view is typically bright (especially if you have a wide aperture lens fitted) and detailed so that you can focus the image easily and quickly if you have to switch to manual rather than auto focus. The image is not a 'what-you-see-is-what-you-get' image as feedback on issues such as how the sensor will handle the subject contrast together with the effects of your choice of exposure and depth of field are not being previewed. A depth of field preview button is available on some DSLR cameras that allows you to preview the image with the aperture stopped down to the one that will be used to capture the image rather than the widest aperture which is normally used to provide the optical view. Although useful in some instances the subject can appear very dark in the viewfinder, making precise depth of field difficult to determine. This information is now more easily viewed on the LCD screen and not in the viewfinder after the image has been captured. The prosumer digicam, on the one hand, has no mirror, pentaprism and usually no optical viewfinder. The LCD view on the fixed lens digicam, on the other hand, is a 'live view' - a miniature version of what you will actually capture. Its advantage is that it includes information about depth of field, exposure and contrast. This 'what-you-see-is-what-your-get' view is usually only available on a DSLR camera after the image has been captured.* The disadvantage of an LCD view is that it can be hard to see in some lighting conditions on location and can make manual focusing difficult or impossible.

***Olympus and Panasonic make digital SLR cameras with a second sensor to provide this live view.**

Exposure

An understanding of exposure is without doubt the most critical part of the photographic process. Automatic exposure systems found in many sophisticated camera systems calculate and set the exposure for the photographer. This may lead some individuals to think there is only one correct exposure, when in reality there may be several. The exposure indicated by an automatic system, no matter how sophisticated, is an average. Creative photographers use the meter's indicated exposure (MIE) reading for guidance only. Other photographers may interpret the same reading in different ways to create different images. It is essential the photographer understands how the illuminated subject is translated by exposure into a photographic image.

Exposure is the action of subjecting a light-sensitive medium to light. Lenses and cameras control how much light (aperture) and how long the light (time) is allowed to reach the image sensor. The intensity of light is determined by the size of the aperture in the lens and the duration of light is determined by the shutter.

Exposure is controlled by aperture and time - amount and duration.

Too much light will result in overexposure. Too little light will result in underexposure. It makes no difference whether there is very bright or a very dim level of light, the image sensor still requires the same amount of light for an appropriate exposure at any given ISO setting.

Overexposure *Correct exposure* *Underexposure*

Exposure must be adjusted to compensate for these changes in the brightness of the available light. This is achieved by adjusting either the amount (**aperture**) or duration of light (**time**) or by adjusting the ISO on the camera. Increasing the size of the aperture gives more exposure, decreasing gives less. Decreasing the duration of the shutter speed reduces exposure, increasing gives more. Changing the ISO on the camera adjusts the sensitivity of the image sensor to the available light. Using a higher ISO setting in the camera means the camera will need less light to make an exposure but also has the effect of lowering the quality of the image by introducing 'noise' (noise in an image can be likened to film grain or interference on a TV). This noise leads to a loss of smooth tone in a digital image that becomes more noticeable the larger the image is printed or magnified on screen.

The aperture

The amount of light hitting the sensor is controlled by the aperture in the lens. The aperture is a mechanical copy of the iris in the human eye. The human iris opens up in dim light and closes down in bright light to control the amount of light reaching the retina. The aperture of the camera lens can also be opened and closed in different brightness levels to control the amount of light reaching the image sensor. The right amount of light is required for correct exposure. Too much light and the image will be overexposed, not enough light and it will be underexposed.

As the aperture is opened or closed it is given a numerical value called an f-stop. When the value of the f-stop **decreases** by one stop exactly **twice** as much light reaches the image sensor as the previous number. When the value of the f-stop **increases** by one stop **half** as much light reaches the image sensor as the previous number. The only confusing part is that the biggest aperture is the f-stop with the smallest value and the smallest aperture is the f-stop with the largest number. The larger the f-stop the smaller the aperture. From a small aperture of f/22 to a wide aperture of f/2.8 the stops are as follows (not all lenses have the range of stops indicated below):

f/22 f/16 f/11 f/8 f/5.6 f/4 f/2.8

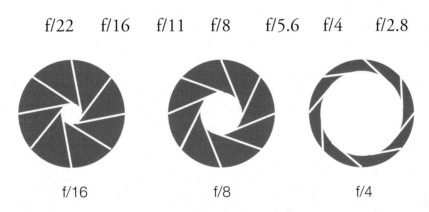

f/16 f/8 f/4

Note > When using the aperture you may find the aperture is opened or closed in 1/3 stop increments instead of one stop increments, e.g. the difference between f/5.6 and f/8 is one stop. The camera's LCD read-out may, however, indicate values of 6.4 and 7.1 as the aperture is stopped down from f/5.6 to f/8.

The shutter

The length of time the shutter is open also controls the amount of light that reaches the image sensor, each shutter speed doubling or halving the amount of light. Exposure, therefore, is a combination of aperture and shutter speed.

To slow the shutter speed down is to leave the shutter open for a greater length of time. Shutter speeds slower than 1/60 second can cause movement blur or camera shake unless you hold the camera steady with a tripod or by some other means.

To use a shutter speed faster than 1/250 second usually requires a wide aperture or a high ISO setting in order to compensate for the small amount of light that can pass through a shutter that is open for such a short amount of time. It is suggested that you use shutter speeds faster than 1/60 second until you are sure you can hold the camera steady using slower speeds.

Choosing an exposure mode

The disadvantage of a fully automatic or program mode is it can often take away the creative input the photographer can make to their images. A camera set to fully automatic is programmed to make decisions not necessarily correct for every situation. If your camera is selecting both the aperture and shutter speed you will need to spend some time finding out how the camera can be switched to semi-automatic or manual operation.

Semi-automatic exposure control, whether aperture priority (Av) or shutter priority (Tv), allows creative input from the photographer (**depth of field** and **movement blur**) but still ensures the meter-indicated exposure or 'MIE' is obtained automatically.

Aperture priority (aperture variable or Av)

This is a semi-automatic function where the photographer chooses the aperture and the camera selects the shutter speed to achieve 'MIE'. This is the most common semi-automatic function used by professional photographers as the depth of field is usually a primary consideration. The photographer using aperture priority needs to be aware of slow shutter speeds being selected by the automatic function of the camera when selecting small apertures in low-light conditions. To avoid camera shake and unintended blur the aperture has to be opened and the depth of field sacrificed.

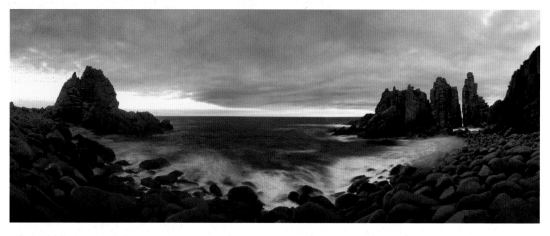

Orien Harvey

Shutter priority (time variable or Tv)

This is a semi-automatic function where the photographer chooses the shutter speed and the camera selects the aperture to achieve correct exposure. In choosing a fast shutter speed the photographer needs to be aware of underexposure as light levels decrease. The fastest shutter speed possible is often limited by the maximum aperture of the lens. In choosing a slow shutter speed the photographer needs to be aware of overexposure when photographing brightly illuminated subject matter. Movement blur may not be possible when using an image sensor set to a high ISO in bright conditions.

Accurate metering

When taking a light meter reading try to avoid pointing the centre of the viewfinder towards a bright light or tone when setting the exposure. Reposition the centre of the viewfinder on the average tones of your subject instead. Set the exposure and then reframe the image.

Dominant tones

If dark tones dominate the framed image the MIE will result in the dark tones being recorded as midtones. Midtones will be recorded as light tones and any light tones may be overexposed. If light tones dominate the framed image the meter indicated exposure will result in the light tones being recorded as midtones. Midtones will be recorded as dark tones and dark tones may be underexposed. If the midtones present in amongst these dominant dark or light tones are to be recorded accurately the exposure must be either reduced (for dominant dark tones) or increased (for dominant light tones) from the MIE.

Black swan (dominant dark tones) MIE

Decreased exposure

White wall (dominant light tones) MIE

Increased exposure

The amount the exposure needs to be reduced or increased is dictated by the level of dominance of these dark or light tones. If it is not possible to point the camera towards tones of an average value to find the correct exposure you must either switch to manual exposure mode or use the exposure compensation function on the camera if available (see 'Exposure compensation').

Reading exposure levels

When taking a picture with a digital camera it is sometimes possible to check the exposure during the capture stage to ensure that the full tonal range of the image has been recorded. The most accurate indication of the exposure does not come from the image on the LCD screen but the histogram (all DSLR cameras and the better fixed lens compact cameras are able to display these histograms). Some fixed lens cameras can even display the histogram before the image has been captured. This 'live preview' is also available on a few DSLR cameras that have a second sensor designed to feed this live view to the LCD screen prior to capture.

The levels of brightness in the histogram are displayed as a simple graph. The horizontal axis displays the brightness values from left (darkest) to right (lightest). The vertical axis of the graph shows how much of the image is found at any particular brightness level. If the subject contrast is too high or the exposure is either too high or too low then tonality will be 'clipped' (shadow or highlight detail will be lost). Most digital camera sensors can only record a limited range of information when compared to the range of tones human vision is capable of seeing detail in. The tones that are out of the range of the image sensor of the digital camera record as black or white with no detail. We should attempt to adjust the exposure or reduce the contrast of the subject matter to ensure maximum information is recorded.

Note > When using the JPEG file format you should attempt to modify the brightness, contrast and color balance at the capture stage to obtain the best possible histogram before editing begins in the software.

Correcting exposure

The photographer can either increase or decrease exposure to ensure a full range of tones is recorded during the capture stage. Photoshop will not be able to replace information in the shadows or highlights that is missing due to inappropriate exposure or excessive subject contrast. The information should extend all the way from the left to the right side of the histogram if the subject contrast and the exposure are appropriate.

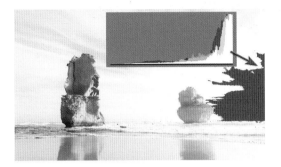 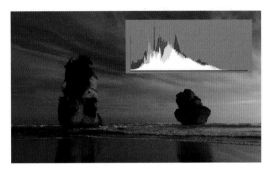

Overexposure and underexposure

If the exposure is too high a tall peak will be seen to rise on the right side of the histogram (level 255). If the digital file is underexposed the peaks are crowded on the left-hand side of the histogram and there is little or no peaks on the right-hand side of the histogram. Some cameras can be programed to blink in the areas that are overexposed.

Solution: Adjust the exposure in the camera using either the exposure compensation controls or the manual controls. If exposure is too low due to bright backlights in the image you can try moving the camera to exclude the bright light source, locking the exposure by half-pressing the shutter release and then reframe.

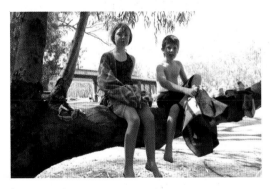 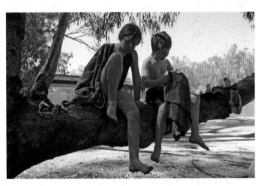

Lowering contrast

If the contrast is too high tall peaks may be evident at either end of the histogram.

Solution: Decrease the subject contrast by either repositioning the subject matter or by lowering the contrast of the lighting. The light source can be diffused or additional lighting can be provided in the form of fill-flash or reflectors. In the image above the camera's tiny built-in flash unit has been used to increase the exposure in the shadows. This allows the overall exposure to be lowered, which in turn prevents the sky behind the children from becoming overexposed.

Exposure compensation

An exposure compensation setting is needed when the subject is backlit and the camera is in auto or program mode. Using an automated metering mode the photographer cannot simply adjust the exposure, from that indicated by the meter, using the aperture or shutter speed. The automatic mode will simply re-compensate for the adjustment in an attempt to record an average tone for the entire frame.

The metering system is being overly influenced by the light source and will indicate a reduced exposure is required to achieve the average. As the light source occupies more and more of the central portion of the viewfinder so the indicated exposure is further reduced. The required exposure for the subject may be many times greater than the indicated exposure.

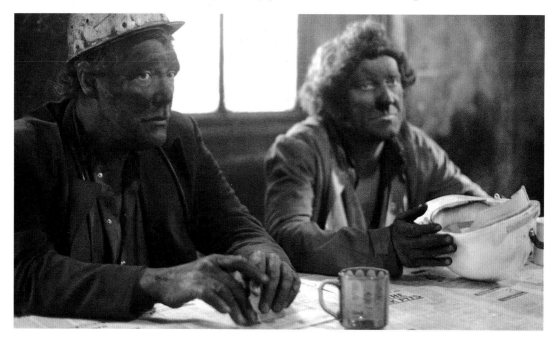

Mark Galer

If the camera is in manual mode or equipped with an exposure lock, the photographer can meter for the specific tonal range required and then re-frame the shot. An alternative used by many professionals is to adjust the exposure using an exposure compensation facility that is available on DSLR cameras and higher quality fixed lens digital cameras. Using this technique the photographer can avoid the need to re-frame their subject in order to achieve an appropriate exposure.

Remember:

Increasing exposure will reveal more detail in the shadows and dark tones.
Decreasing exposure will reveal more detail in the highlights and bright tones.

To some extent the tonality can be adjusted in the image editing software to create a satisfactory outcome. The image-editing software cannot, however, replace information that is missing due to overexposure or underexposure.

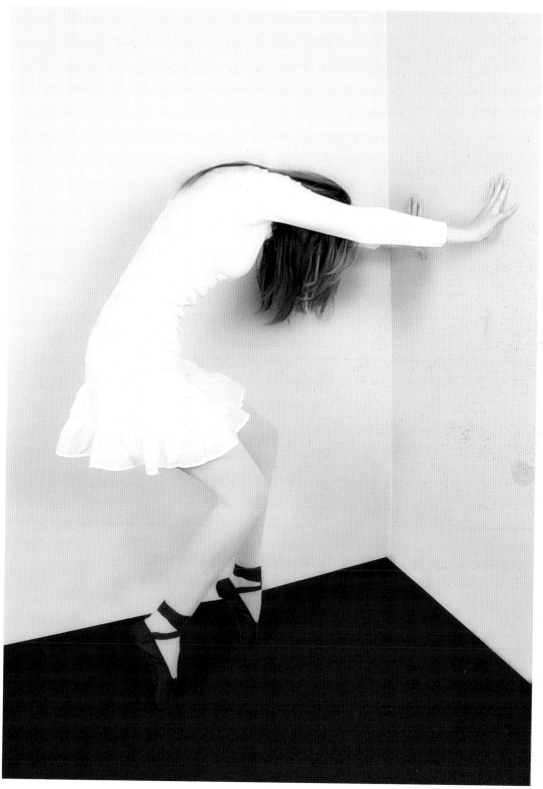

Red Shoes - Madi Wright

Chapter 13

Image Editing

Every digital image that has been captured can be enhanced further so that it may be viewed in its optimum state for the intended output device. Whether images are destined to be viewed in print or via a monitor screen, the image usually needs to be resized, cropped, retouched, color-corrected, sharpened and saved in an appropriate file format. The original capture will usually possess pixel dimensions that do not exactly match the requirements of the output device. In order for this to be corrected the user must address the issues of 'Image Size', 'Resampling' and 'Cropping'.

This chapter focuses its attentions on the standard adjustments made to all images when optimum quality is required. Standard image adjustments usually include the process of optimizing the color, tonality and sharpness of the image. With the exception of dust removal these adjustments are applied globally (to all the pixels). Most of the adjustments in this chapter are 'objective' rather than 'subjective' adjustments and are tackled as a logical progression of tasks.

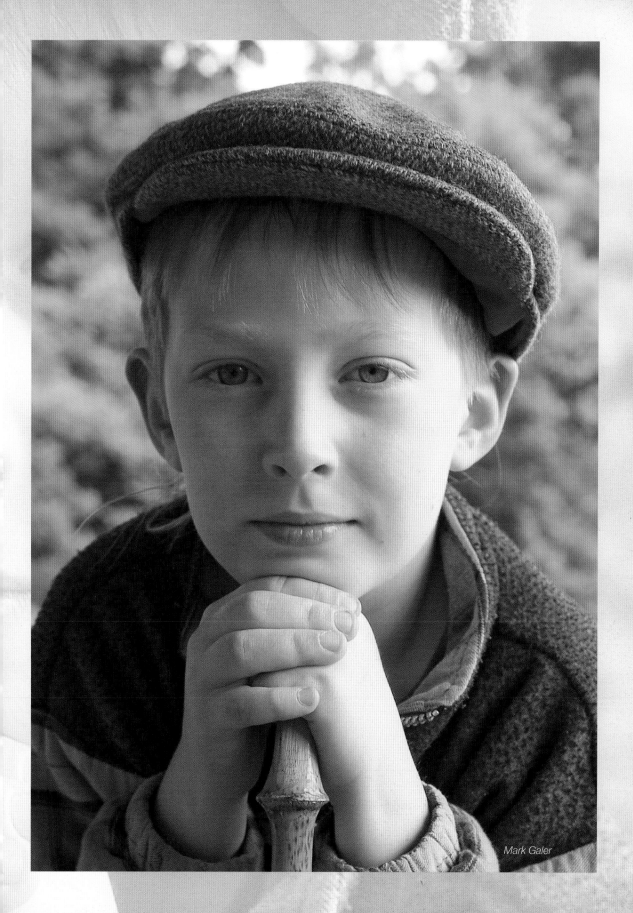

Mark Galer

Aim

~ Test the effectiveness of a post-production editing workflow by creating high-quality images optimized for either print or web viewing.

Image capture - Step 1

Select or create an image that does not have excessive contrast. The image selected should have detail in both the highlights and shadows and should have a range of colors and tones. An image with high contrast and missing detail in the highlights or shadows is not suitable for testing the effectiveness of the capture or output device.

Digital capture via a digital camera

Images can be transferred directly to the computer from a digital camera or from a card reader if the card has been removed from the camera. Images are usually saved on the camera's storage media as JPEG, RAW or TIFF files. If using the JPEG file format to capture images you should choose the high or maximum quality setting whenever possible. If using the TIFF or JPEG file formats, it is important to select low levels of image sharpening, saturation and contrast in the camera's settings to ensure optimum quality and editing flexibility in the image-editing software. If the camera has the option to choose Adobe RGB instead of sRGB as the color space this should also be selected.

Digital capture via a scanning device

Ensure the media to be scanned is free from dust and grease marks. Gloss photographic paper offers the best surface for flatbed scanning. The scanning device can usually be accessed directly from the Adobe software via the 'Import' command. Ensure that you scan the image at an appropriate resolution for your image-editing needs (see 'Foundations > Calculating file size and scanning resolution').

Cropping - Step 2

When sizing an image for the intended output it is important to select the width and height in pixels for screen or web viewing and in centimetres or inches for printing. Typing in 'px', 'in' or 'cm' after each measurement will tell Photoshop Elements or Photoshop to crop using these units. If no measurement is entered in the field then Adobe will choose the default unit measurement entered in the Preferences ('Preferences > Units & Rulers'). The preference can be quickly changed by Control-clicking on either ruler (select 'View > Rulers' if they are not currently selected).

Select the 'Front Image' option to select the current measurements of a selected image. This option is useful when you are matching the size of a new image to an existing one that has already been prepared. Select the 'Clear' option to quickly delete all of the existing units that may already be entered in the fields from a previous crop. The action of entering measurements and resolution at the time of cropping ensures that the image is sized and cropped or 'shaped' as one action. Entering the size at the time of cropping ensures the format of the final image will match the printing paper, photo frame or screen where the image will finally be output.

Note > If both a width and a height measurement are entered into the fields the proportions of the final crop will be locked and may prevent you from selecting parts of the image if the capture and output formats are different, e.g. if you have entered the same measurement in both the width and height fields the final crop proportions are constrained to a square.

Perfecting the crop

If the image is crooked you can rotate the cropping marquee by moving the mouse cursor to a position just outside a corner handle of the cropping marquee. A curved arrow should appear, allowing you to drag the image straight.

 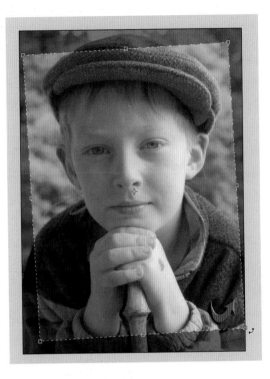

Click and drag the corner handle to extend the image window to check if there are any remaining border pixels that are not part of the image. Press the 'Return/Enter' key on the keyboard to complete the cropping action. Alternatively press the 'Esc' key on the keyboard to cancel the crop.

The marquee tool is programmed to snap to the edges of the document as if they were magnetized. This can make it difficult to remove a narrow border of unwanted pixels. To overcome this problem you will need to go to the 'View' menu and switch off the 'Snap To' option.

Tonal adjustments - Step 3

The starting point to adjust the tonal qualities of EVERY image is the 'Levels' dialog box (go to 'Enhance > Adjust Lighting > Levels' in Adobe Photoshop Elements and 'Image > Adjustments > Levels' in the full version of Photoshop). Do NOT use the 'Brightness/Contrast' adjustment feature in Photoshop Elements or versions of Photoshop prior to CS3 as this can be destructive to the quality of your image. The horizontal axis of the histogram in the Levels dialog box displays the brightness values from left (darkest) to right (lightest). The vertical axis of the histogram shows how much of the image is found at any particular brightness level. If the subject contrast or 'brightness range' exceeds the latitude of the capture device or the exposure is either too high or too low, then tonality will be 'clipped' (shadow or highlight detail will be lost).

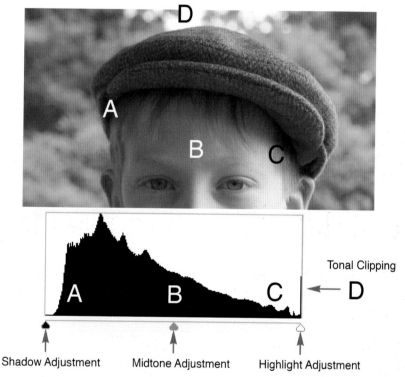

Histograms

During the capture stage it is often possible to check how the capture device is handling or interpreting the tonality and color of the subject. This useful information can often be displayed as a 'histogram' on the LCD screen of high quality digital cameras or in the scanning software during the scanning process. The histogram displayed shows the brightness range of the subject in relation to the latitude or 'dynamic range' of your capture device's image sensor. Most digital camera sensors have a dynamic range similar to color transparency film (around five stops) when capturing in JPEG or TIFF. This may be expanded beyond seven stops when the RAW data is processed manually.

Note > You should attempt to modify the brightness, contrast and color balance at the capture stage to obtain the best possible histogram before editing begins in the software.

Optimizing tonality

In a good histogram, one where a broad tonal range with full detail in the shadows and highlights is present, the information will extend all the way from the left to the right side of the histogram. The histogram below indicates missing information in the highlights (on the right) and a small amount of 'clipping' or loss of information in the shadows (on the left).

Histograms indicating image is either too light or too dark

Brightness

If the digital file is too light a tall peak will be seen to rise on the right side (level 255) of the histogram. If the digital file is too dark a tall peak will be seen to rise on the left side (level 0) of the histogram.

Solution: Decrease or increase the exposure/brightness in the capture device.

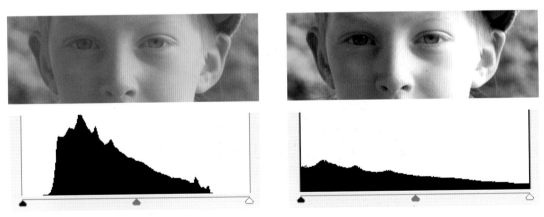

Histograms indicating image either has too much contrast or not enough

Contrast

If the contrast is too low the histogram will not extend to meet the sliders at either end.
If the contrast is too high a tall peak will be evident at both extremes of the histogram.

Solution: Increase or decrease the contrast of the light source used to light the subject or the contrast setting of the capture device. Using diffused lighting rather than direct sunlight or using fill-flash and/or reflectors will ensure that you start with an image with full detail.

Optimizing a histogram after capture

The final histogram should show that pixels have been allocated to most, if not all, of the 256 levels. If the histogram indicates large gaps between the ends of the histogram and the sliders (indicating either a low-contrast scan or low-contrast subject photographed in flat lighting) the subject or original image should usually be recaptured a second time.

Small gaps at either end of the histogram can, however, be corrected by dragging the sliders to the start of the tonal information. Holding down the Alt/Option key when dragging these sliders will indicate what, if any, information is being clipped. Note how the sliders have been moved beyond the short thin horizontal line at either end of the histogram. These low levels of pixel data are often not representative of the broader areas of shadows and highlights within the image and can usually be clipped (moved to 0 or 255).

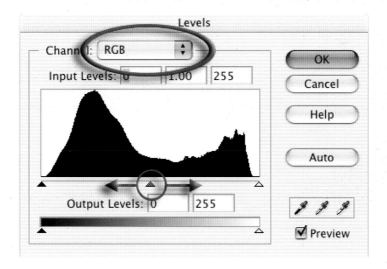

Moving the 'Gamma' slider can modify the brightness of the midtones. After correcting the tonal range using the sliders, click 'OK' in the top right-hand corner of the Levels dialog box.

Note > Use the Levels adjustment feature for all initial brightness and contrast adjustments rather than Brightness/Contrast adjustment feature.

Shadows and highlights

When the tonality has been optimized using the Levels dialog box the shadow and highlight values may require further work. One of the limitations of the Levels adjustment feature is that it cannot focus its attention on only the shadows or the highlights, e.g. when the slider is moved to the left both the highlights and the shadows are made brighter.

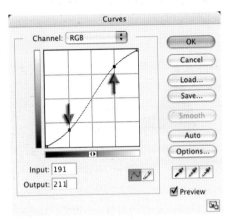 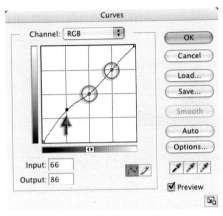

For Photoshop users this can be achieved using the Curves adjustment feature. Curves allows the user to target tones within the image and move them independently of other tones within the image, e.g. the user can decide to make only the darker tones lighter whilst preserving the value of both the midtones and the highlights. It is also possible with a powerful editing feature such as Curves to move the shadows in one direction and the highlights in another. In this way the contrast of the image could be increased without losing valuable detail in either the shadows or the highlights.

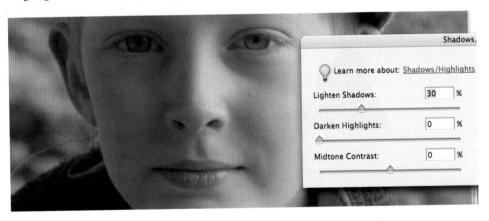

An adjustment feature that is common to both Photoshop Elements and Photoshop is the Shadows/Highlights adjustment feature. This targets and adjusts tonality in a non-destructive way and in many ways offers superior control than the Curves adjustment feature (Midtone Contrast) in a user-friendly interface. See 'Image Enhancements > Shadows and Highlights' for more information.

Color adjustments - Step 4

Neutral tones in the image should appear desaturated on the monitor. If a color cast is present try to remove it at the time of capture or scanning if at all possible.

Solution: Control color casts by using either the white balance on the camera (digital), shoot using the RAW file format or by using an 80A or 80B color conversion filter when using tungsten light with daylight film. Use the available color controls on the scanning device to correct the color cast and/or saturation.

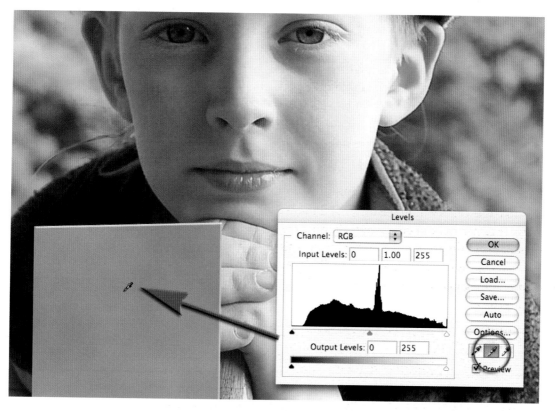

Color correction using Levels

If you select a Red, Green or Blue channel (from the channel's pull-down menu) prior to moving the Gamma slider you can remove a color cast present in the image. For those unfamiliar with color correction the adjustment feature 'Variations' in Photoshop or 'Color Variations' in Photoshop Elements gives a quick and easy solution to the problem.

Setting a Gray Point

Click on the 'Set Gray Point' eyedropper in the Levels dialog box and then click on any neutral tone present in the image to remove a color cast. Introducing a near white card or gray card into the first image of a shoot can aid in subsequent color corrections for all images shot using the same light source.

Variations (not available when editing 16-bit files)

The 'Variations' command allows the adjustment of color balance, contrast and saturation to the whole image or just those pixels that are part of a selection. For individuals who find correcting color by using the more professional color correction adjustment features intimidating, Variations offers a comparatively user-friendly interface. By simply clicking on the alternative thumbnail that looks better the changes are applied automatically. The adjustments can be concentrated on the highlights, midtones or shadows by checking the appropriate box. The degree of change can be controlled by the Fine/Coarse slider.

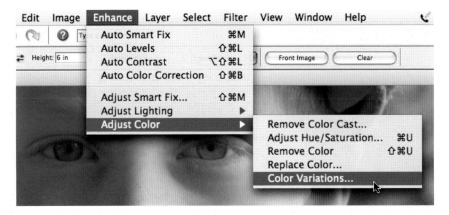

Variations can be accessed from the Adjustments submenu in the Image menu. Photoshop Elements users should go to the 'Enhance' menu and choose 'Color Variations' from the 'Adjust Color' menu. Photoshop Elements users can follow the numbers they see in the box whilst users of the full version of Photoshop have to figure the clicking order out for themselves. Start by selecting the 'Midtones' radio button and then adjust the intensity until you can see a thumbnail that looks about right, and then click on the one you like. Then click 'OK'.

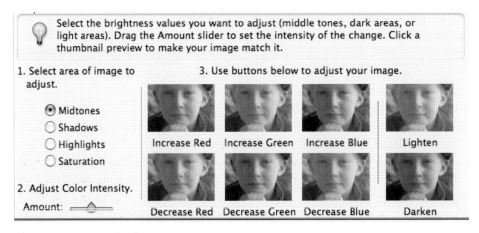

Note > Editing with the highlights, shadows or saturation button checked can lead to a loss of information in one or more of the channels. If the 'Show Clipping' is checked a neon warning shows areas in the image that have been adjusted to 255 or 0. Clipping does not, however, occur when the adjustment is restricted to the mid-tones only.

Cleaning - Step 5

The primary tools for removing blemishes, dust and scratches are the 'Clone Stamp Tool', the 'Healing Brush Tool' and the new 'Spot Healing Brush Tool'. The Clone Stamp is able to paint with pixels selected or 'sampled' from another part of the image. The Healing Brush is a sophisticated version of the Clone Stamp Tool that not only paints with the sampled pixels but then 'sucks in' the color and tonal characteristics of the pixels surrounding the damage. The Spot Healing Brush Tool requires no prior sampling and is usually the first port of call for most repairs. The following procedures should be taken when working with the Spot Healing Brush Tool or Healing Brush Tool.

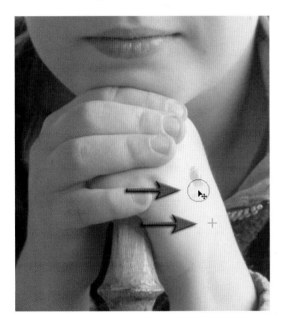 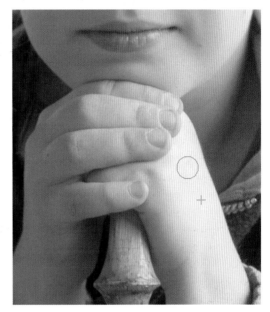

- Select the Spot Healing Brush Tool from the Tools palette.
- Zoom in to take a close look at the damage that needs to be repaired.
- Choose an appropriate size brush from the brushes palette that just covers the width of the blemish, dust or scratch to be repaired.
- Move the mouse cursor to the area of damage.
- Click and drag the tool over the area that requires repair.
- Increase the hardness of the brush if the repair area becomes contaminated with adjacent tones, colors or detail that does not match the repair area.
- For areas proving difficult for the Spot Healing Brush to repair switch to either the Healing Brush Tool or the Clone Stamp Tool. Select a sampling point by pressing the Alt or Option key and then clicking on an undamaged area of the image (similar in tone and color to the damaged area). Click and drag the tool over the area to paint with the sampled pixels to conceal the damaged area (a cross hair marks the sampling point and will move as you paint).

Note > If a large area is to be repaired with the Clone Stamp Tool it is advisable to take samples from a number of different points with a reduced opacity brush to prevent the repairs becoming obvious.

Sharpening - Step 6

Sharpening the image is the last step of the editing process. Many images benefit from some sharpening even if they were captured with sharp focus. The 'Unsharp Mask' filter from the 'Sharpen' group of filters is the most sophisticated and controllable of the sharpening filters. It is used to sharpen the edges by increasing the contrast where different tones meet.

The pixels along the edge on the lighter side are made lighter and the pixels along the edge on the darker side are made darker. Before you use the Unsharp Mask go to 'View > Actual Pixels' to adjust the screen view to 100%. To access the Unsharp Mask go to 'Filter > Sharpen > Unsharp Mask'. Start with an average setting of 100% for 'Amount', a 1 to 1.5 pixel 'Radius' and a 'Threshold' of 3. The effects of the Unsharp Mask filter are more noticeable on-screen than in print. For final evaluation always check the final print and adjust if necessary by returning to the saved version from the previous stage. The three sliders control:

Amount - This controls how much darker or lighter the pixels are adjusted. Eighty to 180% is normal.

Radius - Controls the width of the adjustment occurring at the edges. There is usually no need to exceed 1 pixel if the image is to be printed no larger than A4/US letter. A rule of thumb is to divide the image resolution by 200 to determine the radius amount, e.g. 200 ppi ÷ 200 = 1.00.

Threshold - Controls where the effect takes place. A zero threshold affects all pixels whereas a high threshold affects only edges with a high tonal difference. The threshold is usually kept very low (0 to 2) for images from digital cameras and medium or large format film. The threshold is usually set at 3 for images from 35 mm. Threshold is increased to avoid accentuating noise, especially in skin tones.

168

Saving - Step 7

Go to the 'File' menu and select 'Save As'. Name the file, select 'TIFF' or 'Photoshop' as the file format and the destination 'Where' the file is being saved. Check the 'Embed Color Profile' box and click 'Save'. Keep the file name short using only the standard characters from the alphabet. Use a dash or underscore to separate words rather than leaving a space and always add or 'append' your file name after a full stop with the appropriate three- or four-letter file extension (.psd or .tif). This will ensure your files can be read by all and can be safely uploaded to web servers if required. Always keep a back-up of your work on a remote storage device if possible.

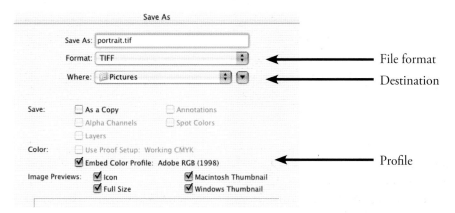

Resize for screen viewing

Duplicate your file by going to 'Image > Duplicate Image' (Photoshop) or File > Duplicate (Photoshop Elements). Rename the file and select OK. Go to 'Image > Image Size'. Check the 'Constrain Proportions' and 'Resample Image' boxes. Type in approximately 600 pixels in the 'Height' box (anything larger may not fully display in a browser window of a monitor set to 1024 x 768 pixels without the viewer having to use the scroll or navigation bars). Use the Bicubic Sharper option when reducing the file size for optimum quality.

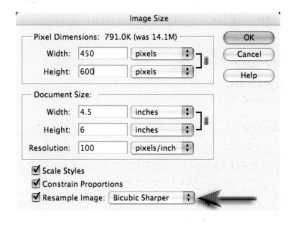

Using the Crop Tool (typing in the dimensions in pixels, e.g. 600 px and 450 px) will also resize the image quickly and effectively. This technique does not, however, make use of Bicubic Sharper and images may require sharpening a second time using the Unsharp Mask.

Note > Internet browsers do not respect the document size assigned to the image by image-editing software - image size is dictated by the resolution of the individual viewer's monitor. Two images that have the same pixel dimensions but different resolutions will appear the same size when displayed in a web browser. A typical screen resolution is often stated as being 72 ppi but actual monitor resolutions vary enormously.

JPEG format options

After resizing the duplicate image you should set the image size on screen to 100% or 'Actual Pixels' from the View menu (this is the size of the image as it will appear in a web browser on a monitor of the same resolution). Go to the 'File' menu and select 'Save As'. Select JPEG from the Format menu. Label the file with a short name with no gaps or punctuation marks (use an underscore if you have to separate two words) and finally ensure the file carries the extension .jpg (e.g. portrait_one.jpg). Click 'OK' and select a compression/quality setting from the 'JPEG Options' dialog box. With the Preview box checked you can check to see if there is excessive or minimal loss of quality at different compression/quality settings in the main image window.

Note > Double-clicking the Zoom Tool in the Tools palette will set the image to actual pixels or 100% magnification.

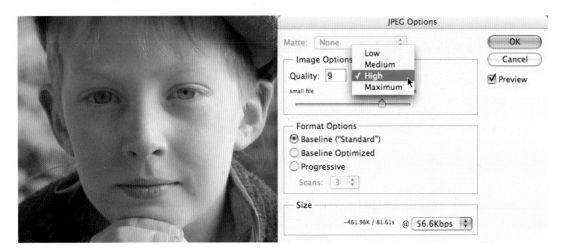

Choose a compression setting that will balance quality with file size (download time). High compression (low quality) leads to image artifacts, lowering the overall quality of the image. There is usually no need to zoom in to see the image artifacts as most browsers and screen presentation software do not allow this option.

Image Options: The quality difference on screen at 100% between the High and Maximum quality settings may not be easily discernible. The savings in file size can, however, be enormous, thereby enabling much faster uploading and downloading via the Internet.

Format Options: Selecting the 'Progressive' option from the Format Options enables the image to be displayed in increasing degrees of sharpness as it is downloading to a web page, rather than waiting to be fully downloaded before being displayed by the web browser.

Size: The open file size is not changed by saving the file in the JPEG file format as this is dictated by the total number of pixels in the file. The closed file size is of interest when using the JPEG Options dialog box as it is this size that dictates the speed at which the file can be uploaded and downloaded via the Internet. The quality and size of the file is a balancing act if speed is an issue due to slow modem speeds.

Save for Web

The Save for Web offers a single command centre for duplicating, resizing and saving using the JPEG file format. It also offers a preview option so that you can view how your image will appear if it is displayed in software that does not read the ICC profile.

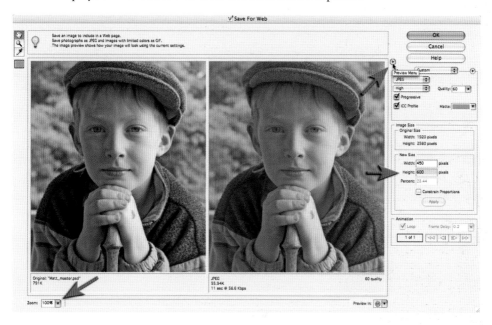

Photoshop and Photoshop Elements users can use the Save for Web option when previewing and saving images destined for a screen presentation. Photoshop users can also go to View > Proof Setup and then choose either Macintosh RGB or Windows RGB depending on the intended monitor that the image will be viewed on. With the Proof Setup switched on, adjustments will usually be required to both image brightness and saturation in order to return the appearance of the image to 'normal'. Brightness should be controlled via the 'Gamma' slider in the 'Levels' adjustment feature and color saturation via the 'Hue/Saturation' adjustment feature. The adjustments required to the first image can usually be replicated on subsequent images using the same settings.

Image adjustments overview

1. Capture an image with sufficient pixels for the intended output device.
2. Resize and crop the image to the intended output size.
3. Optimize the histogram using the Levels dialog box.
4. Adjust the tonality and color.
5. Clean the image using the Clone Stamp Tool or the Healing Brush Tool.
6. Apply the Unsharp Mask.
7. Save the adjusted image as a Photoshop file (PSD).
8. Duplicate the file and resize for uploading to the web if required.
9. Save the file as a JPEG with a suitable compression/quality setting.

Chapter 14

0 3 5 8 10 13 15 18 20 23 26 229 232 235 237 240 242 245 247 250 252 255

Printing

Creating high-quality prints using desktop inkjet printers can be a mystifying and costly experience. Matching the colors of the print to those that appear on your monitor can be an infuriating experience. This example of a printing workflow using Photoshop/Photoshop Elements may help you overcome some of the obstacles you may be encountering and enable you to attain perfect prints.

Color Point - Samantha Amor

Most professionals use the Adobe RGB workspace rather than the sRGB workspace when images are destined for print rather than screen viewing. Adjust the workspace in your image-editing software. It is also recommended that you 'calibrate' your monitor by setting the brightness, contrast and white point to settings suitable for printing. Follow these seven simple steps to turn your edited images into folio masterpieces.

EPSON StatusMonitor

Remaining Ink level

EPSON recommended ink cartridge
Black : T026 Color : T027

Click the image of the ink cartridge to display
information about the current cartridge.

1. Preflight checklist

In an attempt to make the first time not too memorable, for all the wrong reasons, check that your ink cartridges are not about to run out of ink and that you have a plentiful supply of good quality paper (same surface and same make). It is also worth starting to print when there are several hours of daylight left, as window light (without direct sun) is the best light to judge the color accuracy of the prints. If you are restricted to printing in the evening it may be worthwhile checking out 'daylight' globes that offer a more 'neutral' light source than tungsten globes or fluorescent tubes. It is also important to position the computer's monitor so that it is not reflecting any light source in the room (including the direct illumination from windows and skylights). If your monitor is reflecting a brightly colored wall or window then consider shifting your furniture.

Note > Refilling your ink cartridges and using cheap paper are not recommended for absolute quality and consistency.

2. Keeping a record

The settings of the translation process (all the buttons and options that will be outlined next), the choice of paper, the choice of ink and the lighting conditions used to view the print will all have enormous implications for the color that you see on the printed page. The objective when you have achieved a color match is to maintain consistency over the process and materials so that it can be repeated with each successive print. It is therefore important to keep a track of the settings and materials used.

Project	Portrait	Sept 22/04
Image File	TIFF	220 ppi
Paper	Epson	Matte HW
Inks	Epson	AUG 04
Colour Management	Adobe ☐	Printer ✔
Profiles	N/A	Same As Source
Printer Settings	Matte HW	Best Photo
Colour Controls	Photo-realistic	+4 Saturation

There is only one thing more infuriating than not being able to achieve accuracy and that is achieving it once and not being sure of how you did it. Some words of advice … WRITE IT DOWN!

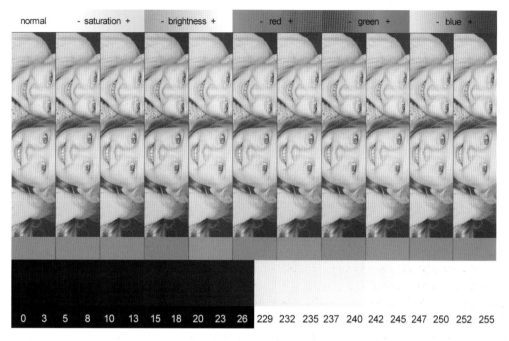

Use a test file to help you target the perfect color balance quickly and efficiently

3. Preparing a test print

Start the printing process by selecting 'Print' from the File menu. As discussed previously there are several methods of printing. There is no one road. In order to discover a workflow that suits your own setup it is recommended that you use a test file that has a broad range of colors of varying saturations. Use a test file that incorporates a range of saturated colors, neutral grays and skin tones. If this file prints perfectly you can be confident that subsequent prints using the same media and settings will follow true to form. The test print file in the illustration above is available to download from the Foundations website (go to http://www.photographyessentialskills.com). It will help you target your optimum shadow and highlight points, and stop you from chasing what initially appears to be a color cast and in the end turns out to be a blocked ink jet.

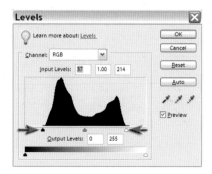
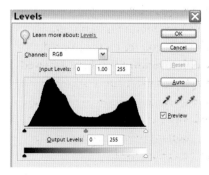

Note > There is an old saying, 'quality in - quality out'. You must check that each image you print has been optimized for printing. The file's histogram should be optimized and any obvious color cast removed.

4. Print preview

Select 'Print' or 'Print with Preview' from the File menu. Although Adobe has the industry standard color management engine it is only effective if you have a custom-made profile for your printer/paper combination. The latest photo printers are, however, more than up to the task of handling the color management.

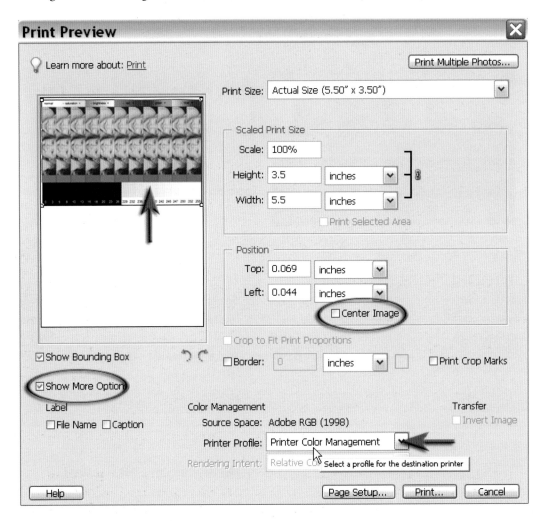

1. Click 'Page Setup' at the bottom of the dialog box to select paper size and orientation
2. Deselect the 'Center Image' checkbox
3. Drag the image preview to one side of the page to save printing paper
4. Click on the Show More Options box to expand the dialog box
5. Select the 'Printer Color Management' option in the Color Management section
6. Select 'Print'.

Note > If you have calibrated your printer and have a unique profile for your printer/paper combination then you should select this as the printer profile and turn off the color management in the printer.

5. Printer driver

Printer drivers are specific to your make and model of printer. The options outlined below will act as a guide for the settings in your own printer driver. Look for the same or similar options in your Printer Driver dialog box:

1. You may need to select 'Properties' in the first dialog box to access the printer settings
2. Select the 'Advanced' option if there is one to access ALL of the settings
3. Select the paper you are using from the Media Type or Paper Options menu
4. Select the maximum dpi from the Print Quality menu or any option that indicates that the 'Best Photo' quality option has been selected
5. Select 'Color Controls' from the Color Management menu (you should see the Magenta, Cyan and Yellow color sliders)
6. Select 'Print'.

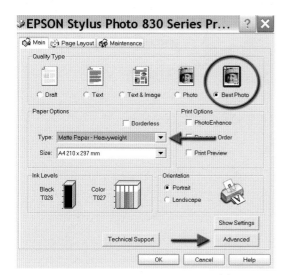 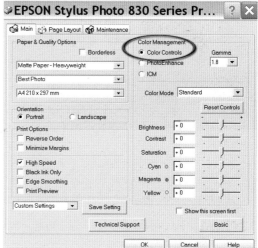

The options for 'Printer Color Management' in an Epson printer driver for a PC

The printer is now handling the color management. Once the test file has been printed you can make an assessment of what changes need to be made before printing a modified or 'tweaked' version. Be sure to let the test print dry for at least 10 to 15 minutes before making an assessment of the color and tonal values as these may change quite dramatically. Subtle changes can continue to occur for several hours during the drying process. See 'Analysing the test print' when assessing whether any changes need to be made to the first test print. To speed up and simplify the procedure for subsequent prints a 'custom setting' or 'preset' can be resaved in the printer driver once you have achieved accuracy by fine-tuning the color sliders. Name the custom setting incorporating the paper surface, e.g. Matte HW-PCM (printer color management).

Note > The precise wording of the options in the printer drivers may vary between different manufacturers and models of printer.

6. Analysing the test print

View the print using soft window light (not direct sunlight) when the print is dry, and try to ascertain any differences between the print and the screen image in terms of hue (color), saturation and brightness. Any differences may be attributed to inaccuracies in your initial monitor calibration.

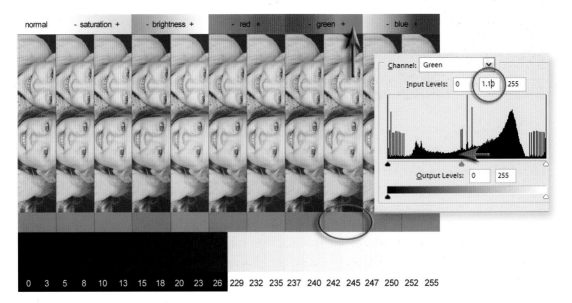

1. Check that the color swatches at the top of the image are saturated and printing without tracking marks or banding (there should be a gradual transition of color). If there is a problem with missing colors, tracking lines or saturation, clean the printer heads using the printer guidelines.

2. View the skin tones to assess the appropriate level of saturation. The lower and higher saturation swatches have a –10 and +10 adjustment applied using Photoshop's Hue/Saturation adjustment.

3. View the gray tones directly beneath the images of the children to determine if there is a color cast present in the image. The five tones on the extreme left are desaturated in the image file. If these print as gray then no color correction is required. If, however, one of the gray tones to the right (which have color adjustments applied) appears to be gray then a color cast is present.

4. Find the tone that appears to be desaturated (the color cast corresponds with the color swatches at the top of the test file). Apply this color correction to the next print. For example, if the plus green strip appears to print with no color cast (the gray swatches on the far left will therefore be printing with a magenta cast) then a 1.1 Gamma adjustment in the green channel is required for the next test print. Alternatively, a minus value can be entered in the Magenta slider in the 'Color Controls' in the printer dialog box.

Note > Each of the color strips in the test image has the same Gamma adjustment applied using the RGB channels. The correction necessary can be made using the Levels dialog box by sliding the Gamma slider to 0.9 or 1.1 in the corresponding color channel.

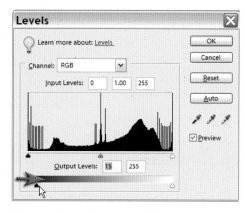

7. Maximizing detail

Examine the base of the test strip to establish the optimum highlight and shadow levels that can be printed with the media you have chosen to use. If the shadow tones between level 10 and level 20 are printing as black then you should establish a Levels adjustment layer to resolve the problem in your Adobe software. The bottom left-hand slider should be moved to the right to reduce the level of black ink being printed. This should allow dark shadow detail to be visible in the second print. A less common problem is highlight values around 245 not registering on the media. However, if this is a problem, the highlight slider can be moved to the left to encourage the printer to apply more ink.

Note > It is important to apply these Output level adjustments to an adjustment layer only as these specific adjustments apply only to the output device you are currently testing.

PERFORMANCE TIP

Materials
Start by using the printer manufacturer's recommended ink and paper.
Use premium grade 'photo paper' for maximum quality.

Monitor
Position your monitor so that it is clear of reflections.
Let your monitor warm up for a while (up to 30 minutes) before judging image quality.
Select a target white point or color temperature of 6500 K (D65).
Calibrate your monitor using a calibration device if available.

Adobe
Set the Color Settings of the Adobe software.
Select 'Let printer determine colors'.
Use a six-ink inkjet printer or better for maximum quality.
Select the 'Media Type' in the Printer Software dialog box.
Select a high dpi setting (1440 dpi or greater) or 'Best Photo' quality setting.

Proofing
Allow print to dry and use daylight to assess color accuracy of print.

Chapter 15

Screen Presentations

It seems everywhere you look these days there is a piece of software offering to present your images as a slideshow. Apple seems to be particularly keen on the idea of presenting a multi-media face with its iPhoto, iMovie and iDVD offerings. Adobe Photoshop and Adobe Photoshop Elements also give us the opportunity to present selected images as PDF presentations. Adobe Elements for PC can also export slideshows in the Windows Media Video format (WMV). The discerning slideshow enthusiast is, however, a difficult animal to please.

Stuart Wilson

Simplicity, speed, sophistication, limitless options, cinematic quality slide transitions and sound are the features that are in demand. Not content with these, the discerning user also demands that the show play on any computer and be small enough to fit on an old floppy disk or to be emailed to your Paraguayan penfriend with a 28K modem. PC users with Photoshop Elements need to look no further than the excellent Slide Show feature.

Aims

- ~ Learn how to create a visual presentation of your photographic work using your image-editing software and additional software usually found on most computers.
- ~ Look at both the limitations and creative possibilities that these software packages afford the creative photographer.

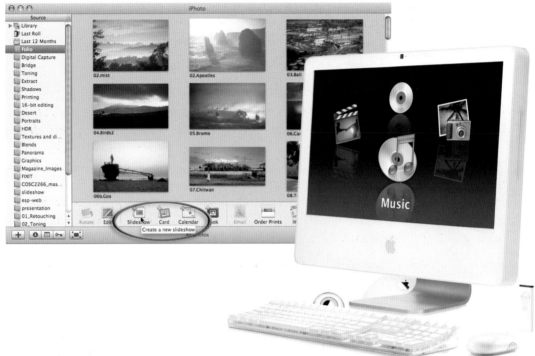

Apple's iFamily

iFamily is Apple's multi-media solution to the digital user who wants to share their life. The four pieces of software are bundled together for DVD burning owners as the iFamily package and come shipped free with every new Mac computer sporting their 'Superdrive' (iDVD is deleted from the package for CD burning owners). iPhoto is the fastest share solution in the iFamily collection with the ability to export your show as a QuickTime movie in a variety of sizes and compression settings - from email to full DVD HD quality. iPhoto takes selected photos or 'albums' from your 'Pictures' archive and presents them with a music file that you nominate from your iTunes collection. All the software interacts with each other pretty intelligently, working together to create a variety of presentation formats to share with your family and friends. For a Mac user who doesn't require small file sizes but requires increased cinematic sophistication they can select a folder of images or 'album' and then click on the iDVD option.

Presentations from image banks and digital cameras

Some consumer digital cameras and many of the portable image banks (an external hard drive with image capability) also offer the user the facility to hook up to a monitor or TV and present a stored sequence of images as a slideshow.

iDVD allows the user to add the interactive splash screen that we have all come to love with DVD movies. The ability to simply drag and drop additional images from your iPhoto archive and add your favorite music file from your iTunes library makes the task relatively painless. Meticulous Mac media freaks wanting precise control over timing and transitions can use iMovie HD (choose the HD option to create larger movies suitable for viewing on High Definition TVs or computer monitors) to fine-tune the multi-media experience before choosing either QuickTime or iDVD as the sharing media. Be sure you select the HDV options in the Create Project dialog box to access the higher resolution capability of iMovie HD.

If the user would like a little more control over the presentation, iMovie HD offers most of the features that the budding movie producers amongst us would require and is capable of creating images suitable for a high definition widescreen TV or computer screen. The creation of precise timings and transitions for sound, music and image files are easy to manage via iMovie's elegantly simple interface. iMovie HD also offers us the 'Ken Burns' effect that allows us to zoom or pan across a still image to breathe a little more interest into the presentation when used in moderation.

PDF presentations

A PDF presentation is part of the automated features in both Photoshop Elements and Photoshop. The option can also be accessed directly from either Adobe Bridge or the Organizer in Photoshop Elements for PC. PDF slideshows are viewed in Adobe's own Acrobat Reader software (freeware) that is usually found on most computers. The advantage of the PDF slideshow is the high-resolution, high-quality images that are possible and the fact that Adobe Acrobat reads the image profiles embedded by Photoshop and Photoshop Elements - thereby ensuring the images will not vary in hue, saturation or brightness.

In the PDF Slide Show dialog box in Photoshop Elements it is possible to select large image sizes (high resolution) that are suitable for larger monitors, duration of time that the slides will be displayed and the transition effect (a fairly limited selection) between each slide. Control over image size and quality are also available for PC users using Elements. The slideshow can be 'looped' to start again after the last slide has been displayed. Although high-resolution images can be viewed in the PDF slideshow there are limited transitions available and there is only support for attaching a music file for PC users of Photoshop Elements.

Note > One of the drawbacks of budget movie software (with the exception of iMovie HD) is the small size of the movies created (640 x 480 or 800 x 600). PowerPoint is one option for both Mac and PC users who require high resolution images and sound.

A PDF presentation plays automatically when the file is launched. After the last slide is displayed the user can exit the slideshow by pressing the 'Esc' key. The slideshow is then visible as a multi-paged pdf document. The slideshow can be returned to the first page using the Adobe Acrobat page controls and viewed again by using the 'Full Screen View' option from the 'Window' menu. Using the page up, page down or the arrow keys on the keyboard will advance the slides manually if the show has been created without a time allocated to the 'Advance Every' option.

The PDF slideshow creates slideshows using a 4:3 aspect ratio (the same shape as non-widescreen TVs or standard monitors). Slideshows will not be displayed full screen on widescreen monitors. If you require your images to be displayed the full size of the slideshow (not necessarily the screen) you will either need to crop the images to the 4:3 aspect ratio in Photoshop or choose the 'Crop to Fit' option in the slideshow dialog box of Photoshop Elements. Only limited control over background color is possible with the PDF slideshows in the full version of Photoshop so specific borders or backgrounds must be added to the images as part of the editing process of each image. If the aspect ratio of an image displayed in the slideshow differs from the aspect ratio of the monitor (and no background has been added in the image-editing software) the PDF slide will use a border on two sides of the image only.

Adobe Slide Show - Photoshop Elements (PC only)

One of the best solutions for the creation of high-quality slide presentations up to 800 x 600 pixels is the Slide Show feature that is part of Photoshop Elements for PC. The Slide Show saves the resulting show as a Windows Media Video that is viewed through the Windows Media Player. The resulting slideshow includes both smooth fades and an embedded sound file and keeps the resulting file size reasonably small.

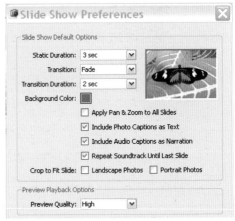

Images destined for the slideshow can be first selected in the Organizer before clicking on the 'Create' button in the Options bar. Choose 'Slide Show' and then choose the default background color, slide duration and slide transition from the Preferences dialog box.

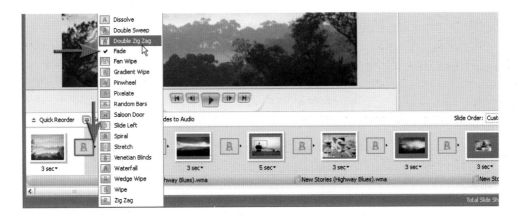

Individual transitions or timings can be selected by clicking on the icons beneath the preview window. This allows the slideshow to be extensively customized. Additional photos can be added by clicking on the 'Add Media' icon in the Options bar. Clicking on the 'Add Audio' icon in older versions of Photoshop Elements, or directly below the thumbnails in the current version, allows a sound file to be added to the slideshow.

It is possible to 'trim' the audio track and add additional soundtracks to the presentation. The duration of each sound file can be controlled along with the start and stop times. Clicking the option 'Fit Slides to Audio' will reorganize the timings so that the music and images end at the same time.

Note > The Windows Media Player required to play the slideshows is available to Mac owners but is not installed by default. The Flip4Mac plug-in enables the slideshows to be played on Macs in QuickTime.

Creating a slide background

1. Create a new document or 'Slide Master' by going to File > New. Enter the width and height of your monitor in pixels. Typical resolutions for a 4:3 format display on a monitor are 1024 x 768, 1400 x 1050 and 1600 x 1200. iMovie HD supports supports the sizes 720p (1280 x 720 pixels) or 1080i (1920 x 1080). Although designed for TV, 720p is ideally sized for a 15 inch laptop whilst 1080i is ideally sized for a 23 inch computer monitor. Fill the Background layer with the color you will use for your slideshow presentation by going to 'Edit > Fill'.

2. Add background graphics or text to a separate layer to act as a title slide or closing slide to your presentation (graphics are usually higher quality if added to the image file rather than using the text options in the slideshow or movie software). Cut and paste one of your presentation images as a new layer (alternatively you can drag the thumbnail of your presentation image into your new document or 'Slide Master' image). Go to 'Edit > Stroke' to apply a thin stroke or border to frame the image.

Note > Create a new layer and load a selection of the image layer before applying the stroke if you want the stroke to be on a separate layer to the image. Ctrl + Click (Command + Click on a Mac) to load the contents of a layer as a selection.

3. It is possible to create a clipping group in your Adobe software that will act as a mask to align or 'register' subsequent slides to the same size and position as the first slide. To create the base layer of this clipping group fill a selection with black on a layer sitting above the background layer. Then drag in a new image from a different file. To reduce the size of an image that is too big, go to the 'Edit' menu (Photoshop) or 'Image' menu (Elements) and select the 'Free Transform' command. Hold down the Shift key as you drag a corner handle to constrain the proportions as you resize the image.

4. Select the image layer and position it above the black mask layer in the Layers palette. Go to the 'Layer' menu and select 'Create Clipping Mask' or 'Group with Previous' to clip and frame the image. Select the Move Tool and drag the image in the image window to fine-tune the composition. Save a maximum quality JPEG of each slide you create to a common folder that will be used as the slideshow image resource. Number each slide starting with 01, 02, 03, etc. if you want the slides to be sequenced automatically. Alternatively you can drag the image files to a new position in the list when the PDF presentation dialog box is open. When all the files are sequenced click OK in the PDF presentation dialog box and then sit back and wait for your Adobe software to complete the construction.

PowerPoint

PowerPoint presentations are synonymous with pie-graphs, sales statistics and slumber-inducing business meetings. Remove the cheesy background graphics, however, and the software can be used to fuel a half decent folio slideshow. As half the planet now seems to own a copy of Microsoft Office (Word, Excel, PowerPoint and Entourage) Mac owners who do not have the luxury of the Custom Slide Show that is shipped with Elements for PC have the option of increasing the level of sophistication over Adobe's PDF presentation without investing in additional software.

Advantages and disadvantages

The advantage of PowerPoint over the iFamily collection for sharing images is that a PowerPoint show scales the slideshow automatically to play full-screen. The size of the finished presentation is considerably smaller than a comparable QuickTime HD movie and the image quality is not compromised by any video compression setting used. PowerPoint also allows each slide to be timed independently and a soundtrack such as an MP3 file can be linked to the show. The down side to creating a slideshow in PowerPoint is that the software does not read the color profiles used by Adobe, and therefore the images are not color managed. The duration of the slide transitions are dictated by the speed of the computer's processor that is playing the show. As a result the duration of the slideshow varies considerably between different machines and attempts to time slides to the supporting music are fairly futile.

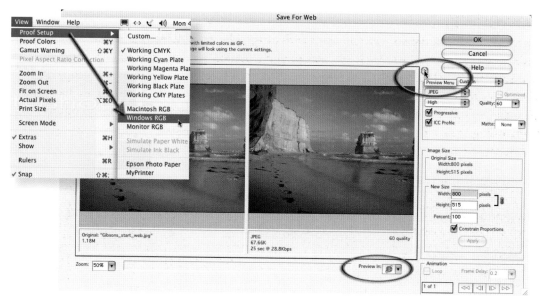

Photoshop and Photoshop Elements users should use the Save for Web option and ensure the image profile is sRGB when previewing and saving images destined for a PowerPoint presentation. Photoshop users can also go to View > Proof Setup and then choose either Macintosh RGB or Windows RGB depending on the intended monitor that the slideshow will be viewed on (if a Mac user has calibrated their monitor using a 2.2 Gamma then the Windows RGB should be selected instead of the Macintosh RGB). With the Proof Setup switched on, adjustments may be required to both image brightness and saturation in order to return the appearance of the image to 'normal'. If adjustments are required brightness should be controlled via the 'Gamma' slider in the 'Levels' adjustment feature and color saturation via the 'Hue/Saturation' adjustment feature. The adjustments required to the first image can usually be replicated on subsequent images using the same settings.

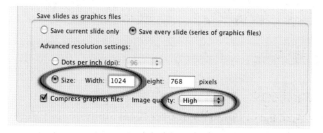

When setting up a new PowerPoint presentation, choose the 'Blank' slide layout whenever you are given a choice and then make sure you choose the appropriate slide dimensions and image quality from the 'Preferences' menu. Before you even start loading the slides into the presentation it is a good idea to save the PowerPoint file into a folder holding the soundtrack file you intend to use (MP3 files currently offer great sound with a relatively small file size).

Important > To avoid ugly artwork, all graphics and text destined for the slide presentation should be created in Photoshop and saved as a JPEG image file, as there is no anti-aliasing option (the technique of removing the jagged edges) in PowerPoint.

Large music files are, by default, linked rather than embedded to the PowerPoint presentation. Before inserting the music file it is wise to place the music file in the same folder as the work-in-progress PowerPoint file. This will ensure the PowerPoint presentation will always be able to find the music to play. When the PowerPoint file is moved to a new platform or burnt to a CD the folder of files should be moved as one item to ensure this link is never broken.

Important > Images are embedded into a PowerPoint document but they should not be inserted into the presentation from an external drive or disc that is connected to the computer as this can cause a few annoying dialog boxes popping up advising the user to insert disc or connect to drive.

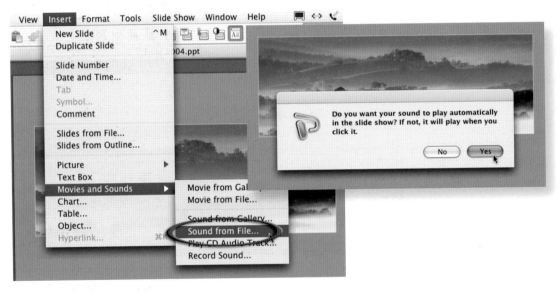

Playing a sound file for the duration of the slideshow rather than the duration of the slide is perhaps the most obscure task to perform in an otherwise simple software package. The first step in the process is simple enough. Go to Insert > Movies and Sounds > Sound from File and then browse to the folder where the PowerPoint file has been saved and choose the music file from the same folder. If the music file is not in this folder move it to this location before inserting the file using this command. Select 'Yes' to start the music playing automatically when the slideshow is launched.

 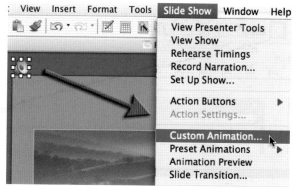

It is also a good idea to click and drag the music file icon off the edge of the slide to hide it from view in the presentation. Alternatively you could insert the music file first and then place the image over the music file icon to hide it. The next step to ensuring the music file plays for the duration of the slideshow rather than the duration of the slide is not obvious, as the menu command comes under the 'Slide Show > Custom Animation' submenu.

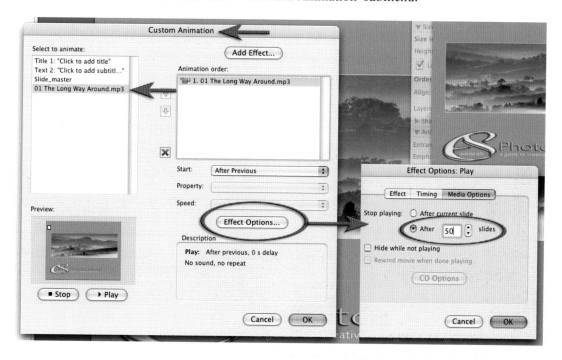

Select the 'Effect Options' menu in the 'Custom Animation' dialog box. Select the 'After' radio button in the Media Options submenu. Specify the number of slides in the slideshow. Select a repeat option in the Timing submenu to ensure the soundtrack does not end before the slides have finished playing. Select OK.

Note > Now that the soundtrack has been linked to the PowerPoint presentation, if it changes its location the link will be broken and the sound file will not play. Choose the PowerPoint Package option when saving the file to ensure the soundtrack link is not broken.

JPEG images of the appropriate pixel dimensions can be dragged from your image resource folder directly onto the PowerPoint slides and edited in situ using the formatting palette. Images should be cropped in the Adobe image-editing software to the 4:3 format and set to a resolution of 100 ppi. This action will ensure that limited resizing is required when the images are dragged into the PowerPoint presentation.

Note > Although PowerPoint prefers the image resolution to be set around 100 ppi it is the pixel dimensions and not the document size or resolution that are critical to the final quality of the presentation. Typical resolutions for a 4:3 format display on a monitor are 1024 x 768, 1400 x 1050 and 1600 x 1200.

Creative ideas

A simple fade or wipe is often the best choice for a transition. This will ensure the effects don't upstage the images you have so lovingly crafted. You can create your own slide transitions with a little imagination by applying a Gaussian Blur to a duplicate slide in Adobe. This duplicate slide can then be assigned a short duration in PowerPoint so that the final effect is one of fading into focus. Using a duplicate slide that has been desaturated can create another interesting transition effect. Interleaving the slides that have been prepared with backgrounds with the occasional full-frame image can also create an element of visual surprise.

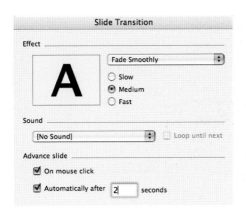

Completing the project

The timing and transition for each slide can be controlled via the 'Slide Transition' dialog box that can be accessed from the 'Slide Show' menu or from the options bar in the 'Slide Sorter' view. PowerPoint offers an option to time the slides to the music track selected (Rehearse Timings). The timings, however, will often vary significantly if the presentation is played on a different computer. When saving the completed project select the PowerPoint Show option from the Format pull-down menu and save the file to the folder containing the music file. When the user opens a PowerPoint Show file (PPS) instead of PowerPoint Presentation file (PPT) the user is transferred directly to the show rather than the construction interface. Later versions of PowerPoint have the option to save the presentation as a 'PowerPoint Package'. This will ensure that any files that were linked instead of being embedded in the document (namely the sound file) will be saved to the same folder. Any option to export the PowerPoint Presentation as a QuickTime movie should be avoided, as even the highest quality setting available in PowerPoint will cause considerable degradation of image quality when viewed in the final movie.

Chapter 16

Resources

Although the digital revolution in photography started more than two decades ago it is only in recent times that all photographers have had to re-evaluate their captu workflows, relearn their post-production skills, and find new ways to present and print their images. The darkroom has been supplanted in most photographers' workflows with a digital lightroom. This chapter looks at setting up a computer system that is suitable for editing photographs in order to present the images on t computer's mointor or print via a print service provider or desktop printer.

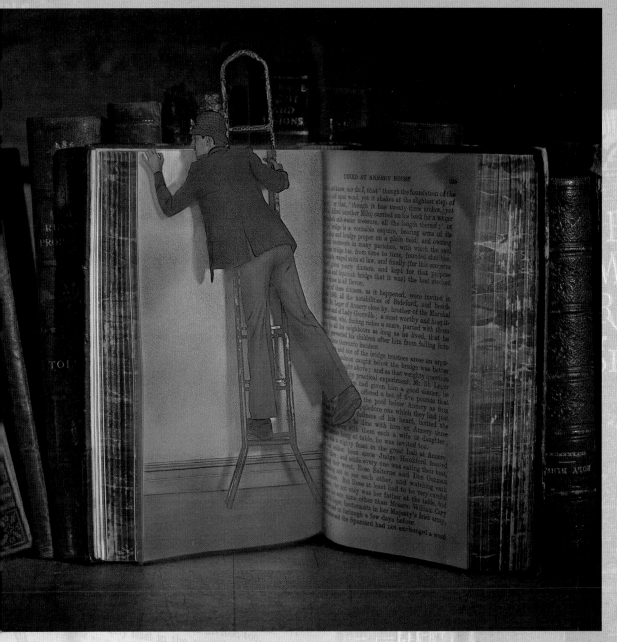

Samantha Everton

The chapter concludes with a series of optional support sheets that are designed to help the teacher and student in the learning process of this course. Additional resources can be found online at http://www.photographyessentialskills.com (click on the 'Foundations' link). You may like to explore the additional links to the other books in the essential skills series that have been designed to extend photographic skills in specialist areas such as studio photography, digital photography in available light and post-production skills using Photoshop or Photoshop Elements.

Digital setup

Adobe is the most popular choice for image editing software. Both Photoshop and Photoshop Elements afford precise control over images that will be viewed on screen and in print. In order to maximize this control it is necessary to spend some time setting up the software and hardware involved in the imaging process in order to create a predictable and efficient workflow.

This chapter will act as a pre-flight checklist so that the user can create the best possible working environment for creative digital image editing. The time required setting up the software and hardware in the initial stages will pay huge dividends in the amount of time saved and the quality of the images produced.

Commands and shortcuts

Digital imaging tutorials will often guide you to select various options from a list of menus on your computer. If a command or dialog box is to be found in a submenu which in turn is to be found in a main menu they will usually appear as follows: 'Main menu > Submenu > Command'. Many of the commands can be executed by pressing one or more of the keyboard keys (known as 'Keyboard shortcuts').

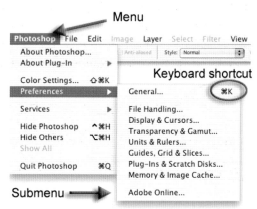

Keyboards: Mac and PC keyboards have different layouts. The 'Alt' key on a PC is the 'Option' key on a Mac. The functions assigned to the 'Control' key on a PC are assigned to the 'Command' key on a Mac (the key next to the Spacebar with the apple on it). When the text lists a keyboard command such as 'Ctrl/Command + Spacebar' the PC user will press the Control key and the Spacebar whilst the Mac user is directed to press only the Command key together with the Spacebar.

The monitor
Resolution and colors

Set the monitor resolution to '1024 x 768' pixels or greater and the monitor colors to 'Millions'. If the 'Refresh Rate' of a CRT monitor (cathode ray tube) is too low the monitor will appear to flicker. Good CRT monitors will enable a high resolution with a flicker-free or stable image. It is possible to use low monitor resolutions but the size of the palettes results in a lack of 'screen real estate' or monitor space in which to display the image you are working on. When working on a 'TFT' or flat panel monitor it is usual to work at the native or highest resolution the monitor offers.

Color temperature - selecting a white point

The default 'color temperature' of a new monitor is most likely to be too bright and too blue for digital image editing (9300). Reset the 'Target White Point' (sometimes referred to as 'Hardware White Point' or 'Color Temperature') of your monitor to 'D65' or '6500', which is equivalent to daylight (the same light you will use to view your prints). Setting the white point is part of the 'calibration' process that ensures color accuracy and consistency.

Calibration

Full monitor calibration of an older style CRT monitor was not recommended until the new monitor had had time to 'bed-in' or 'settle down'. Modern TFT monitors can, however, be calibrated from new and do not have the 'warm-up' time that is associated with the older style CRT monitors.

A full monitor calibration is recommended if you are able to access a monitor calibration device. The brightness, gamma (midtone brightness) and color temperature of the monitor can be set using calibration software such as Adobe Gamma (PC) or Monitor calibrator (Mac) but the subsequent profiling is much more accurate if a hardware device is used (such as Gretag's 'Eye One', ColorVision's 'Spyder' or Monaco's 'Optix'). This will ensure that the appearance of an image on your screen will be the same on any other calibrated screen. When used in conjunction with an accurate printer profile your monitor calibration will also ensure that your prints will appear very similar to your screen image.

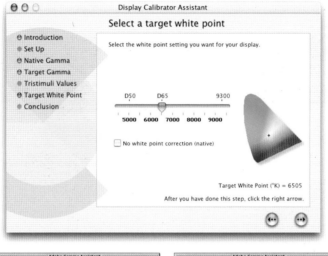

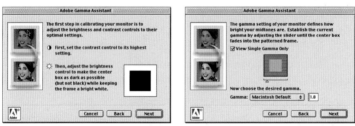

If you have to make do with software calibration on a PC then you could start with 'Adobe Gamma' (found in the 'control panel' or 'control panels' on a PC). On a Mac go to 'System Preferences > Displays > Color > Calibrate'. This will launch the monitor calibrator software. Choose '6500' as the 'Target White Point' or the 'Hardware White Point' and 'Adjusted White Point' if using Adobe Gamma. The software will also guide the user to set the contrast, brightness and 'gamma' of the monitor. You need to ignore the advice to set the contrast of the monitor to 'maximum' when using a TFT display as this advice is targeted to users of CRC monitors. Mac users should also choose the 2.2 Gamma rather than the traditional or default 1.8 Gamma.

On completion of the calibration process you must save the newly calibrated monitor settings by giving it a profile name. It is advised that when you name this profile you include the date that you carried out the calibration. It is usual to check the calibration of a monitor every 3 to 6 months.

Note > When you choose 6500 as your target white point your monitor will initially appear dull and a little yellow compared to what you are used to seeing.

Desktop picture

Although images of tropical beaches and sunsets may look pretty relaxing, splashing them on your screen when editing digital images is not recommended. Any colors we see on the monitor - including the richly saturated colors of our desktop picture - will influence our subjective analysis of color, and our resulting image editing. It is therefore highly recommended to replace the desktop picture with a solid tone of gray. When using Mac OS X select desktop from the System Preferences.

Note > If you do not have a solid gray image in your 'Desktop Pictures' folder you can create one using the image-editing software.

Desktop alias or shortcut

Create an alias or shortcut for your software so that it is quick to launch from the desktop, Apple menu or 'Dock'. Open the Photoshop folder in the Applications folder to locate the Photoshop application icon. Select the Photoshop application icon and right-click in the destination you wish to create the shortcut. When using a Mac drag the application icon into the 'Dock' in OS X to automatically create an alias. To create an alias anywhere else on a Macintosh simply hold down the Command and Option keys as you move the Photoshop icon. Dragging images onto the Adobe alias/shortcut will automatically open them in the software.

File management

There are many software applications available (such as Adobe's 'Bridge', 'Organizer' and 'Lightroom' or Apple's 'iPhoto' and 'Aperture') to help catalog and index image files so they are quick to access, edit, output and archive.

Searching for an image file that is over a year old with a file name you can only begin to guess at is a task best avoided. The software enables 'Keywords' or 'Tags' to be assigned to the image so that a year down the track you can search for your images by date, name or content to simplify the task. Subsets of images can be displayed based on your search criteria. Some packages even provide the option of locating your images via a calendar display where the pictures are collated based on the date they were taken.

For the Mac OSX user it is advised that all images are stored in the 'Pictures' folder associated with each 'User'. For those readers with Windows machines it is good advice to save your pictures in the 'My Pictures' folder. These folders are often set as the default images folder by the indexing or browser

programs. Storing your pictures here will mean that the program will automatically retrieve, index and display images newly added to your system.

Many of the software packages available allow you to assign an image-editing program in the preferences so that the image opens in this software when double-clicked.

iPhoto for Macintosh

Settings and preferences in Photoshop

Before you start working with an image in Photoshop it is important to select the 'Color Settings' and 'Preferences' in Photoshop. This will not only optimize Photoshop for your individual computer but also ensure that you optimize images to meet the requirements of your intended output device (monitor or print). These settings are accessed through either the 'Photoshop' menu or 'Edit' menu from the main menu at the top of the screen.

```
                              Preferences

   ┌ Memory & Image Cache        ⬍ ┐                        ( ⬤  OK  )

     ┌ Cache Settings                              ┐         (  Cancel  )
               Cache Levels: 6
                                                             (  Prev  )
     ┌ Memory Usage                                ┐         (  Next  )
               Available RAM: 979MB

       Maximum Used by Photoshop: 80   ▶ % = 783MB
```

Memory (the need for speed)

If you have a plentiful supply of RAM (256 RAM or greater) you have to give permission for Photoshop to tap into these RAM reserves to a greater or lesser extent when using Mac OSX. Seventy-five percent of the available RAM will automatically be assigned to Photoshop when using a PC. The best advice is to close all non-essential software when you are using Photoshop and allocate more RAM from the 'Memory & Image Cache' preferences (70% is a good starting point).

Image Cache

The Image Cache setting controls the speed of the screen redraw (how long it takes an image to reappear on the screen after an adjustment is made). If you are working with very-high-resolution images and you notice the redraw is very slow you can increase the redraw speed by raising the Image Cache setting (it can be raised from the default setting of 4 up to 8 depending on the speed required). The drawback of raising this setting is that the redraw is less accurate on screen images that are not displayed at 100%.

Color Settings

If you intend to print your images to a desktop printer set the working color space in your Adobe software to Adobe RGB (optimize for printing). Use the sRGB if you intend to present your images on a monitor (optimize for computer screens). On DSLR cameras and higher quality fixed lens cameras you can usually switch between the Adobe RGB color space (for print) and the sRGB (for screen) color spaces.

Printing

When printing from Photoshop to a desktop printer it is recommended that you choose 'Printer Color Management' rather than let Photoshop manage the colors, unless you have an accurate profile of your desktop printer (not usually shipped with budget inkjet printers).

Photoshop or Photoshop Elements?

Photoshop Elements replaced 'Photoshop LE' (limited edition - as in limited function and not availability); both of these software packages share something in common - they offer limited elements of the full version of Photoshop. Adobe strips out some of the features that would be the first port of call for some professional image editors and photographers, but this does not mean that the same level of control cannot be achieved when using the budget software. Professional post-production image editing does NOT have to be compromised by using Photoshop Elements. With editing images there is usually more than a single way to reach the destination or required outcome. With a good roadmap the Elements user can reach the same destination by taking a slightly different course. These roads are sometimes poorly signposted, so are often inaccessible to the casual user of the software. Using a good software manual can provide the information required to unleash this hidden performance.

Adobe Photoshop Elements 5.0 Maximum Performance - a useful guide to post-production image editing if you can't stretch the budget to the full version of Photoshop

Unless you require automated workflows, CMYK conversion and sophisticated vector tools then Photoshop Elements really is a viable alternative to the full version of Photoshop for most professional image-editing tasks. Many photographers may disagree with this statement, as a quick glance at the Elements package may result in a long list of the elements that are missing rather than taking a long hard look at the elements that remain (a case of 'the glass is half-empty' rather than 'the glass is half-full'). After a decade of professional image editing I have learnt that there is more than one way to create an image. There is no 'one way'. In short, it is possible to take a high-quality image file and work non-destructively to create an image which is indistinguishable from one that has been optimized using the full version of Photoshop. Elements is better equipped than many people are led to believe. Photoshop Elements really is the proverbial wolf in sheep's clothes.

Mac or PC?

Photoshop was originally written as a Macintosh-only application back in 1990 and became available for PC with the release of version 2.5. Photoshop now happily works out of either platform. Most commercial image-makers who have to deal with the printing industry, however, are still using Apple Macintosh computers. Macs dominate the industry, but they are not necessarily any better than PCs at image-making tasks. Commercial image-makers tend to purchase them because their colleagues within the industry are using them. It is really just a communication issue. Macs and PCs can talk to each other if required, e.g. Photoshop operating on either platform can open the same image file. The bottom line, however, is that small, but annoying, communication issues can often arise when files are passed 'between' the two platforms. Image-makers who are thinking of choosing the PC platform need to think carefully how, if at all, these communication issues will impact upon them. The biggest communication problem that exists to date is that an image file on a Macintosh formatted disk cannot be accessed easily, or at all, by a PC user.

Use-by date

When choosing a computer for commercial digital imaging it is worth noting that most systems are usually past their use-by date before three years have expired. This may continue to be the case although the whole issue of speed is largely becoming academic for stills image editing. The days of waiting for extended periods whilst Photoshop completed a command are largely over, even using an entry-level computer. The issue of speed, however, is still very much of an issue for creators of DVD (digital video), where disk write speeds are still slow and file sizes are measured in gigabytes instead of megabytes.

Gallery

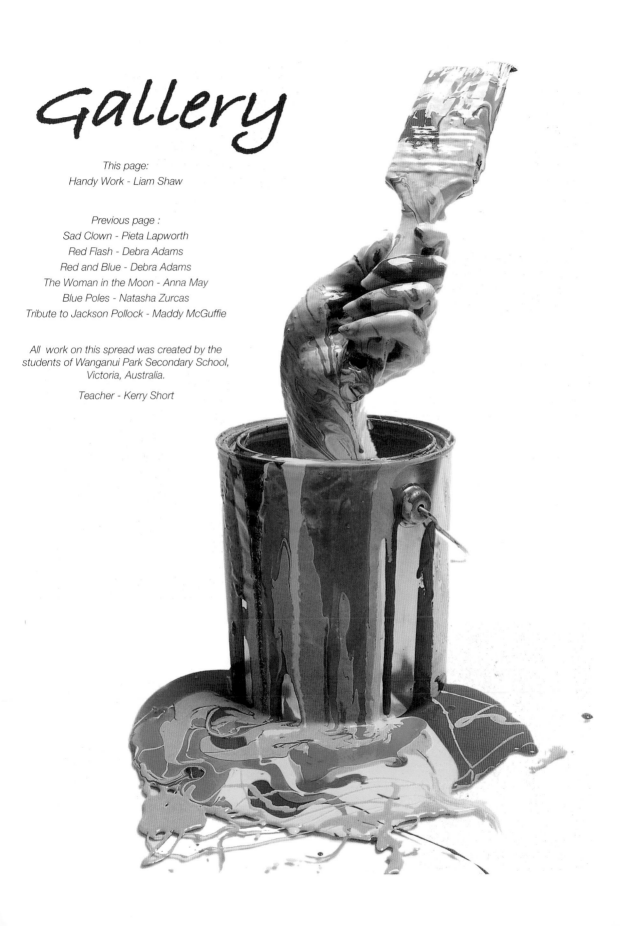

This page:
Handy Work - Liam Shaw

Previous page :
Sad Clown - Pieta Lapworth
Red Flash - Debra Adams
Red and Blue - Debra Adams
The Woman in the Moon - Anna May
Blue Poles - Natasha Zurcas
Tribute to Jackson Pollock - Maddy McGuffie

All work on this spread was created by the
students of Wanganui Park Secondary School,
Victoria, Australia.

Teacher - Kerry Short

Controlled test

Your completed work must include your research, test images as well as your finished presentation piece. You should give clear evidence of how you have approached your work and how your ideas have developed during the course of the test. Any experimentation into style and technique should be recorded clearly in your research documetns.

Note > You are encouraged to make full use of the range of techniques and skills covered by the course wherever appropriate.

Answer ONE question only.

1. *Manual labour* You have been commissioned by the council to present a visual documentary about manual labour. Your piece could focus on a man, woman, group or team. Your work should emphasize the interaction between people and their surroundings, with particular reference to the supporting objects and images associated with their occupations and pastimes.

2. *Theatre workshop* Produce a set of promotional photographs for a theatre workshop that shows the company are encouraged to develop a wide variety of acting styles. Your photographs should demonstrate a variety of moods and emotions using one or more people. It is recommended that you stage the lighting and poses specifically for the camera. The moods and emotions might include happiness, sadness, curiosity, contemplation, boredom, excitement, friendliness, hostility, arrogance, delight, fear, satisfaction, anticipation, anger, peace, concentration, uncertainty and frustration.

3. *Pressure group* Produce a set of promotional photographs that would be suitable for use by a pressure group, e.g. Greenpeace, Friends of the Earth, Campaign for Nuclear Disarmament, Amnesty International or one of your own choice. The images you produce should promote the principal objectives or symbolism related to the particular group.

4. *Illustration* Produce a set of images that illustrates a poem, book extract, song lyric or newspaper article. You may incorporate the text into the finished piece of work.

5. *Surreal story* Produce a sequence of images that communicates a surreal short story. The source of your imagery could be a recent dream or daydream that you may have experienced.

6. *Hands* Photograph hands in expressive postures or engaged in interesting activities. You may photograph one hand by itself, both hands of one person or the hands of several people together. Do not include a full face with the hands, although part of a face is acceptable.

7. *Still life* Produce a set of still life photographs that explores a range of old objects, things that are worn out from age or use. The final work can be either abstract or commercial.

8. *Shadows* Photograph an object (or part of it) along with its shadow, exploring how the shadow can add visual interest to an image.

Progress report

Student Name .. Class Date Time...........

Assignment feedback

Creativity ..

Composition ...

Presentation ..

Exposure ..

Lighting ...

Focusing ..

Tonaility and color ...

Attendance Punctuality Deadlines

General progress

Creative approach to design activities ...

Management of time ..

Technical competency ...

Appropriate use of the study guides to aid research

Points raised by student

...

...

Points raised by tutor ..

...

Negotiated statement on progress

...

...

...

Necessary action agreed to be undertaken

...

...

...

Signature of student ...

Signature of tutor .. Date

Work sheet

Student NameYear Group
Assignment ...

Research
1. What is it you like about the images you have been looking at?
...
...
2. What techniques has the photographer used? ...
...
...

Preliminary work
1. Which images do you like from your first shoot? ...
...
...
2. How could you improve upon these images? ...
...
...

Plans and ideas
1. What elements from your research can you use in your own work?................
...
...
...

2. What ideas do you have to develop a theme? ...
...
...
...
...

Organization of final shoot
Location Time and date ..
Estimated time needed for shoot ...
Permission or tickets required Contact name
Equipment needed ...
Props needed ...

Summer project

The word 'summer' can conjure up many different images: strawberries and cream, hot lazy days, rain-soaked day trippers, excited holidaymakers, bored school children, cricket on the village green, discarded ice-creams in the sand, littered beaches, etc.

Shane Bell

Assignment

In this assignment you must record one aspect of your summer this year, something that has attracted your visual curiosity. Do not necessarily choose a stereotypical view of summer, i.e. a picture postcard shot of the beach or family snapshots.

The images that you choose should relate with each other in some way and portray a theme or aspect of summer that you would like to convey. The photographs may be abstract, documentary shots from real life or shots that have been set up to convey a message.

You will be expected to have taken at 50 images. It is not expected that you will print your own images over the summer. Edit your work down to six images and present these in class on the first week of term.

Assessment criteria

Your work will be assessed using the following criteria:

1. Arrangement and composition of subject matter within the frame.
2. Use of light to create appropriate mood.
3. Sympathetic use of viewpoint and creative use of shutter speed.
4. Visual clarity of idea and theme.
5. Presentation.

Glossary

Aliasing	The display of a digital image where a curved line appears jagged due to the square pixels.
Ambient light	The natural or artificial continuous light that exists before the additional lighting is introduced.
Analyse/Analysis	To examine in detail.
Anti-aliasing	The process of smoothing the appearance of a curved line in a digital image.
Aperture	A circular opening in the lens that controls light reaching the sensor.
Backlit	A subject illuminated from behind.
Balance	A harmonious relationship between elements within the frame.
Bit	Short for binary digit, the basic unit of the binary language.
Blurred	An image or sections of an image that are not sharp. This can be caused through inaccurate focusing, shallow depth of field or a slow shutter speed.
Bounced light	Lighting that is reflected off a surface before reaching the subject.
Bracketing	Over- and underexposure either side of a meter-indicated exposure.
Byte	8 bits. The standard unit of binary data storage containing a value between 0 and 255.
Cable release	A cable that allows the shutter to be released without shaking the camera when using slow shutter speeds.
Camera shake	Blurred image caused by camera movement during the exposure.
CCD	Charge-coupled device. A type of image sensor used in digital image capture.
Channels	A method of separating a digital color image into primary or secondary colors.
Cloning tool	A tool used for replicating pixels in digital photography.
Close down	A term referring to the action of making the lens aperture smaller.
Close-up lens	A one-element lens that is attached to the camera's lens allowing the image to be focused when the camera is close to a subject.
CMYK	Cyan, Magenta, Yellow and blacK. Inks used in four-color printing.
Composition	The arrangement of shape, tone, line and color within the boundaries of the image area.
Compression	A method of reducing the file size when a digital image is closed.
Constrain proportions	Retain the proportional dimensions of an image when changing the image size.
Context	The circumstances relevant to something under consideration.
Contrast	The difference in brightness between the darkest and lightest areas of the image or subject.

CPU	Central processing unit - the 'brains' of a digital camera or computer.
Crop	Reduce image size to enhance composition or limit information.
Curves	Control for adjusting tonality and color in Photoshop.
Decisive moment	The moment when the arrangement of the moving subject matter in the viewfinder of the camera is composed to the photographer's satisfaction.
Dedicated flash	A flash unit that is fully linked to the camera's electronics and uses the camera's own TTL light meter to calculate correct exposure.
Depth of field	The zone of sharpness variable by aperture, focal length or subject distance.
Diagonal	A slanting straight line that is neither horizontal nor vertical.
Differential focusing	Use of focus to highlight specific subject areas.
Diffused light	Light that is dispersed (spreads out) and is not focused.
Diffuser	Material used to disperse light.
Digital image	A computer-generated photograph composed of pixels (picture elements) rather than film grain.
Diminishing perspective	A sense of depth in a two-dimensional image provided by the reduced size of subjects as they recede into the distance.
Dioptres	Unit of power for close-up lenses.
Dissect	To cut into pieces. The edge of the frame can dissect a familiar subject into an unfamiliar section.
Dpi	Dots per inch. A measurement of print resolution.
Dynamic tension	An image which lacks either balance or harmony and where visual elements cause the eye to move out of the image.
Edit	To either reduce the number of images from a larger collection or to enhance or manipulate a digital image.
Evaluate	Assess the value or quality of a piece of work.
Exposure	Combined effect of volume of light hitting a sensor and its duration.
Exposure compensation	To increase or decrease the exposure from a meter-indicated exposure to obtain an appropriate exposure.
Exposure meter	Device for the measurement of light.
Extreme contrast	A subject brightness range that exceeds the image sensor's ability to record detail in all tones.
F-numbers	A sequence of numbers given to the relative sizes of aperture opening. F-numbers are standard on all lenses. The largest number corresponds to the smallest aperture and vice versa.
Feather	The action of softening the edge of a digital selection.
Field of view	The area visible through the camera's viewing system.
Figure and ground	The relationship between subject and background.
Fill	Use of light to increase detail in shadow area.
Fill flash	Flash used at a reduced output to lower subject brightness range.

Filter
Either a treated or colored piece of glass or plastic placed in front of the camera lens or a preset software action that applies an effect to a digital image.

Filter factor
A number used to indicate the effect of the filter's density on exposure.

Flare
Unwanted light, scattered or reflected within the lens assembly, creating patches of light and degrading image contrast.

Focal length
Distance from the optical centre of the lens to the image plane when the lens is focused on infinity. A long focal length lens (telephoto) will increase the image size of the subject being photographed. A short focal length lens (wide-angle) will decrease the image size of the subject.

Focal plane shutter
A shutter directly in front of the image plane.

Focal point
Point of focus at the image plane or point of interest in the image.

Focusing
The action of creating a sharp image by adjusting either the distance of the lens from the sensor or altering the position of lens elements.

Format
The size of the camera or the orientation/shape of the image.

Frame
The act of composing an image. See 'Composition'.

Golden section
A classical method of composing subject matter within the frame.

Gray card
Neutral colored card which reflects incident light at a known percentage.

Half-tone
A system of reproducing the continuous tone of a photographic print by a pattern of dots printed by offset litho.

Hard copy
A print.

Hard drive
Memory facility which is capable of retaining information after the computer is switched off.

Hard light
A light source which appears small to the human eye and produces directional light giving well-defined shadows, e.g. direct sunlight or a naked light bulb.

High key
An image where light tones dominate.

Highlight
Area of subject receiving highest exposure value.

Histogram
A graphical representation of a digital image indicating the pixels allocated to each level.

Horizontal
A line that is parallel to the horizon.

Hot shoe
Plug-in socket for on-camera flash.

Incident light reading
A measurement of the intensity of light falling on a subject.

Interpolation
A method of increasing the apparent resolution of an image by adding pixels of an average value to adjacent pixels within the image.

ISO
International Standards Organization. A numerical system for rating the speed or relative light sensitivity of an image sensor.

JPEG (.jpg)
Joint Photographic Experts Group. Image compression file format.

Juxtapose	Placing objects or subjects within a frame to allow comparison.
Key light	The main light casting the most prominent shadows.
Kilobyte	1024 bytes.
Lasso Tool	Selection tool used in digital editing.
Latitude	Ability of the film to record the brightness range of the subject.
Layers	A composite digital image where each element is on a separate layer or level.
LCD	Liquid crystal display.
LED	Light-emitting diode. Used in the viewfinder to inform the photographer of exposure settings.
Lens	An optical device usually made from glass that focuses light rays to form an image on a surface.
Levels	The method of assigning a shade of lightness or brightness to a pixel.
Light meter	A device that measures the intensity of light so that the optimum exposure for the image sensor can be obtained.
Long lens	Lens with a large focal length and thus a reduced field of view.
Low key	An image where dark tones dominate.
Macro	Extreme close-up.
Magic Wand Tool	Selection tool used in digital editing.
Marching ants	A moving broken line indicating a digital selection of pixels.
Marquee Tool	Selection tool used in digital editing.
Matrix metering	A meter reading which averages the exposure from a pattern of segments over the subject area.
Maximum aperture	
Megabyte	Largest lens opening.
Megapixels	A unit of measurement for digital files. 1024 kilobytes.
MIE	More than a million pixels.
Minimum aperture	Meter-indicated exposure.
Mode (digital image)	Smallest lens opening.
	RGB, CMYK, etc. The mode describes the tonal and color range of
Multiple exposure	the captured or scanned image.
Negative	Several exposures made onto the same image frame.
	An image where the tones are reversed, e.g. dark tones are recorded as
Neutral density filter	light tones and vice versa.
	A filter that reduces the amount of light reaching the image sensor.
Objective	
ODR	A factual and non-subjective analysis of information.
Opaque	Output device resolution.
Open up	Not transmitting light.
	Increasing the lens aperture to let more light reach the image sensor.

Pan	To follow a moving subject.
Perspective	The apparent relationship of distance between visible objects, thereby creating the illusion of depth in a two-dimensional image.
Perspective compression	Flattened perspective created by the use of a telephoto lens and distant viewpoint.
Photoflood	Tungsten studio lamp with a color temperature of approximately 3400K.
Pixel	The smallest square picture element in a digital image.
Polarizing filter	A gray-looking filter used to block polarized light. It can remove or reduce unwanted reflections from some surfaces and can increase the color saturation and darken blue skies.
Portrait lens	A telephoto lens used to capture non-distorted head and shoulder portraits with shallow depth of field.
Portrait mode	A programmed exposure mode that ensures shallow depth of field.
Previsualize	The ability to decide what the photographic image will look like before exposure.
Processor speed	The capability of the computer's CPU measured in megahertz.
Pushing film	The film speed on the camera's dial is increased to a higher number for the entire film. This enables the film to be used in low light conditions. The film must be developed for a longer time to compensate for the underexposure.
Push processing	Increasing development to increase contrast or to compensate for underexposure of films that have been rated at a higher speed than recommended.
RAM	Random access memory, the computer's short-term or working memory.
Reflector	A surface used to reflect light in order to soften harsh shadows.
Refraction	The change in direction of light as it passes through a transparent surface at an angle.
Resample image	Alter the total number of pixels describing a digital image.
Resolution	A measure of the degree of definition, also called sharpness.
RGB	Red, green and blue. The three primary colors used to display images on a color monitor.
Rubber stamp	A tool used for replicating pixels in digital imaging.
Rule of thirds	An imaginary grid that divides the frame into three equal sections vertically and horizontally. The lines and intersections of this grid are used to design an orderly composition.
Saturation (color)	Intensity or richness of color hue.
Scale	A ratio of size.
Selective focus	The technique of isolating a particular subject from others by using a shallow depth of field, also known as differential focus.

Self-timer	A device which delays the action of the shutter release. This can be used for extended exposures when a cable release is unavailable.
Sharp	In focus. Not blurred.
Shutter	A mechanism that controls the accurate duration of the exposure.
Shutter priority	Semi-automatic exposure mode. The photographer selects the shutter speed and the camera sets the aperture.
Silhouette	The outline of a subject seen against a bright background.
Skylight filter	Used to reduce or eliminate the blue haze seen in landscapes. It does not affect overall exposure so it is often used to protect the front lens element from damage.
Sliders	A sliding control in digital editing software used to adjust color, tone, opacity, etc.
SLR camera	Single lens reflex camera. The image in the viewfinder is viewed via a mirror behind the lens which moves out of the way when the shutter release is pressed.
Soft light	This is another way of describing diffused light which comes from a broad light source and creates shadows that are not clearly defined.
Software	A computer program.
Standard lens	A lens that gives a view that is close to normal visual perception.
Steep perspective	Exaggerated diminishing perspective created by a viewpoint in close proximity to the subject with a wide-angle lens.
Stop down	Decreasing the aperture of the lens to reduce the exposure.
Straight photography	Photographic images that have not been manipulated.
Subjective analysis	Personal opinions or views concerning the perceived communication and aesthetic value of an image.
Symmetry	Duplication of information either side of a central line to give an image balance and harmony.
Sync lead	A lead from the camera to the flash unit which synchronizes the firing of the flash and the opening of the shutter.
Sync speed	The fastest shutter speed available, for use with flash, on a camera with a focal plane shutter. If the sync speed of the camera is exceeded when using flash the image will not be fully exposed.
System software	Computer operating program, e.g. Windows or Mac OS.
Telephoto lens	A long focal length lens. Often used to photograph distant subjects which the photographer is unable to get close to. Also used to flatten apparent perspective and decrease depth of field.
Thematic images	A set of images with a unifying idea.
TIFF	Tagged Image File Format. Popular image file format for desktop publishing applications.
Tone	A tint of color or shade of gray.
Transparent	Allowing light to pass through.

TTL meter Through-the-lens reflective light meter. This is a convenient way to measure the brightness of a scene as the meter is behind the camera lens.

Tungsten light A common type of electric light such as that produced by household bulbs and photographic lamps. An 80A blue filter may be used to prevent an orange cast.

Unsharp Mask A filter for increasing apparent sharpness of a digital image.

UV filter A filter used to absorb ultraviolet radiation. The filter appears colorless and may be left on the lens permanently for protection.

Vantage point A position in relation to the subject which enables the photographer to compose a good shot.

Vertical At right angles to the horizontal plane.

Virtual memory Hard drive memory allocated to function as RAM.

Visualize To imagine how something will look once it has been completed.

Wide-angle lens A lens with an angle of view greater than 60°. Used when the photographer is unable to move further away or wishes to move closer to create steep perspective.

X Synchronization setting for electronic flash.

X-sync (PC socket) A socket on the camera or flash unit which enables a sync lead to be attached. When this lead is connected the flash will fire in synchronization with the shutter opening.

Zooming This is a technique where the focal length of a zoom lens is altered during a long exposure. The effect creates movement blur which radiates from the centre of the image.

Zoom lens A variable focal length lens. Zoom lenses have comparatively smaller maximum apertures than fixed focal length lenses.

Index

Acrobat Reader software, 184

Action images, 107, 108

Adams, Ansel, 80

Adjustment layers, 179

Adobe, *see also* Photoshop/Photoshop Elements

Adobe Bridge, 184

Adobe Gamma, 200

Adobe RGB workspace, 158, 173, 203

Adobe Slide Show, 186–9

Advertising, xxii, 113, 130, 132, 134–6

Aesthetics, 119

Agencies, 105

Allister, Paul, 61

Alternative realities, 83

Ambiguity, 73, 136

Anti-shake technology, 147

Aperture, 23, 29, 32, 34, 36, 148–9

Aperture priority (aperture variable/Av) mode, 34, 150

Apple Macintosh:

 keyboard shortcuts, 198

 PC comparison, 205

 screen presentations, 182–3, 187, 190, 191

Aspect ratios 185, 194

Atmosphere, 18

Attractive images, 43

Audio files for screen presentations, 182, 186, 191–3

Automatic camera controls, 144, 148, 150

Automatic flash units, 35

Av *see* Aperture priority mode

Backgrounds:

 images, 24, 53, 92–3, 96, 121

 screen presentations, 185, 188–9

Back lighting, 22, 153, 154

Balance, 9, 124

Beauty, 43

Benetton, 136

Berger, John, 134

Berry, Ian, 13

Bicubic sharpener, 169

Blakemore, John, 82

Blemishes, 167

Blending images, 57

Blend modes, 57–9

Blurring:

 backgrounds, 53

 landscapes, 79

 movement, 31, 32, 34

Brandt, Bill, 4

Breaking rules, 8

Bridge cameras, 146

Bridge software, 184

Brightness, 152, 162

Broken lines, 10

Burgess, Catherine, 43

Butler, Andrew, 135

Calibrating monitors, 199–200

Cameras, 142–55

Camera shake, 31, 147

Capa, Robert, 105

Captions, xxii, 133, 137

Capturing images, 141–55, 162, 165

Capturing stories, 108–10

Cartier-Bresson, Henri, xx, 7, 28, 105

Categories of self image, 42, 45

Character studies, 96, 99

Chim (David Seymour), 105

Classifications of self image, 42

Cleaning images, 167

Clone stamp tool, 167

Closed landscapes, 85

Close-ups, 107, 110

Cluttered pictures, 4, 12

Color:

 adjustments, 165–6

 blend mode, 58

 casts, 165, 175, 178

 monitor set-up, 199, 200

 posterization, 55

 printer management, 176–9, 203

 RGB color space, 158, 173, 191, 203

Color variations feature, 166

Comfort zones, 107

Communication, xxii, 106, 123



Compact cameras, 144, 145
Composite photographs, 67
 see also Photomontage
Composition, 2–15
 changing message, 133
 landscapes, 85–6
 portraits, 93–4
 still life, 123
Compression of JPEG files, 170
Computers:
 setup, 198–205
 see also Digital...
Conformity, 42, 44–5
Connecting with people, 97, 106, 107, 109
Constructed environment, 87
Context of images, xviii, xx, 7, 107, 108
Contradiction, 69
Contrast (subjects), 69
Contrast (tones), 21, 153, 162
Controlled test, 208
Copyright law, 113
Creating stories, 111
Cropping images, 133, 159–60, 169, 185
Curved lines, 11
Curves adjustment, 164
Custom settings for printing, 176–7

Dadaism, 68, 71
Decisive moments, 28
Dedicated flash units, 35
Depth, 13, 85, 125, 127
Depth of field, 23, 51, 53, 95, 126
Desktop setup, 201
Details in photo-stories, 107, 110
Diagonal lines, 11
Differential focusing, 53
Diffusers, 24
Digicams, 23, 146
Digital cameras, xiii, 23, 144–7
Digital formats, 152, 158, 161, 170–1
Digital manipulation:
 distortion, 54–61
 ethics, 70, 113
 post-production editing, 156–71

Digital montage, 60
Digital SLR (DSLR) cameras, 144, 145, 146, 147
Directing subjects, 98
Discussion of images, xvii–xviii
Distance to subject, 6, 13, 93, 121, 133
Distortion, 48–63, 95, 133
Documentary, 81, 104–10
Dominant tones, 151
Dramatic lighting, 19
DSLR see Digital SLR
Dynamic tension, 8, 11

Editing, 112, 133, 138, 156–71
Effects lights, 24
Electronic view finder (EVF) cameras, 146
Emerson, Peter Henry, 79
Environmental portraits, 92, 93, 95, 110
Equipment, xiv, 142–7
Essay sequences, 102–15
Establishing images, photo-stories, 107, 108
Ethical issues, 70, 113
Evans, Walker, 81, 105
EVF (electronic view finder) cameras, 146
Evidence, xviii–xix
Exposure, 21–2, 26–37, 148–55
Exposure compensation, 22, 151, 153, 154
Exposure-lock, 151, 153, 154
Expression:
 personal/self, xxi, 82–4
 portraits, 98

F64 group, 80
Fabricated images, 70, 113
 see also Manipulation, Photomontage
Faces, 43
Families, 132, 139
Farm Security Administration (FSA), 81, 87, 105
Fashion models, 70
Fast shutter speeds, 29, 32, 34
Feel good factor, advertising, 136
Field of focus see Depth of field
Figures of speech, 69
File management, 202
Filling the frame, 6, 121

Fill lights, 24

Filters, 61

Fixed lens cameras, 144, 145, 146, 147

Flash photography, 33, 35–6

Flat light, 18, 21

Flattering lighting, 19

Focal length, 84, 95, 133

Focal points, 6, 8, 13, 126

Focus, 79, 80, 126, 133

 see also Depth of field

Foreground subjects, 13, 86

Formats (digital files), 152, 158, 161, 170–1

Formats (landscape/portrait), 85, 93

Forms, 14, 209–10

Framing, xviii–xix, 2–15, 93, 133

Freezing motion, 29

FSA *see* Farm Security Administration

F-stops, 149

Galer, Mark, 86

Gallery, 206–7

Gamma sliders, 163, 165

Glamour in advertising, 135

Glossary, 212–18

Golden section, 8

Goldsworthy, Andy, 87

Gray point setting, 165

Group portraits, 94

Hard light, 19, 21, 122

Hardware white point, 199, 200

Harmony, 9, 124

Healing brush tool, 167

Heartfield, John, 68

Highlights, 164, 179

High resolution screen presentations, 184

High vantage points, 12

Hilliard, John, xviii–xix

Hine, Lewis W., 104

Histograms, 152, 161–3

History:

 landscapes, 78–81

 photomontage, 66–7

 photo-stories, 104–5

Hockney, David, 72

Horizon line, 85

Horizontal lines, 10

Hosoe, Eikoh, 5

Hue blend mode, 58

Identity, 40–7

iDVD, 182–3

iFamily, 182–3

Image banks, 182

Image cache settings, 203

Image capture, 141–55, 162, 165

Image profiles, 191

Image quality, 145, 147, 148, 154

Image stabilization technology, 147

iMovie, 183

Implied messages, xxii, 133, 134, 135

Impressionist art, 7

Ink, 174, 179

Interpretation of images, xvii–xviii, xx

iPhoto, 182–3

ISO settings, 29, 148

Joiners, 72

Journalism, 130, 132, 133, 138

JPEG file format, 152, 158, 161, 170–1

Juxtaposition of subjects, xxi, xxii, 73, 137

Kennard, Peter, 68, 137

Keyboard shortcuts, 198

Killen, Sean, 99

Landscape/portrait format, 85, 93

Landscapes, 76–89

Lange, Dorothea, 81, 105

LCD screens, 147

Lee, Russell, 105

Legal matters, 113

Lenses, 51, 95, 133, 144, 146

Levels adjustment, 161, 163, 165

Lewis, Luke, 52

Life magazine, 105

Light, 16–25

 back-lit subjects, 22, 153, 154

changing mood, 133

direction, 18, 20

distortion, 52

metering, 21, 22, 148, 151

quality, 19, 122

refraction/reflection, 51

sources, 25

still life, 122

studio lighting, 24

Limitations of capture media, 21

Line, 10–11

Liquify filter, 52, 61

Literacy, xxii, 50, 68, 130–40

Location of photo-stories, 107, 108

Long exposures, 31–2

Low vantage points, 12

McBean, Angus, 71

McBride, Julia, 45

Macs *see* Apple Macintoshes

Magnum agency, 105

Magritte, Réne, 71, 73

Manipulation:

distortion, 54–61

ethics, 70, 113

media images, 70, 113, 133

post-production editing, 156–71

Manual camera control, 144, 151, 154

Masks, digital, 60

Maximum depth of field, 23

Media images, xxii, 70, 113, 130–40

Memory (RAM) allocation, 203

Messages, xxii, 133, 134, 135

Meter's indicated exposure (MIE), 21, 22, 148, 151

Middle distance subjects, 13

MIE *see* Meter's indicated exposure

Model release forms, 113

Models, image manipulation, 70

Moholy-Nagy, Laszlo, 71

Monitor set-up/calibration, 173, 179, 199–201

Montage, 44, 45, 60, 64–75, 133, 137

Moral codes, 70, 113

Movement:

blurred, 31, 32, 34

frozen, 29, 32, 34

shutter speed, 26–37

Movies, 183–4

Multiple exposures, 33

Multiple images:

blending, 57, 60

character studies, 99

photo-stories, 102–15

see also Photomontage

Multiple light sources, 20

Music for screen presentations, 182, 186, 191–3

Narrative techniques, 102–15

Natural environments, 76–89

Naturalism, 79

Noise (digital), 148

Objective analysis, xviii

Off centre subjects, 8–9

Open landscapes, 85

Optical zoom, 146

Ouchterlony, Ann, 96

Overexposure, 148, 151, 153, 154

Ownership of images, 113

Painting influencing photography, 66–7, 71, 78–9, 118

Panning, 30, 31

Paper, 174, 179

PCs:

keyboard shortcuts, 198

Macintosh comparison, 205

screen presentations, 184–9, 191

PDF presentations, 184–5

Peach-Robinson, Henry, 67

People, 90–101, 105–15

Permission to photograph, 97, 113

Personal expression, xxi, 82–4

Personal identity, 40–7

Perspective, 13, 51, 127

Photomontage:

in art, 71–2

conformity, 44–5

digital image combination, 57, 60

figures of speech, 69

history, 66–7

joiners, 72

media images, 70, 133, 137

political, 68–9

surrealism, 71

Photoshop/Photoshop Elements:

image distortion, 53–61

image editing, 159–71

screen presentations, 184–9

set-up, 198, 203

software comparison, 204

Photo-stories, 102–15

Pictorial photography movement, 79

Political photomontage, 68–9

Portfolios, xx

Portrait/landscape format, 85, 93

'Portrait mode', 95

Portraits, 90–101

photo-stories, 107, 110

Posterization, 55

Post-production, blurring backgrounds, 53

Post-production editing, 54–63, 156–71

PowerPoint, 190–5

Preferences, computer setup, 203

Presentations on screen, 180–95

Presentation of work, xvi, xx

Printer drivers, 177

Printer profiles, 176

Printing, 172–9, 203

Privacy, 97, 113

Progress report, 209

Prosumer cameras, 23, 146

Publicity *see* Media images

Quality of light, 122

QuickTime movies, 187, 195

RAM allocation, 203

RAW file format, 158, 161

Ray, Man, 56

Reactions to images, xvii, xx

Realism, 80

Reality distortion, 48–63, 130–40

Record keeping, 174

Reflection, 51

Reflectors, 24

Refraction, 51

Rejlander, Oscar Gustave, 67

Repairing images, 167

Resizing images, 169

Resolution, monitor set-up, 199

Resources, xv–xvi, 196–211

Riboud, Marc, 6

Riis, Jacob, 104

Ritchin, Fred, xxii

Rodger, George, 105

Romantic era, 79

Rotating images, 160

Rothstein, Arthur, 81, 87, 105

Rule of thirds, 8

Sabattier effect, 56

Saturation blend mode, 59

Saving images, 169–71

Scale in photomontage, 69

Scanning, 158

Scicluna, Tom, 44

Screen presentations, 180–95

Self expression, xxi, 82–4

Self image, 40–7

Semi-automatic exposure systems, 34, 150

Sensitive material, 113

Seymour, David (Chim), 105

Shadows, 164, 179

Shallow depth of field, 23, 53

Shapes, 5

Sharpening tools, 168, 169

Shutter priority (time variable/Tv) mode, 34, 150

Shutter speed, 26–37, 148, 149

Single lens reflex (SLR) cameras, 144, 145, 146, 147

Single light source, 20

Slideshows, 180–95

Slow shutter speeds, 31, 32

Slow-sync flash, 36

SLR *see* Single lens reflex

Smith, Maddy, 53

Smith, W. Eugene, 105

Social comment, 83, 136, 137

Soft light, 19, 21, 24, 122
Solarization, 56
Sontag, Susan, 77
Sound for screen presentations, 182, 186, 191–3
Sources of images, xvi, xx
Spot healing brush tool, 167
Spring, Gale E., 73
sRGB color space, 158, 173, 191, 203
Stability, 10, 11
Staeck, Klaus, 68
Stieglitz, Alfred, 80, 82
Still life, 116–29
Storing images, xvi
Storyboards, 111
Story sequences, 102–15
Straight lines, 10–11
'Straight photography', 80
Strand, Paul, 80
Structured learning approach, xiii
Stryker, Roy, 81
Studio lighting, 24
Subject distance, 6, 13, 93, 121, 133
Subjective interpretation, xvii–xviii, xx, xxii
Subject placement, 8–9
Summer project, 211
Sunlight, 122
Surrealism, 71, 73
Symbols, xxi, 118
Symmetry, 9, 124
Szarkowski, John, 7

Talbot, Fox, 68
Target white point, 199, 200
Teaching photography, xiii
Technical guides, 141–211
Telephoto lenses, 95, 133
Tension, 8, 9, 11
Test prints, 175, 178–9
Text, 69, 188, 191
Themes, 14
Thyristors, 35
TIFF file format, 158, 161
Time, 26–37
Time variable (Tv/shutter priority) mode, 34, 150

Tinting, 58
Tonal adjustments, 58, 161–4
Tonal clipping, 152, 161
Tonal interchange, 24
Transitions in screen presentations, 194–5
Truth in photography, 70, 73, 87, 113, 130–40
Tv see Time variable mode

Ugliness, 43
Underexposure, 148, 151, 153, 154
Unsharp mask filter, 168, 169
Uzzle, Burk, 10

Vantage points, 12, 107, 120, 133
Variations feature, 165, 166
Vertical lines, 10
Very long exposures, 31–2
Viewfinders, 147
Viewpoints see Vantage points
Visual literacy, xxii, 50, 68, 130–40
Visual puzzles, 136
Visual tension, 124

Web images, 169, 171
Weston, Edward, 80
'What-you-see-is-what-you-get' preview images, 147
White balance, 165
White point, monitor set-up, 199, 200
Wide angle lenses, 84, 95, 133
Windows Media Videos, 186
Work sheet, 210

Zoom lenses, 34, 51, 146